BAUHAUS

Publisher and Creative Director: Nick Wells
Project Editor: Sarah Goulding
Designer: Lucy Robins
Development and Picture Research: Melinda Revesz
Production: Chris Herbert and Claire Walker

Special thanks to: Hilary Bird and Helen Tovey

FLAME TREE PUBLISHING
Crabtree Hall, Crabtree Lane
Fulham, London, SW6 6TY
United Kingdom

www.flametreepublishing.com

First published 2006

05 07 09 08 06

1 3 5 7 9 10 8 6 4 2

Flame Tree is part of the Foundry Creative Media Company Limited

© 2006 Flame Tree Publishing

The CIP record for this book is available from the British Library.

ISBN 1 84451 336 X

Every effort has been made to contact copyright holders. We apologize in advance for any omissions
and would be pleased to insert the appropriate acknowledgements in subsequent editions of this publication.

While every endeavour has been made to ensure the accuracy of the reproduction of the images in this book,
we would be grateful to receive any comments or suggestions for inclusion in future reprints.

Printed in China

BAUHAUS

Author: Andrew Kennedy Foreword: Michael Robinson

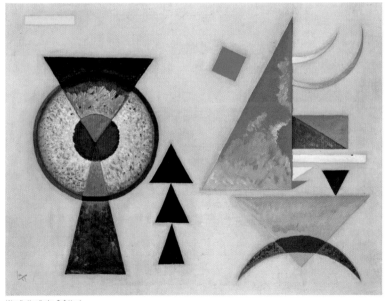

Wassily Kandinsky, *Soft Hard*

FLAME TREE
PUBLISHING

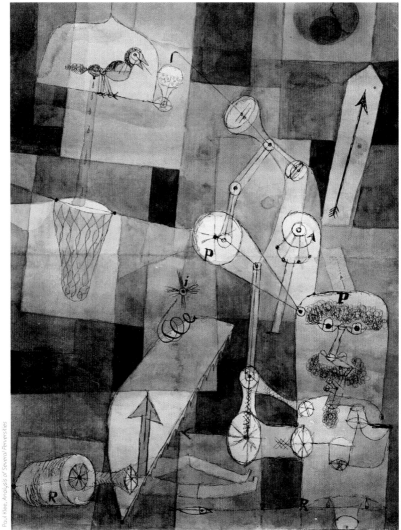

Paul Klee, *Analysis of Several Perversities*

Contents

Walter Gropius, Master House, Bauhaus, Dessau; Erich Dieckmann, Armchair; LászlóMoholy-Nagy, Untitled

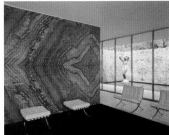
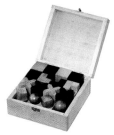
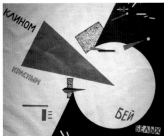

Ludwig Mies van der Rohe, German Pavilion for the International Exposition in Barcelona; Josef Hartwig, Chess set in box; El Lissitzky, *Beat the Whites with the Red Wedge*

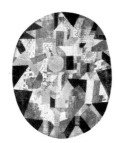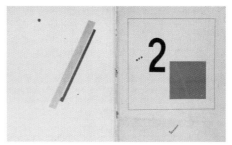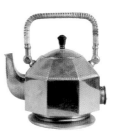

Walter Gropius, Entrance to the Bauhaus, Dessau; Ludwig Mies van der Rohe, Lange House and Esters House, Krefeld, Germany; Ludwig Mies van der Rohe, Maquette for a skyscraper in glass

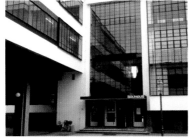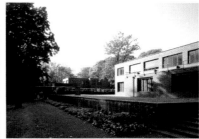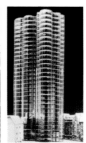

Paul Klee, *Vollmund in Mauem ('Full Moon Within Walls')*; El Lissitzky, Book cover design for *Of Two Squares: A Suprematist Tale in Six Constructions*; Peter Behrens, Electric kettle for AEG

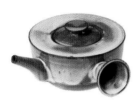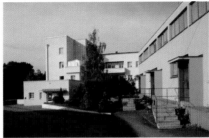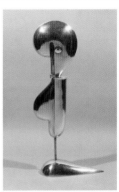

Theodor Bogler, Teapot; Mart Stam & Peter Behrens, Row houses and apartment block, Weissenhof Estate, Stuttgart; Oskar Schlemmer, *Grotesque (Abstract Figure)*

How To Use This Book

The reader is encouraged to use this book in a variety of ways, each of which caters for a range of interests, knowledge and uses.

- The book is organized into five sections: **Movement Overview**, **Society**, **Places**, **Influences** and **Styles & Techniques**.

- **Movement Overview** takes a look over the whole Bauhaus movement, from its beginnings in 1919 to its destruction by the Nazis in 1932, giving readers a perspective on the development of the art and artists within the movement.

- **Society** shows how the wider world in which the artists of this period lived had a bearing on their work, and explores their different interpretations of it.

- **Places** looks at how the Bauhaus flourished in Weimar and later Dessau, in Germany, before dispersing abroad. This section looks at the art and architecture in these places.

- **Influences** shows how Bauhaus art was influenced by Russian Constructivism and Dutch *De Stijl*. It also shows how Bauhaus artists influenced their contemporaries.

- **Styles & Techniques** reveals the myriad techniques employed by Bauhaus artists, allowing them to excel in everything from furniture design and architecture to oil on canvas and sculpture.

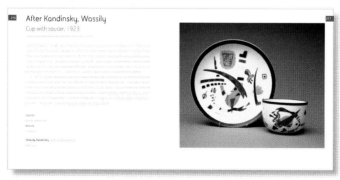

After Kandinsky, Wassily
Cup with saucer, 1923

2. Name of artist, by surname then forename

1. Title of work

3. Date of work (if known)

4. Information about the work and the context within which it was created

8. Picture credit

7. Location in which the work was created (if known)

6. Medium in which the work was created (if known)

5. Biographical information about the featured artist: name, date and place of birth and date of death

326

Albers, Josef

Study for Homage to the Square, 1956

CREATED

MEDIUM

Josef Albers

Foreword

My first encounter with Bauhaus design was, I suspect like many of my postwar generation, through an exposure to the Habitat products of the late 1960s and 1970s. An enthusiastic friend, who was helping me to furnish my first flat after leaving home, suggested their range. I will always remember my total surprise at the clean, functional styling of the products that eschewed the unnecessary adornment and frippery of my parent's generation. To an impressionable twenty-something like me, it seemed so radical a departure from anything I had ever seen, and yet as my friend pointed out, it had its antecedents in the Bauhaus. Until then I had not heard of the Bauhaus and it was suggested that I purchase a copy of Nikolaus Pevsner's *Pioneers of the Modern Movement* (later renamed *Pioneers of Modern Design*) to satisfy my curiosity. From that time on I have remained a devotee of both its aesthetic and design ethos.

Pevsner was right to point out that the Bauhaus ethos of a design aesthetic for an egalitarian mass production had its roots in the ideas of William Morris, who, in the latter half of the nineteenth century, asked the question 'What business have we with art at all, unless we can all share it?'. The founder of the Bauhaus, Walter Gropius, began his career like many of the early Modernist practitioners, such as Le Corbusier and Ludwig Mies van der Rohe, in the office of another forward thinking designer and architect, Peter Behrens. After the First World War, with Germany in a financial depression, Gropius took over an existing art school and turned it into the Bauhaus; an educational establishment that sought, through a new philosophy, to tackle the dilemma that had faced William Morris, namely designing and manufacturing goods that were affordable to most people rather than just the elite.

Other than the Bauhaus building at Dessau, Gropius himself actually designed very little. His real talent lay in founding an educational establishment based on the philosophy of the *gesamtkunstwerk*, or total work of art that had previously inspired Morris, but which now embraced and incorporated new technologies rather than a backward-looking idealism. To achieve this, he surrounded himself with a diversity of artistic and design talent that included Wassily Kandinsky, Paul Klee and László Moholy-Nagy. As Masters (later Professors) at the Bauhaus, these established artists were able to educate and nurture the next generation of designers. It is notable of course that many of these Masters (and guest lecturers) were not just from Germany, but from all over Europe – particularly Holland and the

fledgling communist state of Russia – bringing with them a wealth of other influences such as Constructivism and *De Stijl*. These Masters were ultimately responsible for educating many of the household names associated with the Bauhaus. Marcel Breuer who designed the Wassily chair, which is still in production today, Marianne Brandt and Wilhelm Wagenfeld whose desk and table lamps were so inspirational to future generations of designers, and of course textile designers such as Anni Albers. What they all shared was the common ethos of design 'functionalism'.

As a design and architectural historian, Nikolaus Pevsner failed to acknowledge the influence of Constructivism and *De Stijl* on the Bauhaus philosophy despite the number of revisions and reprints of *Pioneers of the Modern Movement*. Perhaps more importantly, he failed to adequately emphasize the influence of the Bauhaus on future generations of designers. More recently, new scholars such as Gillian Naylor and others have reassessed the Bauhaus and the contribution that its ethos has made to our lives in the so-called Postmodern era. It is clear that Aldo Rossi's *La Conica* coffee makers and Richard Sapper's *Bollitore* kettle embrace Postmodern ideas of emphasizing the symbolic role of an item. However it is equally clear that their designs, unlike those of some other Postmodernists, do not eschew the modernist credo that 'form follows function', since the designs are clearly indebted to the Bauhaus aesthetic. Despite its shortcomings, Pevsner's text rightly posits Gropius as an extraordinary man of rare insight and vision in both design approach and in setting up the Bauhaus.

In this new book by Andrew Kennedy, we are introduced to many of the Bauhaus names and their design artefacts that helped make Gropius's dream of the *gesamtkunstwerk* possible. Through his vision, the Bauhaus was able to instil a design ethos that combined art in design with manufacturing considerations that no one had hitherto. His legacy is that same ethos that continues to inform today's designers.

Michael Robinson, *2005*

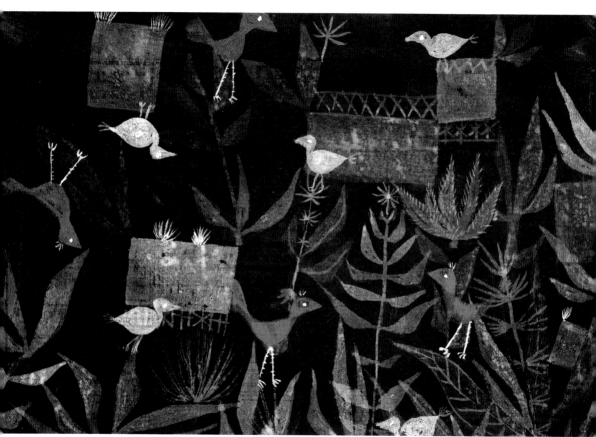

Paul Klee, *Garden with Birds*, Courtesy of Private Collection/Bridgeman Art Library/© DACS 2005

Introduction

The Bauhaus ('construction house') art and design school has exerted an unparalleled influence on the visual culture of the last ninety years. It was founded in 1919, in the chaotic aftermath of the revolutionary upheavals in Germany following its defeat in the First World War. The old civilization seemed to have produced unimaginable barbarism and a new one was ready to be born. The Kaiser had been forced to abdicate, a republic was declared and soldiers' and workers' councils sprang up in emulation of the previous year's Russian Revolution before being bloodily suppressed.

The first manifesto of the Bauhaus, written by the new Director, the architect Walter Gropius (1883–1969), reflects the heady idealism of those days. It was decorated with a woodcut by Lyonel Feininger (1871–1956) entitled *Cathedral* (see page 64). The manifesto begins, 'The ultimate aim of all visual arts is the complete building'. For the English socialist William Morris (1834–1896), the medieval cathedral stood for the unity of the arts and crafts, the harmonious integration of hand and brain, individual and society. Gropius likewise called for an end to artistic isolation and a return to the crafts in a huge co-operative effort. The characteristic ideology of the early Bauhaus was a Romantic anti-capitalism. It attracted as teachers artists such as Paul Klee (1879–1940), Wassily Kandinsky (1866–1944), Feininger and Johannes Itten (1888–1967), who at that time looked back to the imagined integrity of a pre-capitalist culture and forward to a new spiritual and social transformation. A system of workshops for glass painting, metalwork, pottery, weaving, furniture making, etc. was instituted, in a conscious echo of the Middle Ages. Each workshop had a Master of Craft, who taught the technical skills, and a Master of Form who was usually, and problematically, a fine artist. The students were to regard themselves as apprentices.

The first Bauhaus was located in Weimar, capital of the new republic but also symbol of the heights of eighteenth- and nineteenth-century German culture, of the Enlightenment and of Romanticism. Goethe, Schiller and Liszt had lived and worked there. From the beginning this new school and the unconventional, radical students it attracted were regarded with suspicion by local and regional government and by Weimar's more respectable citizens. However, from late 1922 a change in school policy was evident. Gropius had coined the slogan, 'Art and Technology: a new Unity'. The old emphasis on the handicrafts seemed increasingly unsuited to the demands of modern industrial mass production. There were at least two factors involved in this change. The prolonged revolutionary crisis

of 1918–23 seemed to be ebbing, and German capitalism was stabilizing and regenerating itself. Prospects for making links between the Bauhaus and industry looked promising. At the same time, cultural developments in the new Soviet Union seemed to show the way forward for a new unity of art, design and architecture, based on technology, not craft. This was represented, for Westerners, mainly by the Constructivism of Vladimir Tatlin (1885–1953), El Lissitzky (1890–1941) and Aleksandr Rodchenko (1891–1956). The peripatetic El Lissitzky organized an exhibition of the new Soviet art in Berlin in 1922. Theo van Doesburg (1883–1931), of the Dutch group *De Stijl*, who had been thinking along parallel lines, joined Lissitzky at the Dada-Constructivist Congress held in Weimar that same year. László Moholy-Nagy (1895–1946), a Hungarian steeped in this new thinking, had also attended this congress and was appointed as a teacher at the Bauhaus in 1923. He replaced the mystical, craft-oriented Johannes Itten, who had left after signalling his disagreement with the new direction. The Bauhaus exhibition of 1923, staged at the insistence of the Thuringian government, showed a new emphasis on rationalism and functionalism, suited to the demands of industrial production. Of course, the rigid geometric language in which this new vision was frequently expressed was not necessarily functional: flat roofs, for example, help to make nice cubic shapes but are more likely to leak.

Forced from Weimar in 1925 by a new right-wing administration, the Bauhaus were welcomed by the Social-Democratic town council of Dessau, in Saxony-Anhalt. Its mayor, Fritz Hesse, was interested in a progressive fusion of art and industrial design. He had invited enterprises specializing in advanced technology, such as the aircraft firm of Junkers, to the city. It seemed fitting that planes from the factory should regularly fly over the Bauhaus, although the Nazis were to find many uses for the aircraft but none for the school.

The new buildings for the Bauhaus of 1925–26, designed by Gropius, reflect this new-won prestige and industrial ethos. The Craft Master posts had been abolished. The school gained university status and the Form Masters became professors. Rationalization and standardization became the new watchwords, although individual creativity continued to play a role in the thinking of Gropius and Moholy-Nagy. Klee and Kandinsky did not teach classes on painting, but their classes on form and colour had a huge influence, for example, on the designers of the weaving workshop, led by Gunta Stölzl (1897–1983). Nevertheless the influence of the new young technocrats at the Bauhaus, Herbert Bayer (1900–85) in graphic design and Marcel Breuer (1902–81) in furniture and interior design, became paramount in these years. They forged new links with industry, as did Wilhelm Wagenfeld (1900–90) and Marianne Brandt (1893–1983) in the metal workshop.

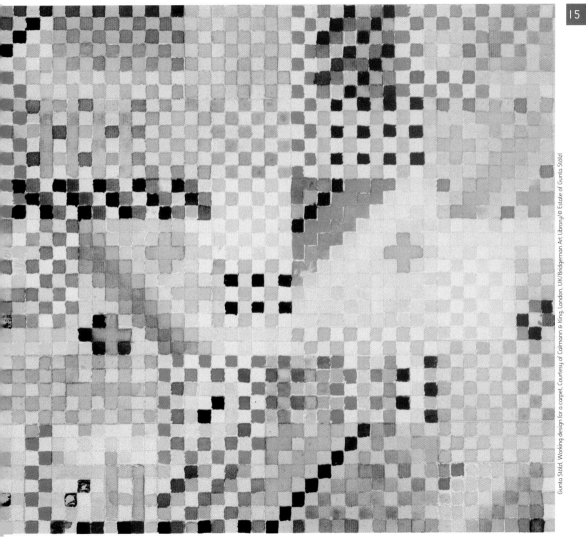

Gunta Stölzl, Working design for a carpet. Courtesy of Calmann & King, London, UK/Bridgeman Art Library/© Estate of Gunta Stölzl

Hannes Meyer was Director from 1928 to 1930. Not content with the existing orientation towards industry, he rejected aesthetics in favour of the notion that design was purely the product of rational, technical calculations and its *raison d'être* was to improve the conditions of the masses. Architecture was thus the most important branch of design. It could be said that he was only pushing certain ideas already present in Modernism, especially Constructivism, to their logical conclusion, but he set himself to eradicate the last vestiges of what he saw as Romanticism, idealism and individualism from the curriculum. To Meyer, this accorded perfectly with his self-declared Marxist beliefs, as a radical materialist could hold no truck with the quasi-religious features of the cult of 'art'. However, this approach seems to have converged very well with the requirements of capitalist industry. He forged a number of successful partnerships with industry at this time. Nevertheless his leftist principles drew the fire of the increasingly right-wing Dessau town government on the Bauhaus. German politics had become polarized after the mass unemployment caused by the Depression of 1929 and the Nazi and Communist parties were both experiencing a growth in support.

Finally Meyer was forced to resign and the architect Ludwig Mies van der Rohe (1886–1969) took over. He seemed the safe choice, an architect who had represented Germany at the International Exposition in Barcelona in 1929. He

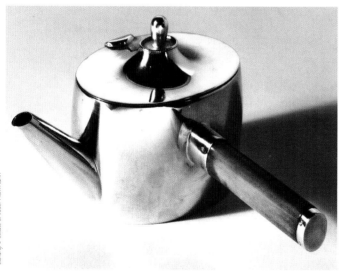

Josef Hoffmann, Chocolate pot, Courtesy of Private Collection/Bridgeman Art Library/© Estate of Josef Hoffmann

forbade political discussion among the students, but this was not enough for the extreme right, which was growing faster than the left across the country, assisted by the failure of the Communist and Socialist parties to unite against them. The Nazis took over control of Dessau council in 1932. For them, the Bauhaus was associated with 'cultural Bolshevism', internationalism rather than German nationalism, 'Arab' flat roofs as against good Aryan pitched roofs, and there were too many Jews among its teachers and students. The Bauhaus was forced to

close and Mies van der Rohe relocated the school to Berlin, until the Nazis' accession to national power caused it to close for good.

Many of its teachers and former teachers had international reputations and could walk into good jobs in America, as did many former students. This applies to Gropius, Mies van der Rohe, Josef and Anni Albers, Feininger, Moholy-Nagy, Bayer and Breuer. Anni Albers later said her designs were her 'passport to America'. Others went to Switzerland, among other places. Yet many ex-students — those left behind — were not so lucky, and it is estimated that twenty to thirty died in concentration camps or through other causes during the Second World War.

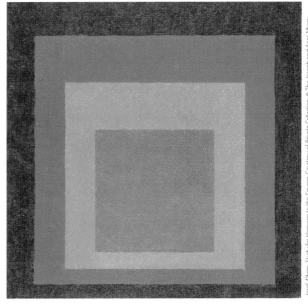

Josef Albers, Study for Homage to the Square. Courtesy of Private Collection. © The Joseph and Anni Albers Foundation; © Christie's Images/Bridgeman Art Library/VG Bild-Kunst, Bonn and DACS, London 2005

Nonetheless, the Bauhaus had arrived in America, which after the Second World War became the leading economic and cultural power in the world. Hence a version of Bauhaus style became the signature style of the postwar economic boom. Instead of workers' housing, Gropius and Mies van der Rohe designed skyscrapers for corporations. Despite this geographical shift, however, Bauhaus ideals crucially informed the huge public projects of postwar European social democracy, until budgetary constraints and institutionalized neglect began to assist in tarnishing the reputation of Modernism. Recent historians, some influenced by Postmodernism, have questioned the heroic Modernist narrative in which the Bauhaus plays such a central role. They have rightly highlighted problems of elitism and gender inequality at the Bauhaus. They have pointed out that there were other centres of Modernism in Germany and that the Bauhaus's importance has been exaggerated. While much of this is true, it may be that what some historians are suspicious of, after the apparent collapse of Communism and of welfare capitalism, is the very notion of a Utopian collective project aimed at changing the way life is lived.

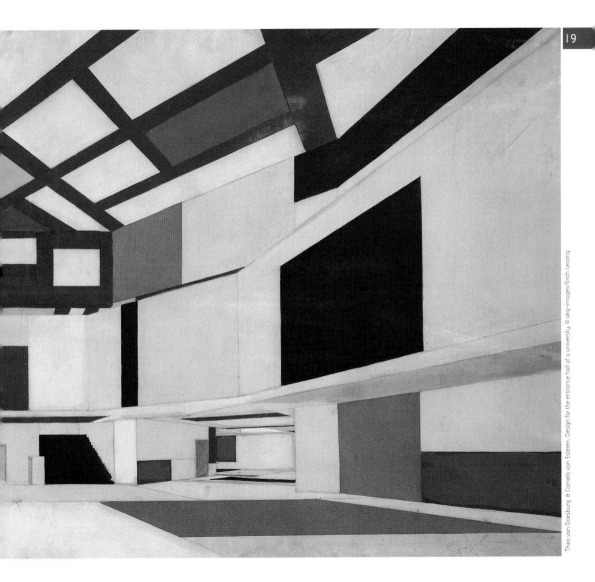

Bauhaus

Movement
Overview

Bayer, Herbert

Invitation card to Bauhaus exhibition, Weimar, 1923

This card, by a student who was to become an influential Bauhaus Master, is based on the new Bauhaus seal that Oskar Schlemmer had designed the previous year. It is the face of the Bauhaus of 1923, which had rejected the idea of a return to the crafts and instead focused on design for industry. This is the new human being: de-individualized, standardized, geometrically perfect, just like the mass-produced forms of his environment. As it happens, Schlemmer thought 'Man' himself was irredeemably imperfect, but art and design offered a partial redemption, a glimpse of a higher, more perfect reality. László Moholy-Nagy, Walter Gropius's new 'prime minister', would have scorned such metaphysics, but fully embraced the new machine aesthetic as a means of achieving a Utopia in material form here on earth.

The Bauhaus exhibition at Weimar was forced on Gropius by the Social Democratic Thuringian regional government, itself under pressure from conservative forces to ensure that State funds were being well spent in the midst of economic crisis. The exhibition marked a break from the 'subjective', handicraft ethos of the early years – it became a statement of the school's new orientation towards design for industry.

CREATED

Weimar

MEDIUM

Lithograph

SIMILAR WORKS

Joost Schmidt, poster for Bauhaus exhibition, 1923

Herbert Bayer *Born* 1900 Haag, Austria

Died 1985

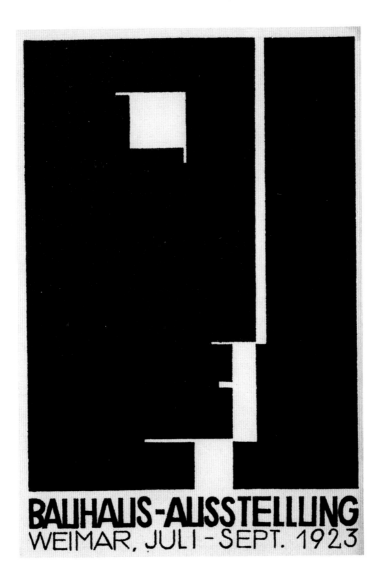

Klee, Paul

Wall painting from the *Temple of Longing Thither*, 1922

Courtesy of Private Collection © Christie's Images/Bridgeman Art Library/© DACS 2005

Klee taught at the Bauhaus from 1921 until 1931, but never fully identified with the idea that art and design could assist the rational progress of society towards a better world. For Klee, the arrows in this picture represented human thought and aspiration, which can measure the depths of the cosmos, but remain tragically earthbound. Architectural shapes restlessly aspire in all directions here, but a remorseless sun fixes them to the earth via their shadows, the counterpart of the arrows. If the 'Temple of Longing Thither' is the Bauhaus, then it will never achieve its goal, just as this watercolour will never become a wall painting.

It was not wrong, Klee taught, to strive for the impossible. But it was wrong to place one's trust in artificial schemas, such as scientific perspective, which is alluded to here in the lines of the shadows. The Dutch *De Stijl* group, so influential at the Bauhaus, rejected the laws of perspective for a different reason – the notion that lines should converge towards a vanishing point stymied their Utopian attempt to make 'infinity thinkable'.

CREATED

Weimar

MEDIUM

Watercolour and transferred printing ink on gesso on cloth, mounted on light cardboard

SIMILAR WORKS

Paul Klee, *Analysis of Several Perversities*, 1922

Paul Klee *Born* 1879 Münchenbuchsee, near Berne, Switzerland

Died 1940

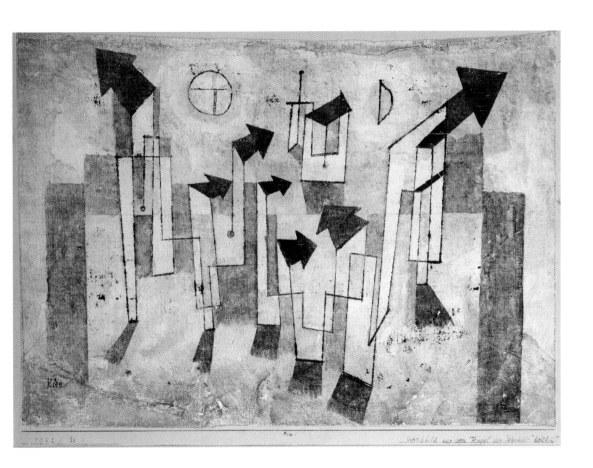

Unknown

The Bauhaus teachers at Dessau, 1926

© Topfoto.co.uk

This photograph was published with the title 'The Bauhaus Masters' in 1926 in an article in *Das Illustrierte Blatt*. Left to right: Josef Albers, Hinnerk Scheper, Georg Muche, László Moholy-Nagy, Herbert Bayer, Joost Schmidt, Walter Gropius, Marcel Breuer, Wassily Kandinsky, Paul Klee, Lyonel Feininger, Gunta Stölzl and Oskar Schlemmer.

In this image the teaching staff stand atop the trademark flat roof of the studio building of the new school at Dessau. At Weimar, reflecting the craft ethos, the staff were called 'Masters'. In October 1926, however, the senior staff were given the new title of 'Professor' after the school had secured university status and hence a new respectability.

In their suits, all the men appear as modern professionals, not as Bohemian eccentrics. The Director, Gropius, and Kandinsky, the oldest teacher and the most famous artist, stand slightly forward of the others in the centre. The large number of painters among the senior staff — Muche, Feininger, Schlemmer and Klee included — show how much importance was attached to 'art' even in the industrially-oriented Bauhaus of the Dessau period. Moholy-Nagy, however, was committed to the rise of industry. He and his disciples Bayer and Schmidt behind him all wear caps, a symbol of a democratic, classless outlook. The latter two, along with Scheper, Albers and Breuer, had been appointed as 'Young Masters' in 1925. The sole woman on the staff, Gunta Stölzl, was at this stage only technical director of the weaving workshop, becoming its head in 1927.

CREATED

Dessau

MEDIUM

Photograph

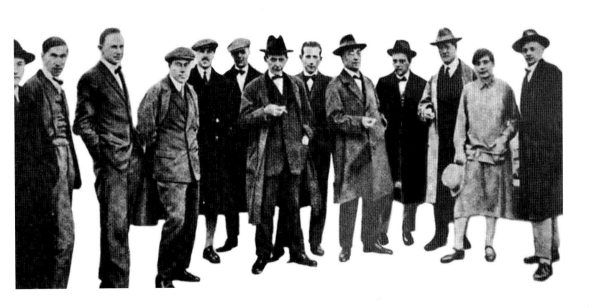

Wagenfeld, Wilhelm & Jucker, Karl Jacob
Table lamp, 1923–24

Courtesy of © Photo CNAC/MNAM Dist. RMN – © Jean-Claude Planchet/© DACS 2005

The Bauhaus metal workshop was at the forefront of the school's attempts to create designs for industrial mass production. This table lamp in its different versions was one of the most successful such designs and continues in production today. Encouraged by László Moholy-Nagy, the workshop's new Form Master, the workshop designed lamps for the centrepiece of the 1923 Bauhaus exhibition, the *Haus am Horn*. Lamps of a similar slimmed-down elegance, sometimes incorporating glass shafts, had been designed in the *Wiener Werkstätte* (Vienna Workshops) between 1901 and 1904.

Jucker's hollow glass shaft leaves the power source visible, clearly indicating function in the approved manner. Wagenfeld's reworking of Jucker's design utilized a frosted glass bell shade which provides a soft, bright glow and floats above the base like a moon. The lamp combines a certain insubstantiality, 'suited' to its purpose of disseminating light, with anchoring elements such as the nickel strip on the shade. Ironically, the lamp's manufacture required a high level of craft skill and was therefore expensive. The Bauhaus's beloved geometric shapes – cylinder, sphere and disk – might be combined to aesthetic effect in this object, but did not in themselves guarantee cheap and efficient mass production.

CREATED

Weimar

MEDIUM

Glass shaft, glass base and glass shade with nickel strip

SIMILAR WORKS

Gyula Pap, floor lamp *c.*1923

Wilhelm Wagenfeld *Born* 1900 Bremen, Germany

Died 1990

Karl Jacob Jucker *Born* 1902 Zürich, Switzerland

Died 1997

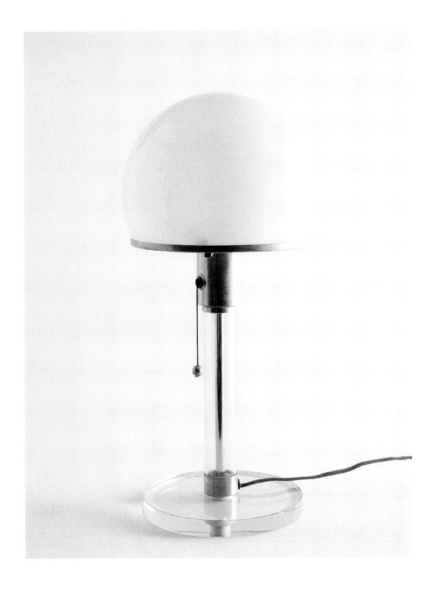

Unknown

The carpentry workshop, Weimar, 1923

Furniture design was given priority at the Bauhaus, and at Weimar, the carpentry workshop was given one of the best studios. The Form Master was Walter Gropius, the Director, although many of his duties were taken on by Johannes Itten. Workshops at Weimar were also overseen by Craft Masters, who taught the technical skills. During the post-First World War economic crisis, especially in the inflationary year of 1923, equipment and materials were scarce or unaffordable.

A personally expressive aesthetic and preference for traditional materials predominated early on. But from 1921–22, students such as Erich Dieckmann (1896–1944) were influenced by the ideas and designs of the rationalist *De Stijl* group. The workshop designed pieces for the *Haus am Horn*, the showpiece house of the 1923 Bauhaus exhibition. From 1923–24 there was a commercial demand for the workshop's products, especially the children's furniture of Marcel Breuer (1902–81) and Alma Buscher (1899–1944). Breuer became leader of the new workshop at Dessau, focusing his energies on tubular steel furniture for mass production. He left when the new Director, Hannes Meyer, was appointed in 1928. Meyer amalgamated the furniture workshop into a new interiors workshop.

CREATED

Weimar, Germany

MEDIUM

Interior design

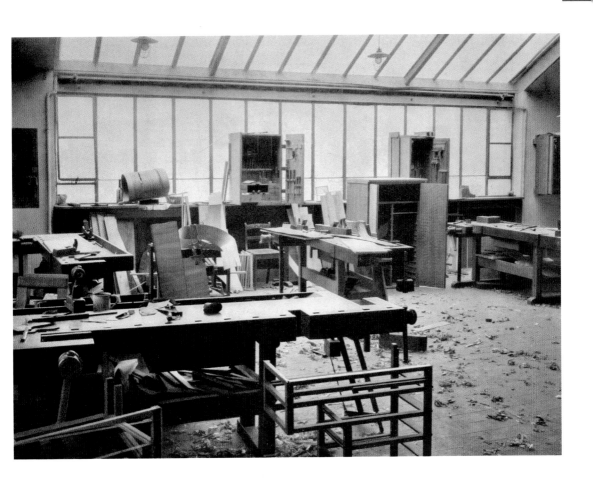

Brandt, Marianne
Teapot, 1924

This teapot was produced by one of the most innovative designers in the Bauhaus metal workshop, a woman in a traditionally male sphere of activity. László Moholy-Nagy encouraged Brandt to join the workshop when he took over as its head in 1923, but she had a hard time from her male colleagues before establishing herself. This piece shows the Constructivist influence of Moholy-Nagy in its use of geometrical forms – circle shapes in the top and a half-circle for the handle. The body of the teapot, a near-hemisphere, particularly recalls shapes that feature in his paintings.

The Constructivists' aim was to design pristine forms for a world transformed by social and technological revolution. It was thought, not always correctly, that simple geometric forms were those most suited to machine production, but they also represented the purity of the new Utopia. This teapot was actually handmade, but it shows the workshop's increasingly industrial orientation. Brandt became temporary head of the metal workshop in 1928, before leaving to work in Walter Gropius's Berlin office. The only woman at the Bauhaus who became a permanent workshop head was Gunta Stölzl, a weaver.

CREATED

Weimar

SIMILAR WORKS

Marianne Brandt, ashtray c.1924

Theodor Bogler, teapot, 1923

Marianne Brandt *Born* 1893 Chemnitz, Germany

Died 1983

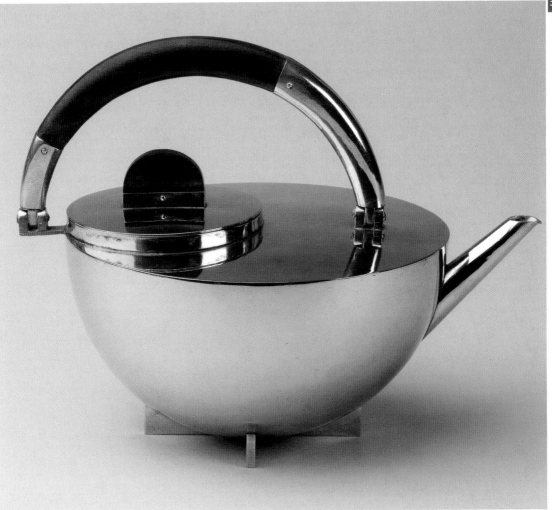

Albers, Josef

Fugue, *c.*1925

Although Albers produced a number of large stained glass windows for public and private buildings, this work on glass, that looks as if it should be of monumental size, only measures 25 × 66 cm (10 × 26 in). He was asked to take over the stained glass workshop at the Weimar Bauhaus in 1922. He also produced furniture and taught furniture design – this piece shows an approach to the construction of form that recalls carpentry. Bauhaus teaching encouraged the idea that there was a universal, non-figurative, visual language, and parallels were often made with the 'universal' language of music, as in the title of this work. The pattern of stripes seems to vibrate, and to recall the black and white of a piano keyboard or a musical score.

From 1925, the year he became a 'Young Master', Albers used a technique of sandblasting coloured glass. Colour (here, red) was 'flashed' onto a sheet of milk glass. Most of the sheet was then masked off and selected areas were then sandblasted to reveal the surface of the glass beneath. Additional colour or, as here, black was then added and the glass was baked. Industrial techniques were thus married with geometric forms and standardized colours.

CREATED

Weimar or Dessau

MEDIUM

Sandblasted flashed glass

Josef Albers *Born* 1888 Bottrop, Ruhr, Germany

Died 1976

Kandinsky, Wassily

Counterweights, 1926

The presence of the famous Kandinsky, and the other fine artists among the senior teaching staff, helped to give the Bauhaus prestige. However, the tension between their presence and the school's increasing orientation towards industrial design was never entirely resolved. Nevertheless, Kandinsky's classes on form and colour were extremely influential on his students. His paintings of this period share in and helped shape the visual vocabulary of the new machine aesthetic.

As the painting's title announces, this is a balanced composition of horizontal and vertical bars and geometric shapes, very different from the dynamic, freely painted compositions of the previous decade. The introduction of circles, with cross-shapes superimposed, owes something to Constructivist influence, particularly that of László Moholy-Nagy, but also to the artists Kandinsky was in contact with prior to his departure from Russia in 1921. Publicly, his paintings of this period were presented as formal experiments, but privately he acknowledged figurative references. Circles, for example, evoked celestial bodies. He saw them as 'Romantic', representing a longing for transcendence of the earthly. The resemblance here between the large circle and an eye – perhaps the eye of the Creator – is hard to miss. But here a balance is struck between spiritual aspirations and the controlled rationality represented by the stable grid of the composition.

CREATED

Dessau

MEDIUM

Oil on cardboard

Wassily Kandinsky *Born* 1866 Moscow, Russia

Died 1944

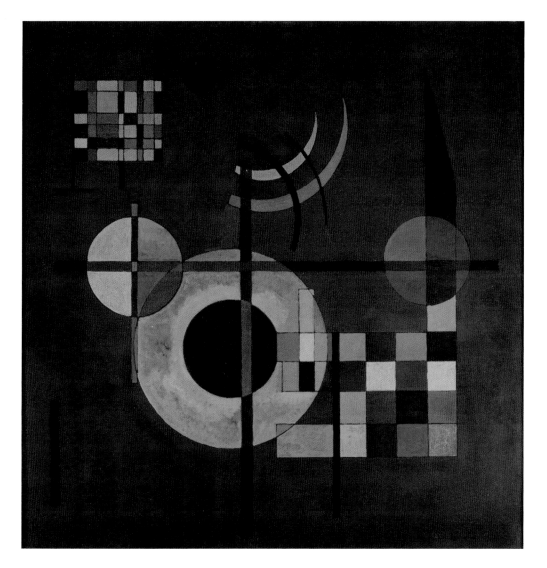

Bayer, Herbert

Poster for Anhalt Art Union exhibition celebrating Kandinsky's 60th birthday, 1926

Bayer's poster is a striking statement of the new approach to graphic design that he pioneered at the Bauhaus. It boldly reduces the message to its essentials, the name of Kandinsky exploding like a shouted slogan, with vivid use of reds and blacks on yellow paper. The strong grid structure, using horizontal and vertical bars for emphasis, is dramatically enhanced by the daring asymmetry of the composition and exposure of large areas of blank paper. In keeping with the impersonality conveyed by the grid, Kandinsky looks coolly away from the viewer.

The Bauhaus's resident Constructivist, László Moholy-Nagy, taught that photography should be integrated with typography. Photographic images gave typographic signs an essential connection with reality. Also characteristic of Constructivism is the dynamic diagonal tilt of the composition, suggesting the constantly changing character of modernity. The expanses of blank paper, as also in the graphic design of *De Stijl*, suggests a Utopian infinite space, in which these elements have momentarily come together.

Appointed a 'young Master' in 1925, as a student Bayer had valued Kandinsky's clear enunciation of the principles of form and colour. This debt is made clear in his poster for the 1968 Bauhaus retrospective.

CREATED

Dessau

MEDIUM

Black and red ink on yellow stock paper

Herbert Bayer *Born* 1900 Haag, Austria

Died 1985

ANHALTISCHER
KUNSTVEREIN
JOHANNISSTR. 13

GEMÄLDE AQUARELLE

KANDINSKY

JUBILÄUMS-AUSSTELLUNG

zum

60.
GEBURTSTAG

Geöffnet:	Wochentags: 2 - 5 nachm.
	Mittwoch u. Sonntag 11 - 1
Eintritt:	Mitglieder: Frei
	Nichtmitglieder: 50 Pfg.

Schmidt, Joost

Cover of issue number 7 of the magazine *Offset*, 1926

Courtesy of Private Collection/Bridgeman Art Library/© Estate of Joost Schmidt

This special edition of the magazine *Offset*, devoted to book and commercial art, was produced by Bauhaus designers. The Russian Constructivist El Lissitzky believed that books were the cathedrals of the modern epoch, the new sites in which the ideas of artists and designers could be combined and made available to the masses through machine production. Schmidt's cover for this publication celebrates the modern technique of offset lithography, showing a print roller morphing into rainbow-like layers as it generates hundreds of colour-printed pages through its circular action.

A link is constructed here between abstraction and the flat, bold forms made possible by contemporary printing technology. The typography is typically modernist, designed without serifs for maximum clarity. The violent breaking of the dark circle by the wedge of colours, and the juxtaposition of horizontal and vertical lines of script, again shows the influence of Constructivism, which aimed to break up the traditional page layout and the stable worldview associated with it.

Joost Schmidt was one of the Young Masters appointed in 1925 as part of the increased focus on designing for industry.

CREATED

Dessau/Leipzig

MEDIUM

Graphic design

SIMILAR WORKS

Wassily Kandinsky, *Small Signs*, 1925

Joost Schmidt *Born* 1893 Wunstorf, Hanover

Died in 1948

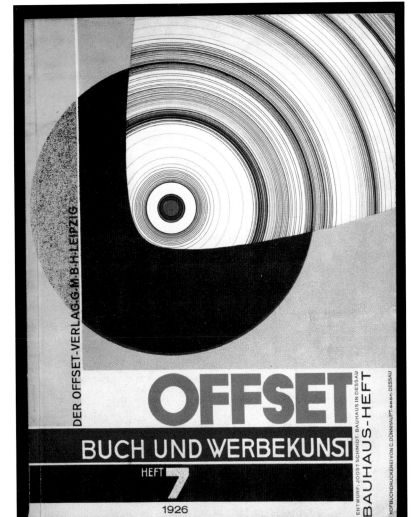

DER OFFSET-VERLAG-A.G.-G.-M.-B.-H.-LEIPZIG

OFFSET

BUCH UND WERBEKUNST

HEFT 7

1926

ENTWURF: JOOST SCHMIDT-BAUHAUS IN DESSAU

BAUHAUS-HEFT

HOFBUCHDRUCKEREI VON C. DÜNNHAUPT-G-M-B-H-DESSAU

Moholy-Nagy, László
Untitled, c.1926

Moholy-Nagy's abstract compositions reference a new world of clean, geometric forms. His images have a highly impersonal quality, in opposition to old-fashioned ideas about art as personal expression. He often employed a ruler and compass, as in this work, which could almost be a design for one of his moving optical-kinetic sculptures.

Moholy-Nagy believed that abstract art would exert its effect on man's 'psycho-physical apparatus' through relationships of colour and tone. This watercolour is to be seen, then, as part of an ongoing quasi-scientific investigation into the principles that governed the production of these effects. Painting had to lose its special place and become one of a number of communication media, including photography and film.

A Hungarian, Moholy arrived at the Bauhaus in 1923 and played a key role in the change from the craft ethos of Weimar to the industrial orientation of Dessau. He took charge first of the metal workshop, then of the Preliminary Course after the departure of the mystic Johannes Itten. Moholy Nagy had sympathies both with Dutch *De Stijl* and with Russian Constructivism, in their search for Utopian forms which could realize a revolutionary new world via mass production.

CREATED

Dessau

MEDIUM

Watercolour, ink wash and collage on paper

László Moholy-Nagy *Born* 1895 Bacsborsod, Hungary

Died 1946

Gropius, Walter
Office at the Bauhaus, Weimar, 1923

Courtesy of akg-images/© Estate of Walter Gropius

The Director's office formed part of the 1923 Bauhaus exhibition. Here and at the *Haus am Horn*, the public were able to see how Bauhaus principles could be applied to modern interiors. The heavy, architectural-looking furniture was designed by Gropius and made in the carpentry workshop. The light fitting, also by Gropius, uses industrial fluorescent tubes and is based on a design of 1922 by Gerrit Rietveld of *De Stijl*. This fitting effectively shows how the whole space has been geometrically conceived as a three-dimensional grid structure, which is seen again in the carpet by Gertrud Arndt and in the wallhanging by Else Mogeln, both weaving students. A lamp by Wilhelm Wagenfeld, a student in the metal workshop, is on the desk.

The photograph emphasizes the light and space of the layout of the office, with its large window and uncluttered expanses of bare floor and wall. Geometric, unornamented forms are associated here with rational planning and with industrial production.

CREATED

Weimar

MEDIUM

Coloured photograph

Walter Gropius *Born* 1883 Berlin, Germany

Died 1969

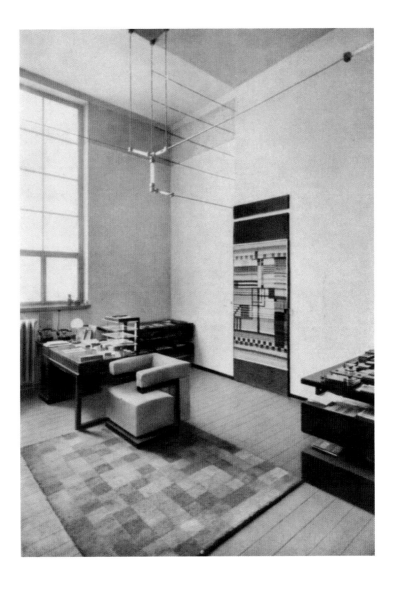

Stölzl, Gunta

Working design for a carpet, c. 1927

Courtesy of Calmann & King, London, UK/Bridgeman Art Library/© Estate of Gunta Stölzl

The grid or chequerboard dominated the visual language of the Bauhaus, not least in the productions of the weaving workshop. The square was regarded as the simplest and strongest form, a basic constructive element. Its repetition and manipulation in a geometric grid suggested rational, objective design and mass unit production. In Constructivist thinking, moreover, the materials out of which an object was made, and its underlying structure, had to be expressed in its final form. A chequerboard pattern expressed the under-and-over structure of a textile.

Here, however, the small shapes with their vibrant colours do not suggest a stable structure. In their evocation of light and spatial dynamism they recall the paintings of the pre-First World War Orphists. In the work of modernist painters more generally, including Paul Klee, who gave classes on form to the weavers, the flat two-dimensional grid was associated with liberation from Renaissance perspective and with the development of abstraction. There was also a fascination at the Bauhaus with the highly stylized, chequered forms of pre-Columbian Andean textiles in the search for a universal visual language.

CREATED

Dessau

MEDIUM

Watercolour

Gunta Stölzl *Born* 1897 Munich, Germany

Died 1983

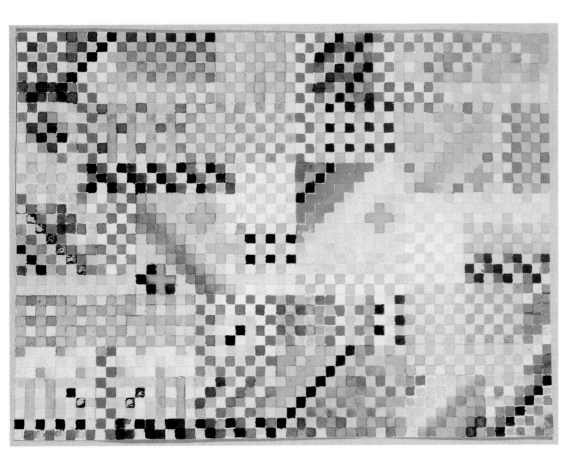

Dieckmann, Erich

Armchair, 1928

Dieckmann studied at the Bauhaus in the carpentry workshop between 1921 and 1925. This chair was produced at the State *Bauhochshule* (school of architecture and design) in Weimar, where Dieckmann became Director of the furniture department after the Bauhaus moved to Dessau. At the Bauhaus he was a key figure in the development of simple furniture designs which were strongly geometrical but were also useable.

This chair is related to a design produced in 1925. It is not upholstered, but is meant to provide comfort through the angling of the seat and back. Lack of upholstery and the unornamented simplicity of the structure also meant that the chair was light and moveable, a key advantage for small dwellings. It is influenced by chair designs by Gerrit Rietveld, a member of the Dutch group *De Stijl*. Theo van Doesburg, the central figure of *De Stijl*, based himself in Weimar in 1921–22 and was a key influence on the productions of the carpentry workshop. It also shows a sound technique, the result of effective teaching by the technically knowledgeable Craft Masters of the workshop.

CREATED

Weimar

MEDIUM

Painted wood and plywood

SIMILAR WORKS

Gerrit Rietveld, red chair, 1918

Marcel Breuer, wood slat chair, 1922

Erich Dieckmann *Born* 1896 Kauernik, West Prussia (now Kurzetnik, Poland)

Died 1944

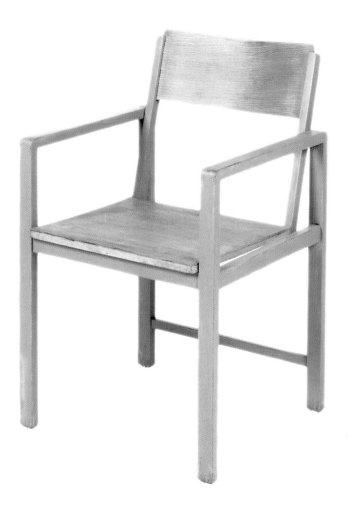

Mies van der Rohe, Ludwig

Entrace to the Villa Tugendhat, Brno, Czech Republic, 1928–30

Courtesy of akg-images/Erich Lessing/© DACS 2005

Already a leading German modernist architect, Mies van der Rohe was appointed Director of the Bauhaus in 1930. He built this villa for the newly married Fritz and Grete Tugendhat, both from textile manufacturing families. The Villa Tugendhat, on a sloping site, has a radically innovative layout. The entrance is at street level, as are the bedrooms. The living area and kitchens are on the intermediate level, while the basement is taken up by utility rooms. The paved courtyard, which is a materialization of the architect's grid plan, rests on top of the lower two storeys. The glazed curve in the wall indicates the main staircase down. Its lightness appears startling contrasted with the heavy roof above. With the steel frame construction, unusual for private villas at that time, there was no need for visible supporting pillars, so Mies van der Rohe was free to create sweeping continuous horizontal spaces in accordance with modernist ideals of light, hygiene and freedom. These spaces, such as the porch area, break down the distinctions between inside and outside. The floor-to-ceiling frosted glazing, however, creates some privacy.

CREATED

Berlin/Brno

MEDIUM

Architecture

SIMILAR WORKS

Ludwig Mies van der Rohe, Barcelona pavilion, 1929

Ludwig Mies van der Rohe *Born* 1886 Aachen, Germany

Died 1969

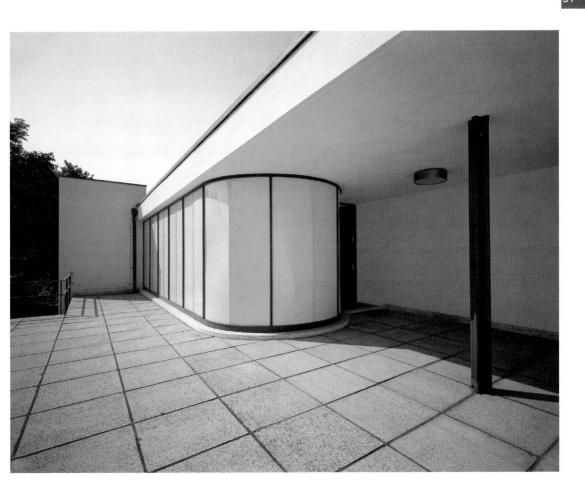

Bayer, Herbert

Advertisement for 'Breuer *Metallmöbel*' chair, c.1927

Courtesy of Stapleton Collection, UK/Bridgeman Art Library/© DACS 2005

This is an advertisement for metal furniture by Marcel Breuer and shows what was later to be called the Wassily chair, Breuer's first piece in the modern material of tubular steel made in 1925. Captions point to the elastic back, armrests and seat. An elegant young woman (Breuer's wife) demonstrates the supportive comfort and weightless appearance of the chair. The freedom of the modern woman, with her unencumbering hairstyle and dress, seems to be associated here with the spatial and formal freedom of modern design.

Breuer co-founded Standard-Möbel (Standard Furniture) in order to market his designs, and this image was printed in negative for the cover of the catalogue. Walter Gropius was dismayed that Breuer had founded a company that was separate from the Bauhaus, but Breuer regarded his designs as entirely his own creations and showed little sympathy on this occasion with the school's collective ethos. Nonetheless, the catalogue was printed at the Bauhaus. This arrangement may have been part of the 'compromise' deal reached, whereby Breuer was allowed to produce furniture for his company in exchange for not resigning from his teaching post.

CREATED

Dessau

MEDIUM

Printed ink on paper

Herbert Bayer *Born* 1900 Haag, Austria

Died 1985

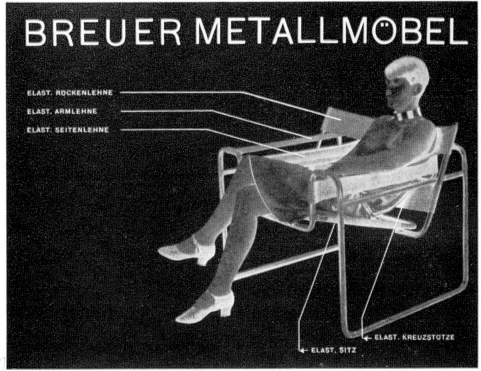

BREUER METALLMÖBEL

ELAST. ROCKENLEHNE

ELAST. ARMLEHNE

ELAST. SEITENLEHNE

ELAST. KREUZSTOTZE

ELAST. SITZ

Gropius, Walter

Bauhaus building at Dessau, workshop wing, 1925–26

The Bauhaus was invited to relocate to the industrial town of Dessau by its Social Democratic Mayor and town council. They funded the building of the new school from scratch, complete with houses for the Masters and accommodation for the students. Appropriately for the town which played host to the Junkers aircraft factory, Gropius's dynamically asymmetrical plan could be seen to advantage from the air.

The workshop wing was the showpiece of the design, where the unity of art and technology, theory and practice could be realized. The projecting elements are painted white in order to give a feeling of weightlessness. The glass curtain wall dramatically accentuates this feeling, and of course admits floods of natural light to the studios. In the German Expressionist theory which had previously influenced Gropius, glass symbolized spiritual liberation. This was the closest that Gropius would come to building the cathedral envisaged in the manifesto of 1919. The Nazis, who thought the glass curtain wall was un-German, bricked it up in 1932 after they had gained control of Bauhaus town council and closed the school.

CREATED

Dessau

MEDIUM

Architecture

SIMILAR WORKS

Walter Gropius, Fagus factory, Anfeld an der Leine, 1911-14

Walter Gropius *Born* 1883 Berlin, Germany

Died 1969

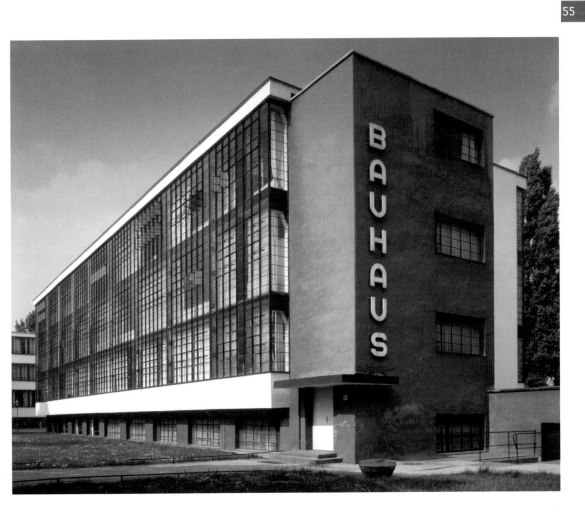

Gropius, Walter

View at Dessau, looking towards the main entrance of the Bauhaus building, 1925–26

Courtesy of Dessau, Germany/Bridgeman Art Library/© Estate of Walter Gropius

This is a view from the technical/vocational school that was opposite the Bauhaus section of the building at Dessau. It is taken from the top of the main staircase, and looks across to the main entrance of the Bauhaus and the staircase above that, with part of the workshop wing seen on the right. The two-storey bridge on the left is where the Director's office and Gropius's private office were located, in a symbolically elevated position at the heart of the complex.

This photograph shows what an extraordinarily transparent environment the Bauhaus must have seemed in the 1920s, and why it was nicknamed 'the aquarium' by its detractors. Given that the basic structure informing much of the work produced at the Bauhaus is the grid, one wonders whether Gropius's steel glazing bars were influential. For many modernists, including painters and weavers at the Bauhaus, the grid represented an assertion of two-dimensional abstract form and a negation of Renaissance perspective. Here, in contrast, the view of the dramatically receding bridge through the glazing bars recalls traditional drawing exercises aimed at rendering perspectival space.

CREATED

Dessau

MEDIUM

Architecture

SIMILAR WORKS

Walter Gropius, Fagus factory staircase, Anfeld an der Leine, 1911–14

Walter Gropius *Born* 1883 Berlin, Germany

Died 1969

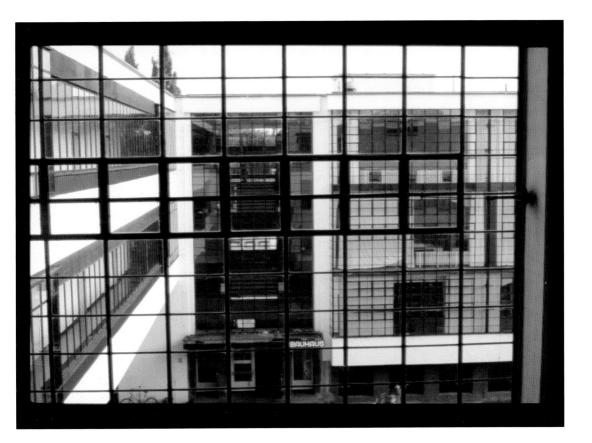

Gropius, Walter

Master House, Bauhaus, Dessau, 1925–26

Gropius designed three buildings, comprising six semi-detached two-storey dwellings, for the senior Masters and their wives. He built a detached house for himself. Junior Masters would usually have to make do with bedroom-studios in the student block until a Senior Master moved out of a house. This view shows part of the block originally inhabited by Georg Muche and Oskar Schlemmer.

The buildings are bold asymmetric assemblages whose geometric shapes suggest the rationality of mass production, although they were built using traditional methods. As Schlemmer pointed out, they were relatively luxurious, given the housing shortage and the average standard of accommodation. Each dwelling had a studio, with large single-glazed windows which proved cold in winter. The vertical rectangle of the staircase window provides a counterpoint to the horizontal rectangle of the studio window, while a partition divides the window in half, marking the boundary between Muche's studio on the left and Schlemmer's on the right. With the contrast between the dark-painted glazing bars and white-painted stucco, Gropius has created a sculptural effect of volumes floating in space.

CREATED

Dessau

MEDIUM

Architecture

SIMILAR WORKS

Georg Muche and Adolf Meyer, *Haus am Horn*, Weimar, 1923

Walter Gropius *Born* 1883 Berlin, Germany

Died 1969

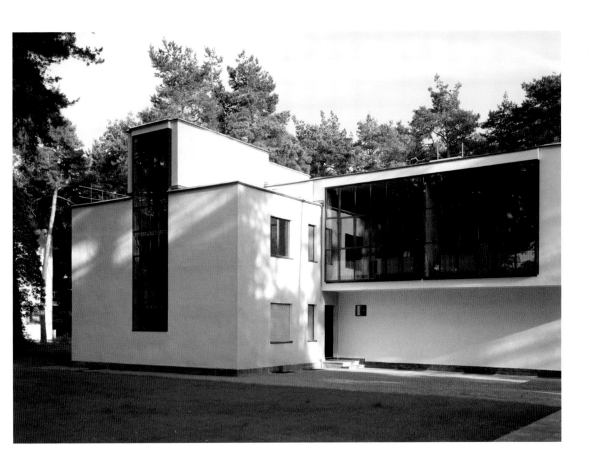

Schlemmer, Oskar

Bauhaus stairway scene, 1932

Courtesy of Hamburger Kunsthalle, Hamburg, Germany/Bridgeman Art Library/© 2005 The Oskar Schlemmer
Estate and Archive, IT-28824 Oggebbio (VB), Italy, Photo Archive C. Raman Schlemmer

Schlemmer was a Senior Master at the Bauhaus from 1920 to 1929. The human figure in space was the principal theme of his paintings and of the elaborate theatre and dance pieces he devised. These paintings speak of a higher, ideal world, purged of the extremes of emotion and irrationality and even individuality, an anticipation of the modernist Utopia.

The stylized figures in this painting move in a stately, choreographed procession down a well-lit staircase. It probably refers to the Bauhaus staircase at Dessau, in which case these are women students, very likely from the weaving workshop. In these stairway paintings, the Bauhaus itself seems to figure as a stage in in which new forms of human existence could be imagined. Yet this painting, which was done after Schlemmer left the Bauhaus, seems to present an alienated, melancholic world, very different to the confident collectivity conveyed in Lotte Stam-Beese's photo of women weavers of 1928 (see page 176). Perhaps it suggests not just Schlemmer's nostalgia for his former school, but his awareness of the threat posed to its very existence in 1932, with the rise of the Nazis.

CREATED

Breslau or Berlin

MEDIUM

Oil on muslin, mounted on plywood

SIMILAR WORKS

Oskar Schlemmer, *Encounter in a Room*, 1928

Oskar Schlemmer *Born* 1888, Stuttgart, Germany

Died 1943

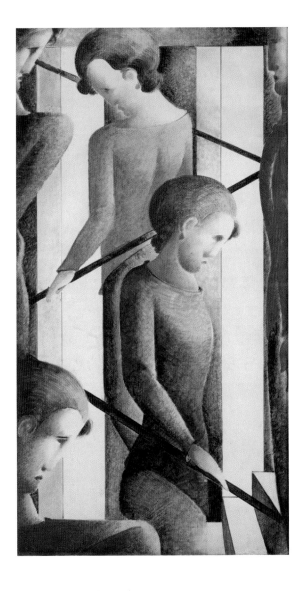

Breuer, Marcel

Stool B37 for Thonet, 1932

Courtesy of Sotheby's/akg-images/© Estate of Marcel Breuer

Breuer has attempted here to reduce the stool to its minimum functionally-necessary form. The stool is seemingly constructed out of one continuous piece of tubular steel, a modern material which was also being used in the construction of aircraft at the Junkers factory in Dessau. It was designed to be inexpensively mass-produced, rather than a one-off craft piece. The springiness of the tubular steel removes the need for upholstery. This and the cantilevered construction, doing away with the four legs, leaves the user apparently sitting on air , a situation envisaged by Breuer in one of his drawings, perhaps only half-jokingly. Transparency, elevation and weightlessness were key elements in the ideal human existence envisaged by the modernists.

Mart Stam designed the first cantilevered tubular steel chair in 1926–27, closely followed by Breuer and Mies van der Rohe in 1927. This chair type became a symbol of a modern way of life. The Thonet company saw the potential of the new furniture and manufactured Breuer's designs from 1928 onwards.

CREATED

Berlin

MEDIUM

Chromium plated tubular steel

SIMILAR WORKS

Marcel Breuer, Wassily steel tube chair, 1925

Mies van der Rohe, side chair, 1927

Marcel Breuer *Born* 1902 Pecs, Hungary

Died 1981

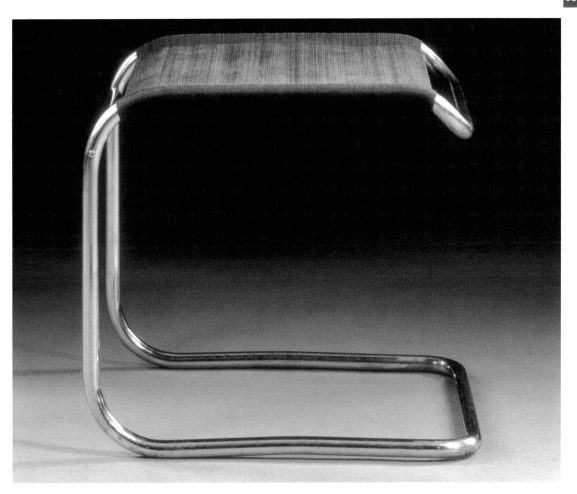

Feininger, Lyonel

The Cathedral of Socialism, frontispiece of the Bauhaus Manifesto, 1919

This is the visual counterpart of Walter Gropius's statement in the 1919 Bauhaus manifesto: 'Together let us desire, conceive and create the new structure of the future, which will embrace architecture and sculpture and painting in one unity and which will one day rise from the hands of a million workers like the crystal symbol of a new faith.'

Feininger's famous woodcut conveys the radical atmosphere, full of Utopian hopes and confused spiritual strivings, in which the Bauhaus was conceived. In this conception, the artist would serve society through a return to the handicrafts, rather than designing for mass production, as in the later Bauhaus credo. The medieval cathedral had represented an ideal of aesthetic and social harmony for William Morris and the English Arts and Crafts movement. It fulfils the same role here – it is the *gesamtkunstwerk* ('total work of art'), a product of communal effort which united all the different branches of art and design. The woodcut was much favoured by the German Expressionists with whom Feininger had links, an honest expression through authentic engagement with the material.

CREATED

Weimar

MEDIUM

Woodcut

SIMILAR WORKS

Lyonel Feininger, *Gelmeroda IX*, 1926

Lyonel Feininger *Born* 1871 New York, USA

Died 1956

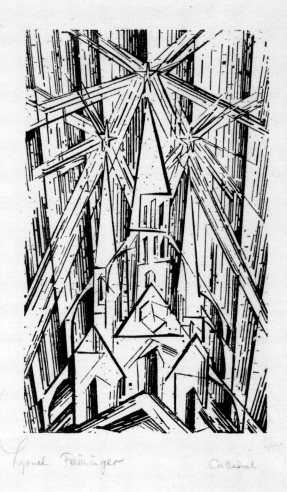

Lyonel Feininger Cathedral

Original Title of "Bauhaus" Program. 1919

Bauhaus

Society

Schmidt, Kurt

Invitation card to Bauhaus exhibition, Weimar, 1923

Courtesy of © Photo CNAC/MNAM Dist. RMN – © Jacques Faujour/Estate of Kurt Schmidt

This irreverent invitation to the Bauhaus exhibition of 1923, designed by a student, contains clues about the character of the early Bauhaus at Weimar and of the challenge it posed to the values of the more conservative townsfolk. Weimar enjoyed world fame as the town of Johann Wolfgang von Goethe (1749–1832) and Friedrich Schiller (1759–1805), yet it was now the location of a modernist art school, apparently influenced by Bolshevism. This populated the town with its unconventionally dressed students, some of whom were Jews or foreigners, and the town council was markedly hostile to the Bauhaus from the beginning. At the bottom of the card is the parodic legend: 'Forbidden by the censor'.

This hand-drawn map shows the way from the station to the Bauhaus. It takes in the houses of Goethe, Schiller and Liszt but cheekily gives the Bauhaus Masters an equal claim to fame. Johannes Itten's workshop and home, the *Tempelherrenhaus*, is indicated here. Itten's teaching encouraged students to develop their personal inclinations, as perhaps seen in the somewhat Dadaist nature of this card. Itten left in 1923 in protest at the Bauhaus's new industrial orientation, which was signalled in the exhibition of that year.

CREATED

Weimar

MEDIUM

Colour lithograph

SIMILAR WORKS

Kurt Schwitters, *Merz Drawing 229*, 1921

Kurt Schmidt *Born* 1901 Limbach, Germany

Died 1991

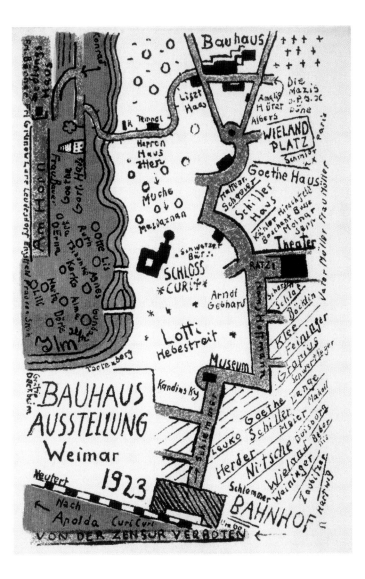

Schlemmer, Oskar

Invitation card to Bauhaus exhibition, Weimar, 1923

In the turning point year of 1923, this invitation card is an example of the new, impersonal machine aesthetic, as opposed to the earlier personal and expressionistic emphasis. It utilizes the basic geometric forms of the circle and the square, which were key elements in the new Bauhaus visual language. Schlemmer had designed an ideal, geometric machine-man for the Bauhaus seal of 1922. That human beings as well as objects can be standardized is suggested by the double profile.

This has a lot in common with Schlemmer's working drawings for wire sculptures between 1921 and 1924 – he was one of two Form Masters in the metal workshop from 1920 until 1923. The Constructivists Naum Gabo and Antoine Pevsner had stated their aim of dematerializing sculpture with the use of modern materials. The square here with its reddish tint, together with the diagonal lines, recalls the abstract, Utopian forms in Russian Suprematist-Constructivist compositions, such as those by Malevich and El Lissitzky. Yet the fluid lines also suggest Schlemmer's affinity with the decorative modernism of Art Deco.

CREATED

Weimar

MEDIUM

Colour lithograph

SIMILAR WORKS

Herbert Bayer, invitation card 1923

Oskar Schlemmer *Born* 1888 Stuttgart, Germany

Died 1943

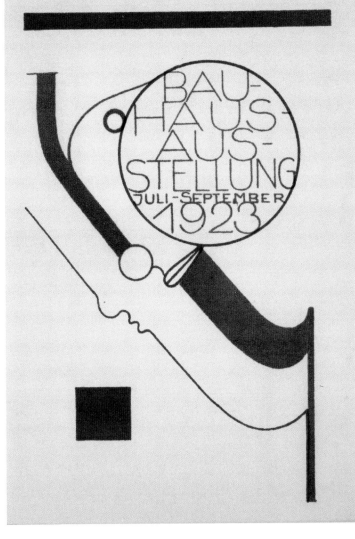

Bayer, Herbert

Two one million mark banknotes, 1923

These bank notes and others of values up to ten million marks were commissioned from Bayer by the regional State Bank of Thuringia during the Bauhaus exhibition of 1923. Inflation was raging out of control. At the beginning of the Bauhaus exhibition that year, Frank Whitford points out, the dollar was worth two million marks; at the end, it was worth 160 million. Bayer completed the commission in two days. The banknotes were in circulation the following day, but even these high denominations were soon out of date.

The design completely avoids the traditional flourishes and curlicues that derive from eighteenth and nineteenth century engraved banknotes in favour of a bold clarity and simplicity. Presumably, in the conditions of 1923, forgery was not considered to be a problem. The different denominations are signified by different colours as well as by large-point lettering. The stable horizontals and verticals recall the cool rationalism of the Dutch *De Stijl* group and perhaps have a reassuring effect in this context. Russian Constructivist designs, with their diagonals evoking change and movement, were probably not the best models for an inflationary capitalist banknote.

CREATED

Weimar

MEDIUM

Printed paper

SIMILAR WORKS

Vilmos Huszar, *De Stijl* cover, 1917

Herbert Bayer *Born* 1900 Haag, Austria

Died 1985

1000000

EINE MILLION MARK

WEIMAR, DEN 9. AUGUST 1923
DIE LANDESREGIERUNG

1000000 Mark zahlt die Kasse der Thüringischen Staatsbank dem Einlieferer dieses Notgeldscheines. — Vom 1. September 1923 ab kann dieses Notgeld aufgerufen und gegen Umtausch in Reichsbanknoten eingezogen werden.

Wer Banknoten nachmacht oder verfälscht oder nachgemachte oder verfälschte sich verschafft und in den Verkehr bringt, wird mit Zuchthaus nicht unter zwei Jahren bestraft.

1000000

EINE MILLION MARK

WEIMAR, DEN 9. AUGUST 1923
DIE LANDESREGIERUNG

1000000 Mark zahlt die Kasse der Thüringischen Staatsbank dem Einlieferer dieses Notgeldscheines. — Vom 1. September 1923 ab kann dieses Notgeld aufgerufen und gegen Umtausch in Reichsbanknoten eingezogen werden.

Wer Banknoten nachmacht oder verfälscht oder nachgemachte oder verfälschte sich verschafft und in den Verkehr bringt, wird mit Zuchthaus nicht unter zwei Jahren bestraft.

Teltscher, Georg

Invitation to Bauhaus Week, Weimar, 1923

Courtesy of © Photo CNAC/MNAM Dist. RMN – © Adam Rzepka/© Estate of Georg Teltscher

The week of performances, cabaret events and lectures which took place during the 1923 Bauhaus exhibition opened with Oskar Schlemmer's theatre piece *Triadic Ballet*. Schlemmer thought that the theatre offered an outlet for the 'Utopian fantasies of the moderns', especially in the absence of opportunities to design for industry during the economic crisis. Three actors in geometricized costumes performed stylized dances. The effect was one of depersonalization rather than subjective expression, an evocation of the social collectivity made possible by the machine age.

Schlemmer was fascinated by the marionette, depicted here in this student work. It permitted new expressive possibilities, freeing 'man from his physical bondage' and also from his individuality. Art and theatre should not be imitative, but stress their own artificiality, their 'made' quality, anticipating new Utopian forms of existence rather than reproducing existing reality. The leaping marionette suggests that in the use of artifice there is the possibility of liberation from the everyday material world.

CREATED

Weimar

MEDIUM

Colour lithograph

SIMILAR WORK

Oskar Schlemmer, *The Dancer*, 1922–23

Georg Teltscher *Born* 1904 Germany

Died Unknown

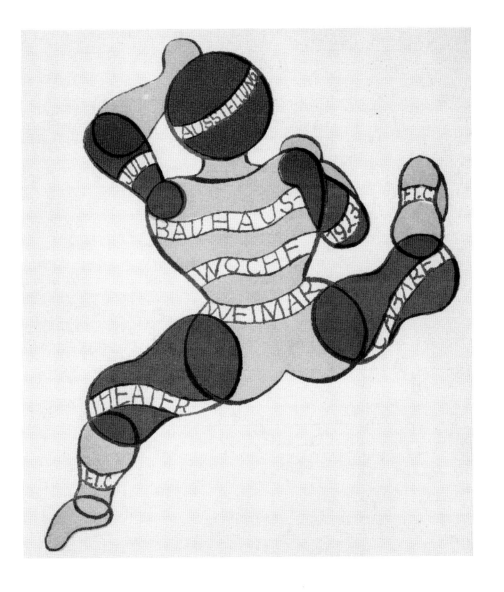

Umbehr, Otto

The Newest Offer in Profile, 1928

Courtesy of Christie's Images Ltd/© Estate of Otto Umbehr

Umbehr studied at the Bauhaus between 1921 and 1923, before working as a commercial photographer and photojournalist in Berlin. Photography was never formally taught at the Bauhaus, but it became a means of creative and often playful experimentation. This image contains elements of surrealism and of social satire. Mannequins clad only in stockings and shoes, with identical hairstyles, stand in stereotyped poses. The title suggests that fashion is a superficial gloss on the selling of sexuality – a case of 'the emperor's new clothes'. But the critique does not appear very deep or challenging. The reader is encouraged to be a voyeur, to make the commonplace parallel between dolls and naked woman. Each can be viewed in terms of the other. The image may be intended to convey the misogynistic notion that the free, young, modern woman is always 'on offer'.

On the other hand, Umbehr may be commenting on the way that women's bodies are objectified and turned into sexual commodities in consumer culture. At the same time, in this culture, the world of objects becomes more powerful. Commodities are fetishized and magically take on human qualities, like the mannequins here.

CREATED

Berlin

MEDIUM

Gelatin silver print

SIMILAR WORKS

Joost Schmidt, *Wood and Plaster*

Otto Umbehr *Born* 1902 Dusseldorf, Germany

Died 1980

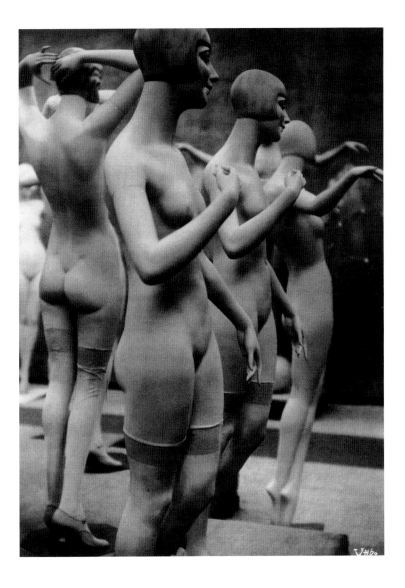

Bayer, Herbert

Frontal Profile, 1929

A frontal profile is of course a contradiction in terms. Bayer has taken a frontal portrait and cut it to make a profile, recalling the multi-angle views of cubism but also the dream-visions of surrealism. This was one of a series of photocollages made by Bayer after he left the Bauhaus, called 'Man and Dream'. The 'Dream' here is at least in part a collective one, created by the German and US film industries, in the shape of the movie star and sex symbol Louise Brooks. The airbrushed silhouette suggests that this is a double portrait of two lovers, but disturbingly the dark shape could be the result of Brooks' profile being cut out. A favourite Surrealist theme was the losing and confusion of identity in desire. The mysterious 'R' may refer to the name of one of the lovers here. It almost seems to be a character in its own right.

America, represented both by Brooks and by the photograph of a skyscraper, is perhaps the real object of desire of the collective unconscious of Weimar Germany. Rather than the rational social Utopia envisaged by the Bauhaus, Bayer's subsequent commercial work constructs an irrational Utopia for the consumer.

CREATED

Berlin

MEDIUM

Silver print photocollage

SIMILAR WORKS

Otto Umbehr, *The Newest Offer in Profile*, 1928

Herbert Bayer *Born* 1900 Haag, Austria

Died 1985

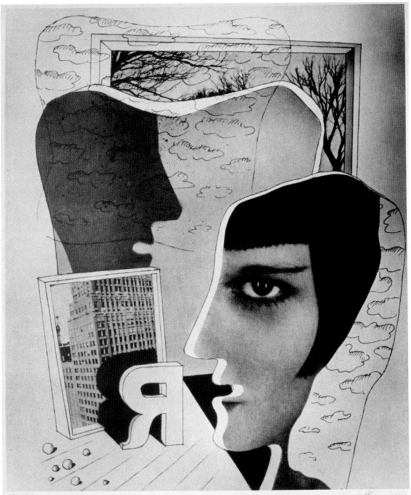

37/40 Bayer 79

Bayer, Herbert

Pont Transbordeur ('Transporter Bridge'), Marseilles, 1928

A number of photographers and artists in the 1920s were fascinated by the forms and engineering achievement of the transporter bridge that moved vehicles and pedestrians across the old port at Marseilles. This high-angle photograph, taken from the bridge itself, fuses this technological fascination with an almost disengaged interest in two-dimensional abstract forms, in a way that recalls László Moholy-Nagy's approach to photography. The whole structure appears insubstantial, in keeping with the modernist interest in weightless futuristic forms. The small boat serves to emphasise height and scale, and perhaps the contrast between old and new forms of life. J. M. W. Turner used a similar device when painting the railway viaduct at Maidenhead in his *Rain, Steam and Speed* of 1844.

This photograph was taken during Bayer's extended holiday in the south of France after leaving the Bauhaus and before undertaking the new challenge of commercial graphic design work in Berlin. Moholy-Nagy, who took photographs looking straight down from the Radio Tower in Berlin in 1928, produced a number of photographs of the transporter bridge the following year, in 1929.

CREATED

Marseilles

MEDIUM

Photograph, gelatin silver print

SIMILAR WORKS

László Moholy-Nagy, photographs of the *Pont Transbordeur*, Marseilles, 1929

Herbert Bayer *Born* 1900 Haag, Austria

Died 1985

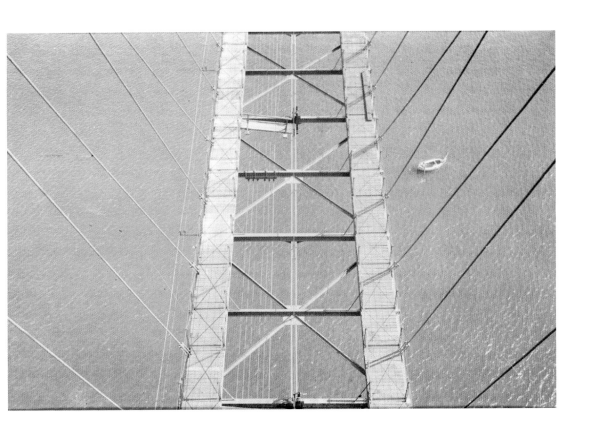

Klee, Paul

Buddhist Monk, 1920 and Madame La Mort, 1921

Collection of Felix Klee, Bern, Switzerland. © Held Collection/Bridgeman Art Library/© DACS 2005

Klee fashioned numerous figures like this as toys for his son Felix between 1916 and 1925. The heads were nearly always of plaster, as here. Klee added bits of cloth and other accessories, which often suggested names. The fearsome Madame La Mort (Death), with her upraised arms and bald head, is dressed in ghostly white grave-clothes but adds a feminine touch with red lipstick kisses. The Buddhist monk, also bald, lives a life of self-denial in his rags, disdaining, presumably, both death and desire.

Klee's approach here is very different from Oskar Schlemmer's view of puppets as embodying superhuman perfection. Klee saw his puppets, like his paintings, as being formed in an organic process of creation, the imperfections of which offered an opportunity for playful improvisation. Just as with the personages in his paintings, the formal quirks and eccentricities of his puppets suggest something about their characters and identities. Klee held that children were small 'primitives'. Their worldview had a primal, pure authenticity that the artist should learn from. Klee's friend Lyonel Feininger likewise carved and painted wooden toys for his own and others' children in the early 1920s.

CREATED

Weimar

MEDIUM

Mixed media

SIMILAR WORKS

Lyonel Feininger, scene from the series 'Town at the End of the World', c.1920–25

Paul Klee Born 1879 Münchenbuchsee, near Berne, Switzerland

Died 1940

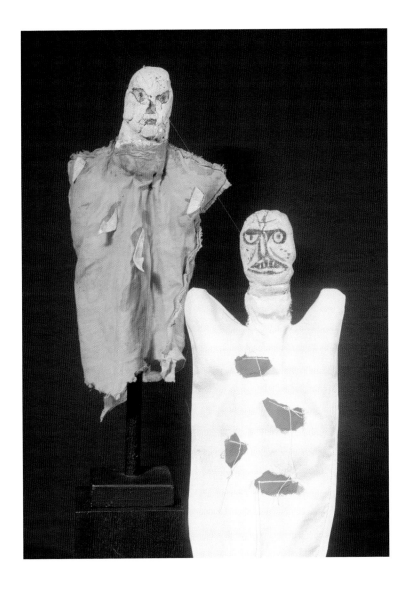

Feininger, Lyonel

Scene from the series 'Town at the End of the World', *c.* 1920–25

This scene seems to be a miniature version of the Thuringian town of Gelmeroda, near Weimar, first visited by Feininger in 1906. Its church was to become a favourite motif in his paintings (see page 342). Feininger regularly carved and painted wooden toys for his own and his friends' children. His pre-First World War paintings and graphic work on the same theme also feature crabbed, repressed Gothic grotesques amid the rickety architecture of Gothic German towns. In works of 1910 and 1911 he shows the deceptive security of these provincial towns breaking down in the face of revolution. This harsh, ironic social awareness is hard to reconcile, not only (possibly) with the function of these objects as children's toys, but with the apparently harmonious vision of socially integrated medieval communities in his many paintings of Gelmeroda and other churches. As Feininger noted, however, 'sarcasm is a prickly, protective armour for artists who feel very deeply'. He felt that the Utopian aspirations and harmonious past represented by the Gothic church or cathedral were harshly contradicted by present-day bigotry and conservatism.

CREATED

Weimar

MEDIUM

Painted wood

SIMILAR WORKS

Lyonel Feininger, *Gelmeroda IX*, 1926

Lyonel Feininger *Born* 1871 New York, USA

Died 1956

Hartwig, Josef
Chess set in box, *c.* 1928

This chess set was first produced in 1924 in Weimar, and sold well. The chess pieces have been reduced to geometrical shapes, each shape indicating how the piece moves. Thus the bishops are cross-shapes, since they can only move diagonally. The queen is the most mobile piece, and hence is represented by a sphere on a cube. There may have been a certain satisfaction in reducing kings, queens and bishops to geometric solids — removing ornament and clutter was widely associated with countering traditional pomp and pretension.

The appearance of these pieces suggests that they are prototypes for mass production, but in fact they were hand carved. Hartwig was Master Craftsman of the woodcarving workshop at the Weimar Bauhaus. In 1922 he fell out with Oskar Schlemmer, the workshop's Form Master, who believed that the future lay with industrial production, not with the handicrafts. In the move to Dessau, the woodcarving workshop was abolished and Hartwig took up a teaching post in Frankfurt. Nonetheless, it appears that production of the set continued at Dessau, and it was regarded highly enough to be featured in the catalogue of the Bauhaus exhibition of 1938 in New York.

CREATED

Dessau

MEDIUM

Natural wood stained black

Josef Hartwig *Born* 1880 Munich, Germany

Died 1956

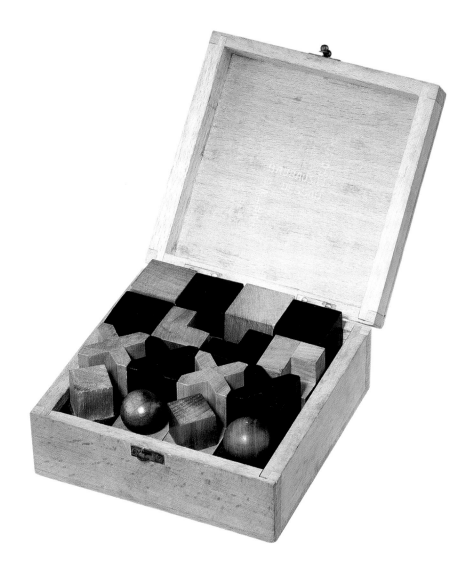

El Lissitzky
Beat the Whites with the Red Wedge, 1920

This work is a classic statement of the identification of avant-garde artists with the Russian Revolution of 1917. During the Civil War, when the revolution was surrounded by foreign and domestic armies, artists responded to the call to abandon easel painting for a private clientele and produce revolutionary propaganda instead. This design uses the Suprematist and Constructivist theme of abstract forms seen from above, floating in space, to produce an image resembling a military battle plan. A dynamic red (revolutionary) wedge drives deeply into the encircling white (counter-revolutionary) armies, flanked by smaller mobile forms which could be read as reconnaissance or scouting units.

The overwritten message – also the poster's title – clarifies the meaning. Much of the intended audience would have been illiterate, however, which was one reason that figurative images were frequently employed for propaganda purposes. The wedge shape is much a much more energetic and powerful form, apparently disposing of more material force than the quadrilaterals and circles usually favoured by the Suprematists around Kasimir Malevich. It features in the work of Kandinsky in the mid-1920s and a magazine cover by his fellow Bauhaus Master Joost Schmidt.

SIMILAR WORKS

Joos Schmidt, cover of *Offset* magazine, 1926

Wassily Kandinsky, *Small Signs*, 1925

Wassily Kandinsky, *Green and Red*, 1925

Eliezer (El) Lissitzky *Born* 1890 near Smolensk, Russia

Died 1941

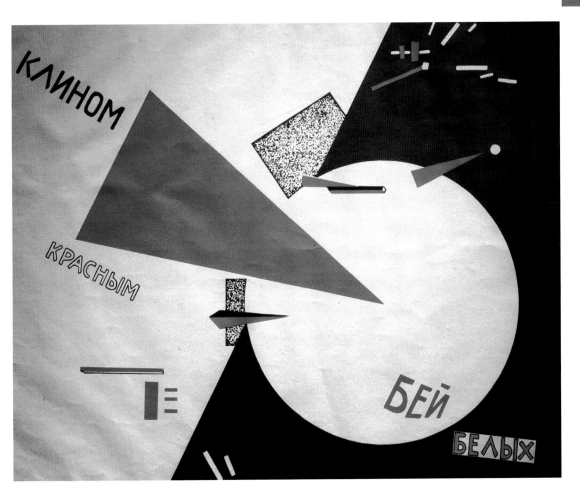

Schlemmer, Oskar

The Dancer, 1922–23

Schlemmer's dancer seems both to advance towards us and to recede. She or he (the figure is androgynous, suggesting one standard human type) puts out a huge leg yet warns us sternly off with a tiny hand. S/he exists in a world which is parallel to ours but is not ours – an impersonal world where the normal laws of space and time do not apply, and the figure attains new and strange expressive possibilities.

Such was the world that Schlemmer attempted to create in his paintings and sculptures and in his theatrical and ballet pieces such as the widely acclaimed *Triadic Ballet* of 1922, where the costumes of the actors were likewise based on exaggerated geometrical forms. As in much of the rest of the artist's work, this alternative world could evolve in the direction of parody and the grotesque, or of perfect mechanical serenity. Schlemmer saw humans as imperfect fallen beings. Art allowed release from this state, but also made one aware of the gap between reality and the Utopian ideal.

CREATED

Weimar

MEDIUM

Oil on canvas

SIMILAR WORKS

Georg Teltscher, invitation to Bauhaus Week, 1923

Oskar Schlemmer *Born* 1888 Stuttgart, Germany

Died 1943

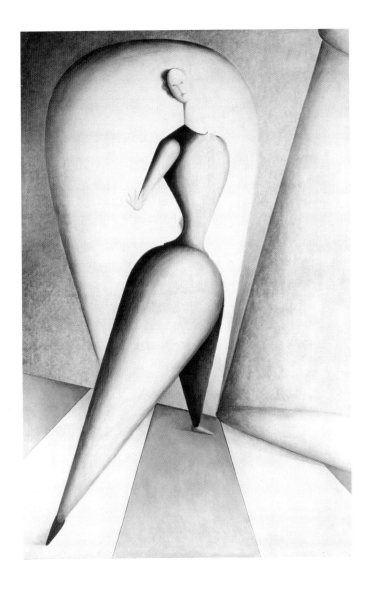

Gropius, Walter
Writing desk and occasional table, *c.* 1924

Courtesy of Christie's Images Ltd/© Estate of Walter Gropius

This set of furniture looks as though it was designed by an architect, and indeed it was. With its appearance of daring cantilevers, and even the bridge-like form of the desk, it recalls some of the structures in Gropius's Dessau Bauhaus (see page 164) and Masters' houses of 1925–26 (see pages 58 and 170). In actual fact, the materials and method of construction used here did not permit cantilevers, and steel rods have been inserted to ensure stability.

This furniture is made mostly of wood – a traditional material – but also incorporates modern materials – linoleum (on the occasional table), and tubular steel, which later became the principle material used in cantilevered furniture by Marcel Breuer, Mart Stam and Ludwig Mies van der Rohe. The steel is nickel-plated to give a cool, silvered finish, rather than the warm brass of traditional metal fittings for furniture. Similar pieces can be found in the photograph of Gropius's office at Weimar, dated to 1923.

CREATED

Weimar

MEDIUM

Cherry-veneered pine, nickel-plated tubular steel, linoleum tiles and glass

Walter Gropius *Born* 1883 Berlin, Germany

Died 1969

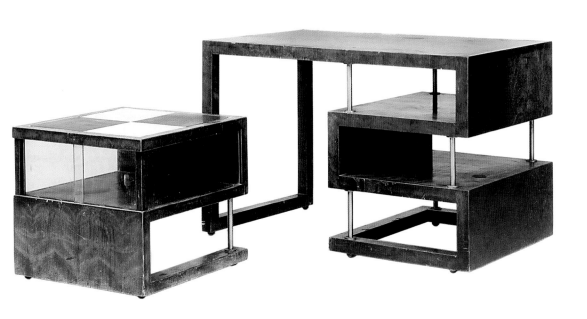

Dieckmann, Erich

Armchair, c. 1926

Courtesy of Christie's Images Ltd/© Estate of Erich Dieckmann

Along with Marcel Breuer, Dieckmann had been an outstanding student and innovative designer of furniture in the carpentry workshop of the early Bauhaus at Weimar, studying there between 1921 and 1925. He then taught in the interior design workshop of the State College for Crafts and Architecture at Weimar, where this piece was manufactured.

Dieckmann tended to use high quality wood for his furniture, as here, and this armchair looks solid and well made, but costs were kept down through standardization of parts. He was particularly desirous of developing inexpensive furniture for low-income families living in small rooms, and his work was cited in books on the new mode of living. This chair features woollen upholstery in a simple and bold modernist design. The emphasis overall is on practical utility and comfortable appearance, rather than on adherence to a dogmatically geometrical style. The debt to Gerrit Rietveld and *De Stijl* is still evident, but Dieckmann has moved some distance from his initial influences.

MEDIUM

Walnut and wool upholstery

SIMILAR WORKS

Gerrit Rietveld, Militar table and chairs, 1923

Marcel Breuer, wood slat chair, 1922

Erich Dieckmann *Born* 1896 Kauernik, West Prussia (now Kurzetnik, Poland)

Died 1944

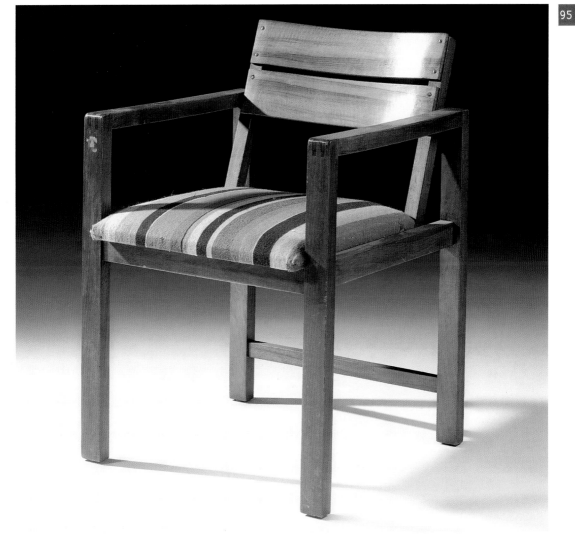

Buscher, Alma

Children's changing unit, 1924

Courtesy of akg-images/Electa/© Estate of Alma Buscher

Children's furniture was one of the most popular products of the early period of the Bauhaus at Weimar. The designs of Alma Buscher were particularly innovative. She was the only woman consistently active in the otherwise male-dominated carpentry workshop. The simple, geometric lines of this children's changing unit, or nursery dresser, recall the work of Josef Hoffmann in the *Wiener Werkstätte* of the 1900s, as does the colour scheme of white and light grey. The unit had separate compartments for clean and dirty linen and a slide-in stool with a wash basin, which made changing nappies more hygienic. Research on children's play and behaviour informed Buscher's designs. The plain, round knobs were easily graspable by small fingers and added to the unornamented, functional appearance of the piece.

Herbert Bayer was responsible for most of the publicity for Bauhaus products in the mid-1920s and developed a homogeneous corporate profile for the school. Strong bar shapes emphasize the grid structure underlying the page layout here, echoing the grid elements in the rationally compartmentalized dresser. The design shows *De Stijl* influence in its congregation of geometric elements in space.

CREATED

Weimar

MEDIUM

Wood, lacquered with colour

SIMILAR WORKS

Josef Hoffmann, cabinet, 1906

Alma Buscher *Born* 1899 Creutzthal, Germany

Died 1944

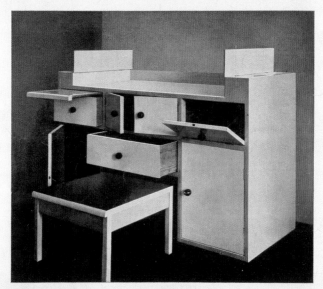

gesch.
Platte 120 X 65 cm
AUSFÜHRUNG

weiß und hellgrau lackiert
mit Fächern für Kinderwäsche
Salbenkasten rechts und links von der Platte
mit einschiebbarem Schemel für ein Waschbecken

TI 23 **WICKELKOMMODE**

Inv.-Nr.
857716 BAUHAUS-ARCHIV

Breuer, Marcel & Otte, Benita

Children's chair & table on rug, 1923 and c. 1925

Courtesy of akg-images/© Estate of Marcel Breuer

Breuer's furniture pieces for children, along with those of Alma Buscher, were among the best-selling products of the carpentry workshop at Weimar. The childrens' chairs shown around the table in this magazine photograph were first produced in 1923 and could be made in different sizes, as well as for adults. Their plywood backs and seats made them light and hard-wearing. In their rigidity, however, the chairs clearly show a *De Stijl* influence. More innovative is the small cube table, which, with its legs flush with the corners, is functionally stable as well as geometric.

The rug by Benita Otte, one of the students of the weaving workshop, features squares, a chequerboard motif and triangles. The design evidences the early Bauhaus interest in pre-Columbian Andean textiles, reinforced by the emphasis on primary colours and basic universal shapes. Children were 'primitives' whose senses required the stimulation of pure, simple forms and colours. Hence also the bright red frame of the chair.

One of Breuer's wood-slat chairs, first produced in 1922, can be seen at the back. This photograph was used in black and white form in Herbert Bayer's Bauhaus prospectus of 1925.

CREATED

Weimar

MEDIUM

Light plywood furniture

SIMILAR WORKS

Gerrit Rietveld, red chair

Marcel Breuer *Born* 1902 Pecs, Hungary

Died 1981

Benita Otte *Born* 1892 Stuttgart, Germany

Died 1976

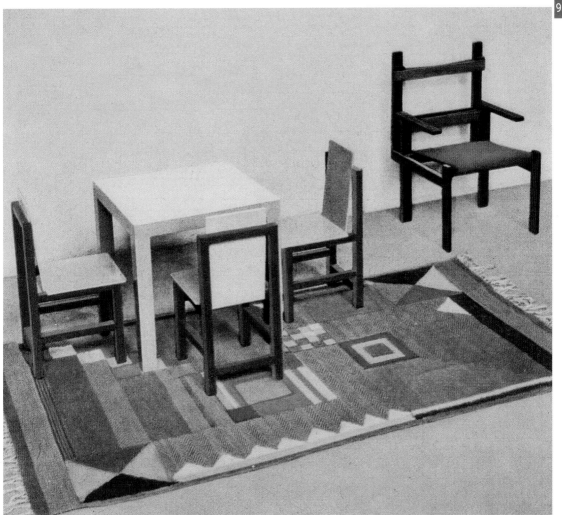

Dieckmann, Erich

Child's chair angled back with flat panel, 1928

Courtesy of Christie's Images Ltd/© Estate of Erich Dieckmann

Dieckmann and Marcel Breuer appear to have worked closely together in the Weimar carpentry workshop to develop practical, lightweight furniture based on geometrical forms. However, this piece appears to have been produced after the move to Dessau in 1925. Dieckmann stayed on in Weimar, teaching furniture design at the State *Bauhochschule* (School of Architecture and Design).

The angled back was thought to be healthier for child development, which (it was thought) should not be subject to unnecessary restrictions, such as sitting severely upright. The simple colours – cream and a restive shade of blue – are characteristic of Bauhaus children's furniture They also recall the pieces produced in the *Wiener Werkstätte* in the 1900s (see pages 234 and 242).

CREATED

Weimar

MEDIUM

Painted plywood

SIMILAR WORKS

Marcel Breuer, children's chair, 1923-onwards

Erich Dieckmann *Born* 1896 Kauernik, West Prussia (now Kurzetnik, Poland)

Died 1944

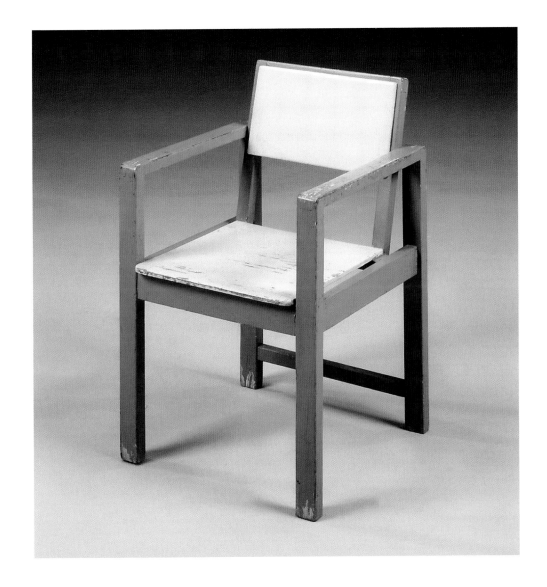

Brandt, Marianne & Briedendieck, Hin
Kandem table lamp, 1928

This design became the basis for most later bedside lamps. Here, form really appears to be determined by function rather than by a rigid geometrical schema, like some of Brandt's earlier designs, for example his ashtray of 1924 (see page 152). The bell-shaped shade directs the beam, while the base is big and stable with a simple push-button switch, suitable for operation by tired hands and minds.

The metal workshop began designing lights for the manufacturer Kandem (Korting und Matthiessen, Leipzig) in 1928, a contract that proved very lucrative for the school. Rather than producing finished prototypes, workshop members functioned as close advisors to the firm in an integrated design and production process. A competition to design a logo for Kandem was run at the Bauhaus in 1932.

1928 was the year that Marianne Brandt became temporary head of the metal workshop, thus becoming only the second female workshop head after Gunta Stölzl in the weaving workshop. She left to work in Walter Gropius's Berlin office. This lamp is relatively unusual in being painted pale green – most of the lamps were pure white.

CREATED

Dessau

MEDIUM

Sheet steel and enamel

Marianne Brandt *Born* 1893 Chemnitz, Germany
Died 1983

Hinrich (Hin) Bredendieck *Born* 1904 Aurich, Germany
Died 1995

Gropius, Walter & Meyer, Adolf
Plaster model of Kellenbach House, Berlin, 1922

Courtesy of akg-images/© Estate of Walter Gropius and Adolf Meyer

This model is from a project for a domestic house which was never realized. It is an odd mixture of expressionist irrationalism and machine-age rationalism in architecture. In the post-First World War revolutionary crisis, Gropius was drawn temporarily to the emotive, irrational language of Expressionism, which was linked to longings for spiritual and social transformation. This is a restless composition, with bay windows that look like right-angled corners in the left-hand block (unusual then, not now), different levels, and a staircase in the block on the right, marked by three windows forming a diagonal that appears to go nowhere.

On the other hand, in its concern with asymmetric combinations of units based on regular quadrilaterals, it can be compared with Gropius's Master Houses at the Dessau Bauhaus of 1925–26. From 1922 onwards, Gropius was seeking to develop standard building elements which could be produced industrially and combined in different ways onsite. This design was never built, however. There was little money around in Germany in 1922 for building projects, especially private commissions by modernist architects.

CREATED

Berlin/Weimar

MEDIUM

Plaster

SIMILAR WORKS

Walter Gropius, Master Houses at the Dessau Bauhaus, 1925–26

Walter Gropius *Born* 1883 Berlin, Germany

Died 1969

Adolf Meyer *Born* 1831 Germany

Died 1905

Oud, J. J. P.

Terrace of five houses on the Weissenhof estate, Stuttgart, 1926–27

Courtesy of © Jochen Helle/Bildarchiv Monheim/© DACS 2005

The Weissenhof estate was designed as part of the *Deutscher Werkbund* (German Craft Union) exhibition of 1927 in Stuttgart. It was an experimental showpiece, but also a real attempt to provide civic housing at a time of housing shortage. Ludwig Mies van der Rohe, later to be head of the Bauhaus (1930–33), was the overall director of the project but other modernists contributed, including Walter Gropius. The buildings were geometric, unornamented, white-painted and flat-roofed – a definitive break from tradition, much praised and much criticized.

These three-bedroom, two-storey houses were designed by Oud, an ex-member of the Dutch *De Stijl* group, for working-class families. They were built quickly using a poured-concrete system. Here we see the north-facing fronts, bold statements of rationality and standardization. Oud tried to follow the home economist Dr Erna Meyer's advice about space- and labour-saving features. The projecting structures contain a bicycle store and laundry on the ground floor and a drying room on the first floor.

CREATED

Stuttgart, Germany

MEDIUM

Architecture

SIMILAR WORKS

Walter Gropius, Torten estate, Dessau, 1926–28

Jacobus Johannes Pieter Oud *Born* 1890 Purmerend, Holland

Died 1963

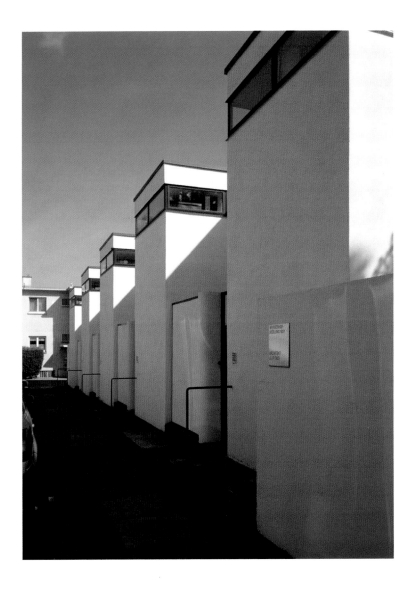

Mies van der Rohe, Ludwig

German Pavilion for the International Exposition in Barcelona, 1928–29, reconstructed 1987

Courtesy of akg-images/Erich Lessing/© DACS 2005

The original Pavilion, of which this is a reconstruction, was commissioned by the German government for the Barcelona Exposition of 1929. Planned to resemble a private villa, it functioned as a reception area for dignitaries – the chairs were designed for the King and Queen of Spain – and as a retreat for visitors from the summer heat. It was designed on a radical open plan, to ensure both light and a free flow of space, with glazing from floor to ceiling. The original glass was noticeably more coloured and gave a greater sense of enclosure. The single-storey building was a statement of the Weimar Republic's modernity and lack of presumption, in contrast to the traditional architecture associated with German militarism. However, the onyx, the carpet and the upholstered, over-sized furniture create a feeling of luxury, as did the original chrome-plated glazing bars. The pool area, with its marble surround and the statue by Georg Kolbe, combine with the antique x-shapes of the furniture to lend a touch of classical Roman villa to the radical modernist structure.

CREATED

Berlin/Barcelona

MEDIUM

Onyx wall, Barcelona chairs and sculpture by Georg Kolbe

SIMILAR WORKS

Ludwig Mies van der Rohe, Villa Tugendhat, Brno, Czech Republic, 1928–30

Ludwig Mies van der Rohe *Born* 1869 Aachen, Germany

Died 1969

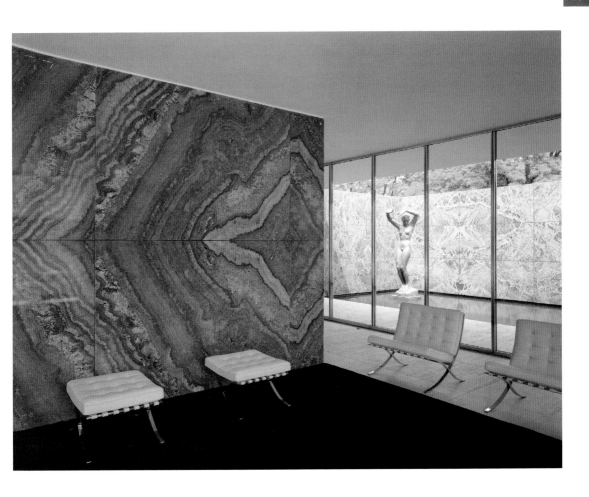

Mies van der Rohe, Ludwig

Bathroom at Villa Tugendhat, Brno, Czech Republic, 1928–30

This is the smaller of the two bathrooms which are located at the top of the Villa Tugendhat, on the street level. It connects to the former master bedroom of Fritz and Grete Tugendhat, to a dressing room and also to the front terrace. The bathroom still preserves something of its original cool, functionalist austerity, with hygienic tiling on floor and ceiling, illumination from above, and considerable distance between the different fittings. Mies has contrived an effect of perspective even in this small space.

The villa has been extensively but inaccurately restored. This photograph shows that the original double sink has been replaced by two new sinks and taps. Moreover, a small screen has been placed between the toilet and the sinks – hardly modernist, since it does not even gesture towards functionality and it blocks the flow of space. Perhaps to counteract any feeling of claustrophobia and to make the bathroom less austere, there is also extra lighting and a wall-to-wall mirror; the original mirror was much smaller and not much wider than the double sink over which it was placed.

CREATED

Berlin/Brno

MEDIUM

Interior design

Ludwig Mies van der Rohe *Born* 1869 Aachen, Germany

Died 1969

Designer unknown
Bauhaus kitchen, 1930

© Mary Evans Picture Library/Weimar Archive

This rare photograph shows the characteristics of the modern kitchen developed in the 1920s at the Bauhaus and elsewhere, such as the new Frankfurt housing developments (see page 118). This is the kitchen as an efficient machine for cooking and washing in, rather than a general family or social area. It shows floor-to-ceiling space-saving fitted cupboards. There are large windows lighting the work surfaces, and a specially designed chair allows the housewife to sit while performing her tasks. Light colours maximise the available light and aid in identifying and removing dirt on surfaces.

This follows the precedent set by the pioneering fitted kitchen produced by the Bauhaus workshops for the *Haus am Horn* in the school exhibition of 1923, and Gropius's kitchens for the Masters' Houses at Dessau (1925–26) and for the houses on the Torten estate (1927–28). However, there was a more general concern in Weimar Germany to minimize and rationalise the workload of the modern, servantless woman. This partly involved a progressive redefinition of the housewife's role to highlight her planning and production skills, but it could also be viewed as an attempt to give a modern technology-led gloss to women's continuing domestic subordination.

MEDIUM

Interior design

Gropius, Walter

Designs for houses on the Torten estate, 1926–28, featured on cover of *Gropius Bauhaus Buildings in Dessau*, designed by László Moholy-Nagy, 1930

Courtesy of akg-images/Electa/© Estate of Walter Gropius

Moholy-Nagy's cover for Number 12 in the series of Bauhaus Books features Gropius's designs for workers' housing on the Torten estate in Dessau. The composition is based on repeated forms arranged in a Constructivist diagonal, suggesting a dynamic activity that extends far beyond the pictorial space. Commissioned by the Social Democrat-led town council of Dessau, over 300 houses were built between 1926 and 1928. For most modernists at the time, the central purpose of the new architecture and design was to improve the conditions of the masses. Gropius's houses were geometric, white and flat-roofed, and of a very standardized, not to say monotonous, appearance, which was partly (but not entirely) dictated by the need to mass-produce the housing to a tight schedule. The resulting terraced two-storey houses were small but cheap, with double glazing, central heating, built-in cupboards and gardens. By 1929, however, many of the houses were affected by damp and cracked walls, and they were also insufficiently heated.

MEDIUM

Black print on glassine

SIMILAR WORKS

J. J. P. Oud, houses on the Weissenhof estate, Stuttgart, 1927

Walter Gropius *Born* 1883 Berlin, Germany

Died 1969

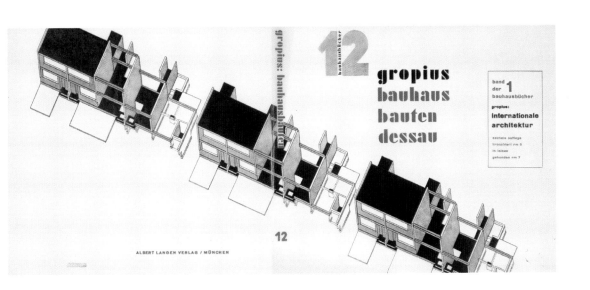

12

**gropius
bauhaus
bauten
dessau**

band
der **1**
bauhausbücher

gropius:
**internationale
architektur**

sechste auflage
broschiert rm 5
in leinen
gebunden rm 7

ALBERT LANGEN VERLAG / MÜNCHEN

12

Gropius, Walter

Kitchen on the Torten estate, Dessau, 1926–28

Courtesy of © Florian Monheim/Bildarchiv Monheim/© Estate of Walter Gropius

In 1920s Germany there was a widespread movement to rationalize domestic tasks. Industrial time and motion techniques were applied to the organization of the kitchen. For working-class women on the Torten estate, however, the time saved in this way might have resulted in an employer or husband exerting pressure on them to do more factory or other paid work.

Household reformers stressed that frequently used items should, if possible, be visible. Hence there are storage jars on open shelves rather than in cupboards. A large window lights the main working areas, including the sink, which was not always fitted in the kitchens of working class homes. In the recess there is a large copper for heating water and washing clothes. Next to it is a bath – not an unusual feature in the kitchens of poorer families at this time. The kitchen in Gropius's own house at Dessau was much more lavishly equipped, but the same principles of rationalization were held to apply. The electric rings shown here are not original.

CREATED

Dessau

MEDIUM

Interior design

SIMILAR WORKS

Grete Schutte-Lihotzky, Frankfurt kitchen, 1927

Walter Gropius, kitchen in Director's House, Dessau, 1925–26

Walter Gropius *Born* 1883 Berlin, Germany

Died 1969

Schutte-Likotzky, Grete
Frankfurt kitchen in the Gropius House, 1931

Courtesy of akg-images/© Estate of Grete Schutte-Likotzky and Walter Gropius

This illustrated article in the influential magazine *Die Neue Linie* ('The New Line') gives examples of the modern kitchen, that of the Gropius house at Dessau among them. Top: Grete Schutte-Likotzky, Frankfurt kitchen; bottom right: Walter Gropius, kitchen in Director's House, Dessau, 1925–26; bottom left, Adolf Heerdt, steel kitchen. The kitchen was to be organized as an efficient productive unit that would also benefit the housewife. Her labour was analyzed into its separate components and the kitchen was designed accordingly. As the article explained, 'The criterion for this compartmentalisation is work and its comfortable, time-saving and hygienic execution.'

The main photograph, captioned 'The space- and labour-saving Frankfurt kitchen', shows a kitchen designed by Grete Schutte-Likotzky for Ernst May's New Frankfurt housing development in 1927. Walter Gropius installed built-in kitchens into his and other teachers' houses at Dessau and corresponded with Dr Erna Meyer, author of *The New Household*. In a short publicity film, a maid demonstrates the facilities of the kitchen in the Gropius house. Julia Moholy's publicity shot (bottom right), shows the space-saving dish rack above the sink, as well as the hot water pressure hose for washing the dishes.

CREATED

Frankfurt

MEDIUM

Steel interior

Grete Schutte-Likotzky *Born* 1897 Vienna, Austria

Died 2000

ORGANISATION
DER KÜCHE

In den reinen Nützlichkeiträumen, wie Küche und Bad, soll, sagt BRUNO TAUT, das Ästhetische nicht nur die Folge des Praktischen, sondern mit diesem Praktischen vollkommen gleichbedeutend sein. Durch praktische richtige Anlage, die nichts an Bequemlichkeit früherer Einrichtungen aufzugeben brauche, könne eine **Klarheit und Ruhe der Lebenshaltung** erreicht werden, die man mit dem Ästhetischen des Eindrucks in Parallele ziehen dürfe.

Jede Form darf also „nichts anderes als sich selbst" geben, das heißt, nur Behälter oder Handhabe sein, damit die Hausfrau dieses Werkzeuges in arbeitsparender Weise sich bedienen kann. Aber gerade hier versuchten die Fabrikanten, möglichst viel „Sonnenschein" über die Hausfrauenarbeit gleiten zu lassen; es gab kaum einen Gegenstand, auf dem nicht ein ungeschickter Schnörkel, ein sinnloses Ornament angebracht war. Sie, die wie übrigens auch die Hausarchitekten, sagen „es müsse zur Sachlichkeit noch etwas hinzukommen". ADOLF BEHNE antwortet hier sehr richtig: „Nun, was zur Sachlichkeit hinzukommt, kann doch nur entweder die Sache fördern, und dann ist es Sachlichkeit, oder ihr schaden, und dann ist es vom Übel; oder aber, es nützt weder noch schadet es der Sache, und dann ist es überflüssig."

Soviel von den Teilen, die in ihrem Nebeneinander restloser Zwecklösung jenen ästhetischen Gesamteindruck klarer und ruhiger Lebenshaltung ergeben sollen. Nun zur räumlichen Organisation dieses Nebeneinander. Den Leitfaden zu dieser Einteilung bildet die Arbeit und deren bequeme, zeitsparende und hygienische Ausführung. Die kluge Hausfrau reiht an diesem Faden alles auf, was sie in der Küche nötig hat, möglichst nach dem zeitlichen Ablauf bzw. nach der Gleichzeitigkeit des Gebrauchs. Überlegt und beobachtet sie richtig, so findet sie sie in den Grundzügen gleichbleibendes System leicht heraus. Da es, nach vorhandenen Raumverhältnissen und persönlicher Neigung immer besondere Lösungen geben wird, können nur Beispiele gezeigt werden. **F. H.**

Die Raum und Arbeit sparende Frankfurter Küche. — Ausführung des Städtischen Hochbauamtes in Frankfurt am Main. — Entwurf: Architektin GRETE SCHÜTTE-LIHOTZKY

links: Stahlküche, Fabrikant Adolf Heerdt, Frankfurt am Main; rechts: Spüle im Hause Gropius (Seite 20)

foto lucia moholy

Bauhaus students

Title page of newspaper published by communist students at Bauhaus college in Dessau, 1932

Courtesy of akg-images

This is the front cover of the Bauhaus students' *Loudspeaker*, the organ of the Kostufra, an acronym for the Communist students' organization. Addressing itself to both male and female students ('Bauhaus-ettes') and to everyone from the preliminary course students to 'the gentlemen Masters and Director personally', it sardonically asks if there is 'peace in the house' and boldly splashes the word 'terror' in its place. This rather suggests the attitudinizing of Bohemian rebels, but in 1932 the Bauhaus faced a real crisis: the Nazis were rapidly gaining in strength and they regarded the Bauhaus as Bolshevik, Jewish and un-German.

The appointment of Ludwig Mies van der Rohe as Director in 1930, following the dismissal of the self-identified Marxist Hannes Meyer, was seen by many students as an unjustified retreat in the face of right-wing attacks. Meyer had organized classes on politics and sociology and sought to ensure that the school was oriented towards collective and social purposes. Mies forbade political discussion among the students and expelled several Communists, but this did not appease the Nazis, who closed down the Bauhaus in 1932, forcing it to move to Berlin as Mies's private school.

CREATED

Dessau

MEDIUM

Printed newspaper

jahrgang 3 april 32

sprachrohr der studierenden organ

bauhaus
der

kostufra

an die bauhäusler und

bauhäuslerinnen **12**

der direktor

frieden im hause ?

an die vorkursler — an die herren

meister und direktor

‚persönlich' **TERROR**

preis:15

Bauhaus

Places

Gropius, Walter & Meyer, Adolf
Fagus Works, Alfeld an der Leine, 1911–14

Courtesy of akg-images/Electa/© Estate of Walter Gropius and Adolf Meyer

This commission, for a shoelace factory in Lower Saxony, established the young Gropius as a progressive and innovative architect not long after he had completed his training with Peter Behrens (1868–1940). The plan had been commissioned from another architect, but Gropius gave the building its distinctive glass and steel façade, in place of the conventional load-bearing walls. The radical use of apparently unsupported glass-clad corners anticipates his own workshop wing for the Bauhaus at Dessau.

The client saved money with this construction method, but it was also thought that a well-lit interior would benefit both the workers and the productive process. Gropius's brick entrance still retains elements of traditional classicism, assisted by the regular vertical elements along the side, which recall classical pilasters. But these repeated elements also evoke the character of modern industrial production. The finished product is an expression of rational functionality and monumental dignity, modernity and tradition.

CREATED

Alfeld an der Leine

MEDIUM

Glass and concrete construction

SIMILAR WORKS

Peter Behrens, AEG turbine factory, Berlin, 1908–09

Walter Gropius *Born* 1883 Berlin, Germany

Died 1969

Adolf Meyer Born 1831 Germany

Died 1905

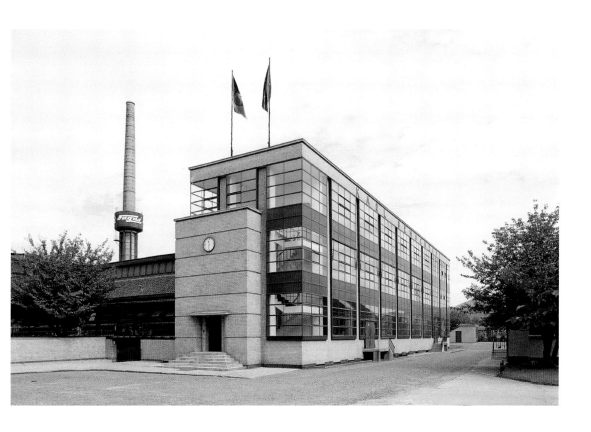

Gropius, Walter & Meyer, Adolf
Staircase, Fagus Works, 1913–14

Courtesy of akg-images/Hilbich/© Estate of Walter Gropius and Adolf Meyer

This staircase occupies the right-hand corner of the façade seen in the previous image. It is illuminated from two sides by the glass cladding and appears to float in space – a look down from the landings (as in Albert Renger-Patzsch's famous photograph of 1928) confirms that the staircase does not touch the glass. In the late 1920s it was celebrated as the precursor of contemporary staircases like the one in the main building of the Bauhaus. It certainly appears to anticipate a modernist language of weightlessness and transcendence. Early photographs of the building do not stress these aspects.

Like the Bauhaus staircase depicted by Oskar Schlemmer, it is a series of functional diagonals, conceived in a simple economical structure, the austerity of which forms a counterpoint to the dramatic exploitation of light and space. It can be contrasted with Peter Behrens' heavy, monumental double staircase for the administrative building of Hoechst AG (see page 214).

CREATED

Alfeld an der Leine

MEDIUM

Glass and concrete construction

SIMILAR WORKS

Walter Gropius, Bauhaus main staircase, 1925–26

Walter Gropius *Born* 1883 Berlin, Germany

Died 1969

Adolf Meyer *Born* 1831 Germany

Died 1905

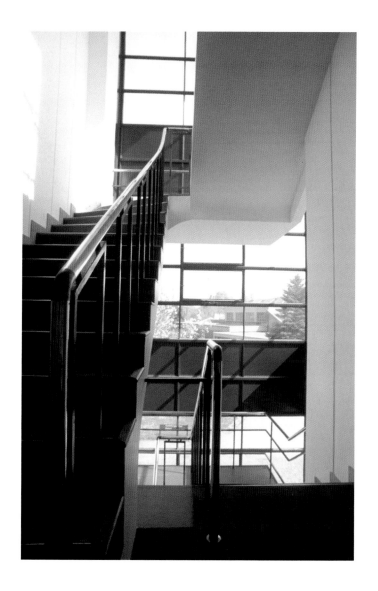

Unknown

Invitation card, Bauhaus exhibition, Weimar, 1923

Courtesy of © Photo CNAC/MNAM Dist. RMN – © Adam Rzepka

This invitation card, designed by a student, advertises the 1923 Bauhaus exhibition. It depicts the *Haus am Horn*, the exhibition's showpiece. So central was the house considered to be to the school's aims and ethos that its image is allowed to substitute for 'haus' in the word 'Bauhaus'. But the omission of the word 'haus' also encourages the viewer to go straight from 'Bau' ('construction') to the similarly large 'Aus'of the word 'Austellung' (exhibition). 'Aus' by itself means 'out'. Indeed, the exhibition signalled the school's shift away from the inward-looking concerns of fine art and the handicrafts towards practical development of environments for the masses to live in.

The heavy lettering has a suitably architectural quality – the word 'Bau' ('construction') appearing to support the façade of the house, while the house itself seems to be appropriately generated by the word. Graphic design and architecture are shown to be part of the same rational investigation, in which the concept on paper is linked to its three-dimensional realization.

CREATED

Weimar

MEDIUM

Colour lithograph reproduced in black and white

SIMILAR WORKS

Walter Gropius, model for Kellenbach House, 1922

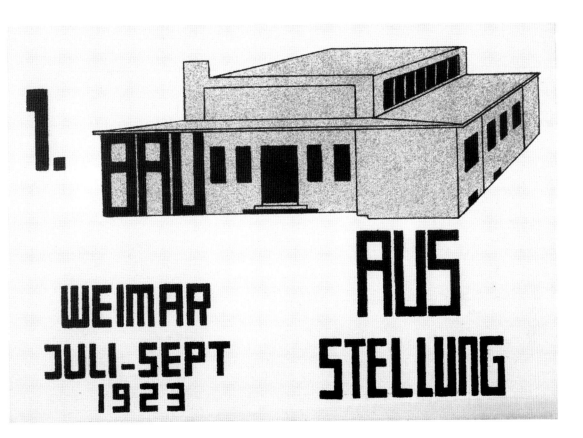

Unknown

The metal workshop, Weimar 1923

The initial focus of the metal workshop at Weimar was on craft work in precious and other metals. Its first Craft Master was the jeweller Naum Slutzky; its second, from 1922 to 1925, was the experienced Christian Dell. The Form Master until 1923 was Johannes Itten, who encouraged the students to engage in personal expression. The highly aestheticized character of the workshop's production in this period is shown with the jug by Gyula Pap standing on the right. One of his candelabra (a seven-branched Jewish menorah) is at the back.

 The lack of equipment (two vices, a boring machine by the door) shows the obstacles facing László Moholy-Magy, who took over as Form Master of the metal workshop in 1923 with the intention of re-organizing it to make protoypes for industry. Many of the objects were, in fact, hand hammered to look as though they had been produced industrially. The work of Wilhelm Wagenfeld, Marianne Brandt and Karl Jacob Jucker at this period is extremely geometric. The metal workshop was forced to become its own factory to earn money, with the students turning out pieces based on the workshop models. At Dessau, contracts were eventually signed with industrial firms in 1928. Finally, the workshop was amalgamated into a modern interiors workshop in 1929.

CREATED

Weimar

MEDIUM

Interior design

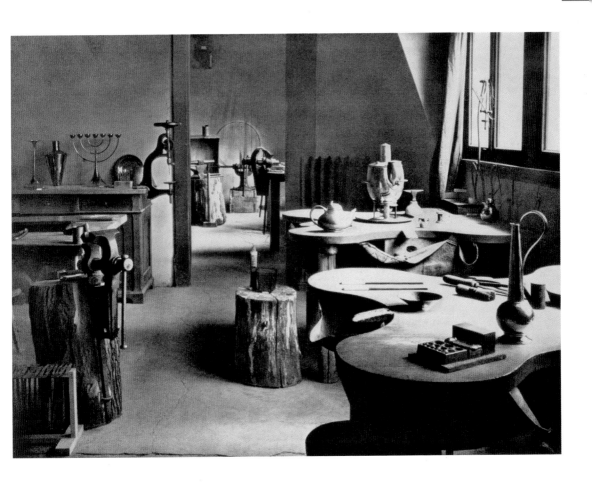

Moholy-Nagy, László

Poster for Bauhaus exhibition, Weimar, 1923

Courtesy of Nationalgalerie, Berlin, Germany, Alinari/Bridgeman Art Library/© DACS 2005

It is significant that this poster (for the exhibition that signalled the Bauhaus's new industrial orientation) should have been designed by a Constructivist brought in to replace Johannes Itten, who had encouraged personal expression. This poster deliberately suppresses evidence of personal manner or human trace. The shapes suggest the new world of geometrical machine forms that it was the duty of the modern artist-designer to bring into being.

Segments of a circle, drawn with compass and ruler, recur frequently in Moholy-Nagy's painting and graphic works of the 1920s. They are seen earlier in the work of Aleksandr Rodchenko, the Russian Constructivist. The form is echoed in the body of a teapot by Marianne Brandt made in the metal workshop, which Moholy-Nagy took over in 1923. Here it is intersected by a white form like a shard of glass and by a red quadrilateral, which was becoming a Bauhaus trademark but also evokes the Russian avant-garde designs of Malevich and El Lissitzky. A thin diagonal shape at the top recalls El Lissitzky's dynamic prouns, or new forms, which were halfway between painting and architecture; between two-dimensional concept and spatial realization.

CREATED

Weimar

MEDIUM

Colour lithograph

SIMILAR WORKS

El Lissitzky, *A Tale of Two Squares*, 1920

László Moholy-Nagy *Born* 1895 Bacsborsod, Hungary

Died 1946

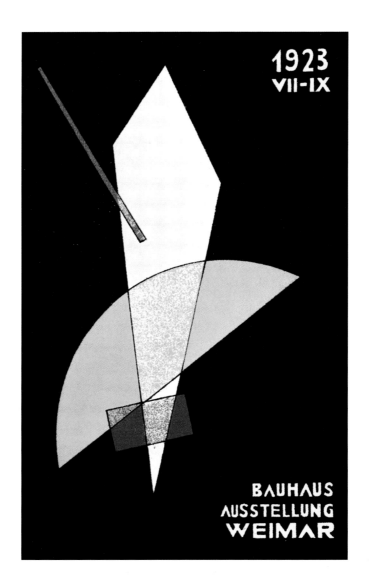

Bayer, Herbert & Maltan, Josef

Sign for Bauhaus exhibition, Belvedere entrance to Bauhaus, Weimar, 1923

Courtesy of Private Collection, The Stapleton Collection/Bridgeman Art Library/© DACS 2005

Here the *Jugendstil* (Art Nouveau) architecture of Henry van der Velde's former Academy of Fine Arts (1904–11) plays host to Bayer's and Maltan's sign announcing the keynote Bauhaus exhibition of 1923. There is a strong *De Stijl* and Constructivist influence in the radical verticalizing of the word *Austellung* ('exhibition'), which mimics the tall forms of the entrance doorway but contrasts with the decorative organic forms on the gates.

The sign was produced later than the invitation cards, as is shown by the fact that it includes the correct dates of the exhibition: 15 August–30 September. This is a side entrance to the building, which showed work from the Preliminary Course and objects made in the workshops as well as an exhibition of international modern architecture. The building's vestibule was drastically remodelled and Rodin's statue of 'Eve' removed to make way for abstract reliefs by Joost Schmidt. The stairwell of the former Arts and Crafts School, which housed the Bauhaus workshops, was adorned with reliefs and murals by Oskar Schlemmer. These were destroyed by the Nazis in 1930.

CREATED

Weimar

MEDIUM

Black and white photograph

Herbert Bayer *Born* 1900 Haag, Austria

Died 1985

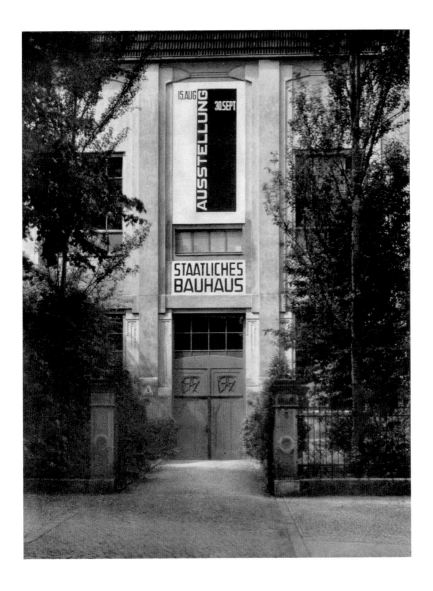

Schmidt, Joost

Poster for the Bauhaus Exhibition, Weimar, 1923

Courtesy of The Art Archive/Dagli Orti/© The Estate of Joost Schmidt

Schmidt's poster, done when he was still a student, shows the influence of the new Master, László Moholy-Nagy. There is a tinge of Dutch *De Stijl* in the integration of lettering with bold abstract shapes, while the influence of Constructivism is seen in the poster's use of blacks and reds to create a diagonal composition which produces an effect of dynamic movement. The circular and semi-circular forms suggest the wheels of industry, but with a passing echo of the elegant curves of Art Deco.

The extended serifs in the lettering add to this elegance but also aid in giving a strong impression of movement. With their traditional calligraphic associations, serifs were later excised from Bauhaus typography. The use of ruler and compass, in the Constructivist manner, suggests the precision of industrial drawings rather than the personal quality of 'art'. Schmidt's design incorporates the face of the machine-man designed by Oskar Schlemmer for the Bauhaus seal of 1922 (see also page 22). There is an ambiguity here as to whether human beings are in control of technology or whether they are crushed by it.

CREATED

Weimar

MEDIUM

Printed ink on paper

SIMILAR WORKS

Oskar Schlemmer, Bauhaus seal, 1922

Herbert Bayer, invitation card to Bauhaus Exhibition, 1923

Joost Schmidt *Born* 1893 Wunstorf, Hanover

Died 1948

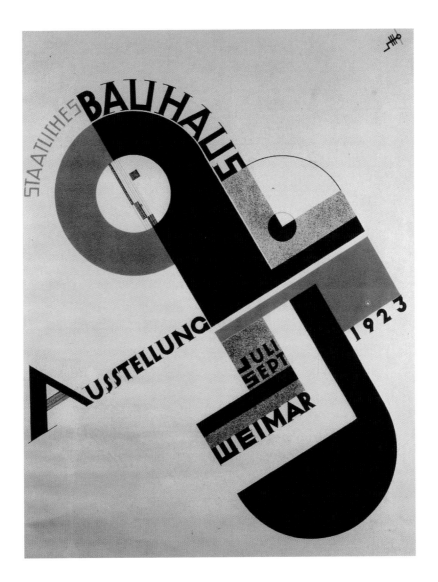

Muche, Georg & Meyer, Adolf

Haus am Horn, Weimar 1923

Courtesy of © Jochen Helle/Bildarchiv Monheim/© Estate of Georg Muche and Adolf Meyer

This house was the centrepiece of the 1923 Bauhaus exhibition, and was intended to demonstrate the Bauhaus's commitment to the slogan 'Art and Technology – a new unity'. Here, a modest single-storey house replaced the cathedral of the Bauhaus's first manifesto as the ideal of integrated art and design. In theory, at least, it embodied the aim of design for the masses through industrial production.

The house was meant for a small, modern, servantless family with young children. Clerestory windows light the central living room from above, and the other rooms are arranged around it. The lines of the house are stark, clean and geometric, suggesting that in the future the parts could be mass-produced and assembled on site (as happened with the Torten estate at Dessau). Function apparently determines the form, and from this, rather than from ornament, beauty is supposed to arise. Nonetheless, the house is essentially a modernist version of a traditional classical villa.

Georg Muche, a painter, thought art should have nothing to do with technology, but he did agree that living spaces should be rational and beautiful.

CREATED

Weimar

MEDIUM

Architecture

SIMILAR WORKS

Walter Gropius, plaster model for Kellenbach House, 1922

Georg Muche *Born* 1895 Querfurt, Germany

Died 1986

Adolf Meyer *Born* 1882 Germany

Died 1929

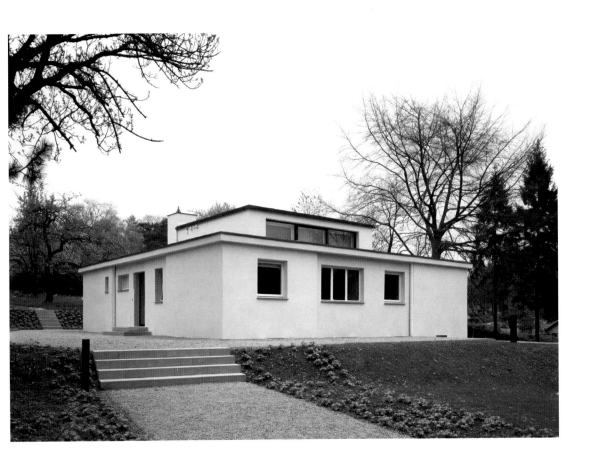

Muche, Georg

View of the children's room, *Haus am Horn*, Weimar, 1923

Courtesy of © Jochen Helle/Bildarchiv Monheim/© Estate of Georg Muche

The children's room in the *Haus am Horn* reflected progressive ideas on child development. The furnishings were made in the carpentry workshop from designs by Alma Buscher and Erich Brendel. They include multicoloured boxes which could be used both for sitting on and for building with, thus developing spatial and cognitive skills. They are painted in bright primary colours to stimulate the visual faculties.

Coloured wooden boards for drawing or writing on are a feature of the wainscot, and there is a toy cupboard by the door that can also be used for puppet shows. Frosted plate glass disks, developed in the metal workshop, ensure a clear and even light.

The children's room is linked directly to the female's bedroom, suggesting that the responsibility of bringing up the children was principally hers. The 'master' bedroom was located on the other side of the house. It is linked to the female's bedroom for conjugal purposes and to the central living room for other forms of relaxation. The children would no doubt be admitted to his presence when they were dressed, fed, watered and well-behaved.

CREATED

Weimar

MEDIUM

Interior design

Georg Muche Born 1895 Querfurt, Germany

Died 1986

Unknown

Glass painting workshop, Weimar, 1923

This workshop seems to be modestly equipped, like all the workshops at the Weimar Bauhaus at a time of economic crisis. Its main orientation was the production of stained glass with all the medievalist handicraft associations of that activity. The ubiquitous Johannes Itten was the first Form Master of the workshop, succeeded in 1922 by the painter Paul Klee who continued in that role in 1923. In 1920–21 one of its students, Josef Albers, designed the stained glass windows for the new house of the Berlin lumber dealer Adolf Sommerfeld. He became the technical supervisor, or Craft Master, from 1923 and played a key role in the workshop's new direction as the entire school re-oriented itself towards industrial design.

The workshop was abolished in the move to Dessau in 1925, as the focus upon the fusion of art and technology became ever more central to the work of the school. Glass staining still had religious associations, which meant that it had little role to play in the new architecture. Albers, however, was appointed Junior Master in 1925 and continued to work with glass. He investigated mechanical techniques such as sandblasting and developed a geometric aesthetic in keeping with much of the rest of the Bauhaus's output at Dessau.

CREATED

Weimar

MEDIUM

Interior design

Bayer, Herbert

Title page of *Staatliches Bauhaus in Weimar almanac, 1923*

Sometimes attributed to László Moholy-Nagy, who in fact edited this book, the cover of this almanac, covering the work of the Bauhaus in Weimar, was as much praised and criticized as the contents. The cover's radical design was a bold statement of the new Bauhaus values of 1923. Bayer did away with the traditional stability and balance of the printed page by alternating dynamic blocks of pure red and blue lettering. Red, blue and yellow, the basic (primary) colours, which featured so much in the teaching of Kandinsky and Johannes Itten, continued to be a preoccupation of Bayer's.

The letters have a heavy, architectural quality, in keeping with the restated school aim of designing a total environment, rather than simply engaging in craft work. The traditional serif has been eliminated, as has any notion of personalized expressionistic calligraphy or Dada-inspired typographic anarchy from the earlier period of the Bauhaus. The lettering was nevertheless hand drawn since no equivalent typefaces were available and there were no means for photographic blow-up and printing, but that is not the impression given.

CREATED

Weimar

MEDIUM

Graphic design

Herbert Bayer *Born* 1900 Haag, Austria

Died 1985

STAATLICHES BAUHAUS IN WEIMAR 1919-1923

Unknown

The printing works, Weimar, 1923

© Private Collection, The Stapleton Collection/Bridgeman Art Library

The printing workshop at Weimar was initially ill-equipped to develop links with industry. There was no typographic printing press and no commercial art department. The workshop trained students in fine art techniques and directed them towards reproducing the compositions of fine artists among the staff, such as Lyonel Feininger, who was the workshop's Form Master. Nonetheless the invitation cards for the Bauhaus exhibition of 1923 already show the influence of Dada, Constructivism and *De Stijl*, suggesting that the students had not been entirely occupied with printing the works of their teachers.

László Moholy-Nagy, although not formally employed in the workshop, exerted a huge influence on its style and output from 1923, strengthening the Constructivist/*De Stijl* elements in its graphic design, especially in the famous Bauhaus Books. In 1925 Herbert Bayer was appointed leader of the new, well-equipped workshop at Dessau. He developed the Bauhaus's corporate image and made links between the Bauhaus and the world of commerce. Joost Schmidt became head of the workshop in 1928, on Bayer's departure, and it was redesignated as the advertising workshop.

CREATED

Weimar

MEDIUM

Interior design

Klee, Paul

Invitation card for Bauhaus Exhibition, Weimar, 1923

Courtesy of Galerie Nierendorf, Berlin, Germany, Alinari/Bridgeman Art Library/© DACS 2005

The 1923 Bauhaus exhibition marked the school's new orientation towards industry, but this invitation card by Klee provides a reminder of the Expressionistic spirit of the early Bauhaus, with its emphasis on personal exploration. The design is evidently hand drawn and does not attempt to be precisely geometric. The grand structure, culminating in an entrance portal with a red solar disk/eye above it, totters slightly in a self-parodying way. But it is serious too. Klee named this composition the 'Sublime Aspect', representing the high ideals of the institution. His other invitation card, in which strange little figures show their delight, was entitled the 'Cheerful Aspect' – in other words the fun-loving, social side of the Bauhaus.

Progressive educational theory held that to recapture the primitive purity of childhood perception it was necessary to explore the three basic shapes (circle, triangle and square) and the three basic colours as a foundation for further development. Klee's poster, in the spirit of the early Bauhaus, playfully shows that triangles did not have to be yellow, squares did not have to be red and circles did not have to be blue. Bayer's poster for the 1968 Bauhaus exhibition (see page 202) on the other hand shows a solidification of the the original principles into machine-aesthetic modernist orthodoxy.

CREATED

Weimar

MEDIUM

Colour lithograph

SIMILAR WORKS

Paul Klee, *Temple of Longing Thither*, 1922

Paul Klee *Born* 1879 Münchenbuchsee, near Berne, Switzerland

Died 1940

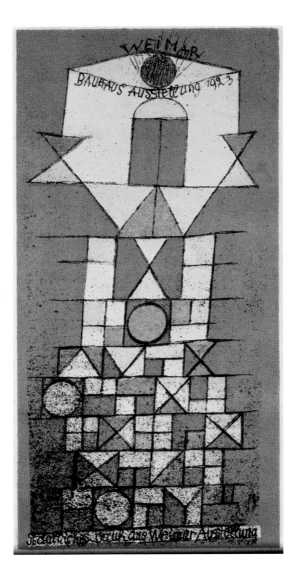

Buscher, Alma
Child's bench 1923–24

Courtesy of © Photo CNAC/MNAM Dist. RMN – © Jacques Faujour/© Estate of Alma Buscher

This daringly simple piece is an example of the attempts in the carpentry workshop at Weimar to radically reduce furniture to its essential form. This bench is easily moveable but also stable, a requirement of furniture made for active children. Buscher was a pioneer of children's furniture and conducted research into their behaviour. It recalls the pieces produced by the pre-First World War *Wiener Werkstätte* and represented the endeavour to construct an environment that was airy and light.

It is the antithesis of the expensive connoisseur furniture designed by Ludwig Mies van der Rohe. It also displays a craft emphasis on sound technique, using a traditional material. Marcel Breuer was to re-orient the workshop towards the use of modern materials like tubular steel and cane. Pieces similar to this were placed in the children's room of the *Haus am Horn*, the centerpiece of the 1923 Bauhaus exhibition. The white paint is highlighted by the black edging, making the piece appear weightless.

CREATED

Weimar

MEDIUM

Painted beech

SIMILAR WORKS

Erich Dieckmann, child's bench *c.* 1925

Alma Buscher *Born* 1899 Creutzthal, Germany

Died 1944

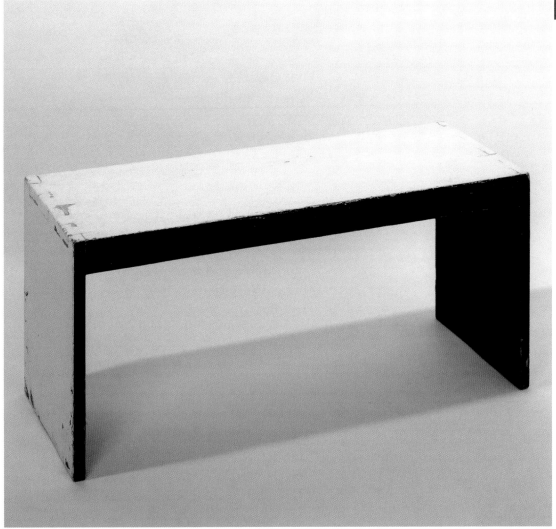

Brandt, Marianne

Ashtray, c. 1924

This is the most sharply geometrical of Brandt's ashtrays, with its hemispherical body and its lid composed of a circle with a triangle cut out of it. It recalls the designs and paintings of the Constructivist László Moholy-Nagy, who provided Brandt with encouragement early on. The triangle motif is more associated with Kandinsky, however. It was described as one of the three basic shapes in his teaching, along with the circle and the square. The sphere, of which of course a hemisphere is a part, was one of the three basic solids.

The warmth of the brass, a traditional material, is countered by the machine-age coldness of the nickel-plated lid. The visually pleasing contrast nonetheless suggests this is a high status, expensive piece. Indeed in early versions the removable lid was made of silver and the body of bronze, in the Weimar handicraft tradition of working with precious metals which was gradually phased out.. The ashtray was carefully handmade, although ironically the smooth finish is meant to suggest machine production.

CREATED

Weimar

MEDIUM

Brass body and nickel-plated lid

SIMILAR WORKS

Marianne Brandt, ashtray, 1928

Marianne Brandt *Born* 1893 Chemnitz, Germany

Died 1983

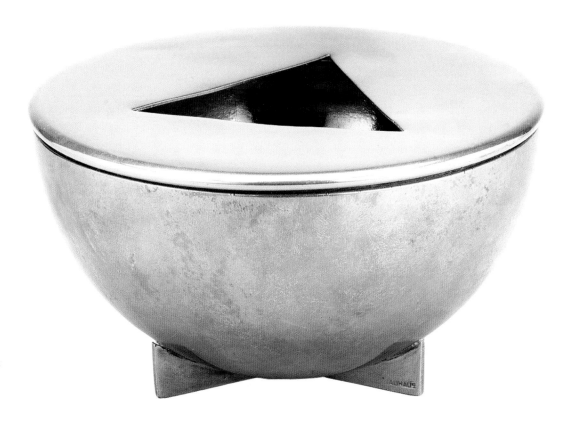

Dieckmann, Erich

Child's bench, c. 1925

This is typical of Dieckmann's work in combining lightness, a solid sense of form and structure and an unornamented simplicity. The piece is versatile, in that a child could either sit on the lower cross-piece and write or draw on the top cross-piece, or sit on the top and place their feet on the lower panel, or use it as a step ladder.

The rectangular frame, here enclosing the child in one position, is also characteristic of Dieckmann's furniture. This piece shows the influence of the orientation of the Bauhaus carpentry workshop towards producing cheap, inexpensive furniture for small family homes. This was an approach that Dieckmann maintained when he left the Bauhaus in 1925 on its move to Dessau, and began teaching at the crafts and architecture school in Weimar.

MEDIUM

Polychrome painted wood (hetre)

SIMILAR WORKS

Furniture in the children's room of *Haus am Horn*, 1923

Alma Buscher, child's bench 1923–24

Erich Dieckmann *Born* 1896 Kauernik, West Prussia (now Kurzetnik, Poland)

Died 1944

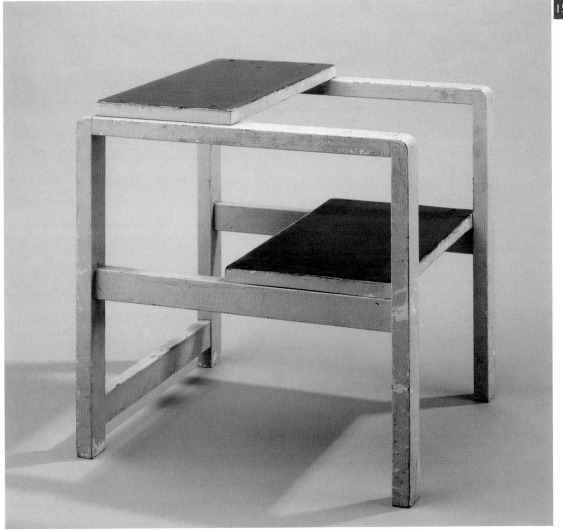

Itten, Johannes
The Red Tower 1917–18

These interlocking forms aspiring towards a star recall Feininger's *Cathedral* woodcut of 1919 (see page 64), and may have influenced it. Like Feininger, Itten found inspiration in Cubism and German Expressionism. He was probably the main guiding influence on students during the early years of the Weimar Bauhaus, between 1919 and 1923. In his Preliminary Course, he taught students to develop their individual personalities through expressive work in line and colour. He left after Walter Gropius, the Director, began to encourage the development of a more impersonal aesthetic oriented towards mass production. The celestial circle appears here, in all three primary colours, an anticipation of the importance of basic shapes and colours in Itten's teaching at the Bauhaus.

Like the 1919 Bauhaus manifesto, this work displays an Expressionist-derived interest in the complete building, a Utopian vision of social and creative integration. In its implied unification of spiritual and social struggles, this work seems to show the impact of the 1917 Bolshevik Revolution on a mystically-inclined artist. The dynamic forms so evident here signify the upward and forward progress of the workers in the slightly later projects of Walter Gropius and Vladimir Tatlin.

CREATED

Vienna

MEDIUM

Oil on canvas

SIMILAR WORKS

Johannes Itten, *Tower of Fire*, 1920

Johannes Itten *Born* 1888 Suden-Linden, Switzerland

Died 1967

Breuer, Marcel

Gentleman's Room, Deutsches Werkbund section of the French Society of Artist-Decorators' Exhibition, Paris, 1930

Courtesy of akg - images/© Estate of Marcel Breuer

Breuer collaborated with Walter Gropius, Herbert Bayer and László Moholy-Nagy on the design of five rooms for the Paris exhibition of the French Society of Artist-Decorators. The commission was from the *Deutsche Werkbund* ('German Craft Union'). As part of a Gropius project for a ten-storey apartment block, Breuer designed a gentleman's room and a lady's room separated by a bathroom and a study. The photograph is of the gentleman's room, which, unlike the lady's room, had a globe, books and telephone, connoting public affairs and rationality. Nonetheless, it was still fairly innovative to include a woman's room in a flat or house at this time, although one had been included in the *Haus am Horn*, the show house at the Bauhaus exhibition at Weimar of 1923.

Breuer's famous cantilevered chair B32, of 1928, is visible at the desk, while his 1929 steel and rattan armchair B25 is in the foreground. The lady's room, by contrast, had an armchair upholstered with padded fabric. All the above named designers had left the Bauhaus by this time, but reviews of the exhibition treated the Bauhaus and modern German design as synonymous. Germans had not been allowed to exhibit at the 1925 exhibition, so this evidence of the advanced nature of that country's design came as a surprise to audiences.

MEDIUM

Exhibition display

Marcel Breuer *Born* 1902 Pecs, Hungary

Died 1981

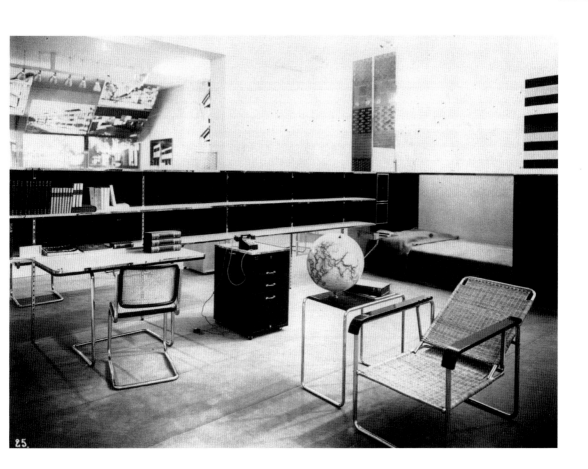

25.

Albers, Anni

Design for a rug in Smyrna wool, 1925

Both Anni and Josef Albers produced work which featured the so-called 'thermometer stripe', where light and dark horizontal bands build up inside a structure of rectangular forms. Josef's design for a work in glass, also from 1925, the year they married, is reproduced on page 34. It is similar in its austerity and in its choice of tones and colours: red juxtaposed with black and white (and here, in addition, grey). Gunta Stölzl, the leading figure in the weaving workshop, was also interested in horizontal motifs (see page 178). This type of design is intended partly to evoke the impersonal, repetitive forms of mass production and partly to convey the idea that the the work is not an evanescent product of the artist's brain, but a material construction.

Anni and Josef Albers wished to achieve effects of depth, or 'pronouncement', in their compositions by creating contrasts between shapes and their backgrounds. Anni had the advantage over Josef here, since she could exploit the three-dimensional quality of the warp and the weft. Anni Albers was a student in the Bauhaus weaving workshop between 1922 and 1925. She then worked, studied and taught in the workshop until 1933, when she fled the Nazis, escaping to the US with her husband.

MEDIUM

Watercolour, gouache and pencil on paper

Anni Albers (née Fleischmann) *Born* 1899 Berlin, Germany

Died 1994

D ü 28 Annelise Albers

Mies van der Rohe, Ludwig

Maquette for a skyscraper in glass, 1922

In spite of their modern steel frames and startlingly modern character, skyscrapers were designed in a notoriously traditional way, recalling Greek, Roman, Gothic and Egyptian buildings. This skyscraper appears to dematerialize as it shoots upwards, the modern equivalent of the Gothic cathedral aspiring heavenward. Glass was favoured by German Expressionist architects as a material that connoted transcendence and spirituality. The influence of Expressionism is apparent here in the cultivation of a dramatic and powerful effect. The curving glass façade, far from being rationally geometric, is intended to create a disorienting play of reflections of the surrounding city.

The principles of construction are plain for all to see, in the modernist manner. The strength of the structure is its inner steel frame, obviating the need for load-bearing walls. Rather than expressing mere functionality, however, the design was intended to be a statement of faith in the future, based on the latest materials. Mies van der Rohe called architecture 'the will of an epoch translated into space'. He was Director of the Bauhaus between 1930 and 1933.

CREATED

Berlin

MEDIUM

Architectural design

SIMILAR WORKS

Walter Gropius, entry for Chicago Tribune Tower competition, 1922

Ludwig Mies van der Rohe *Born* 1886 Aachen, Germany

Died 1969

Gropius, Walter

Entrance to the Bauhaus, Dessau, 1925–26

Courtesy of Margot Granitsas/The Image Works/Topham Picturepoint/© Estate of Walter Gropius

The new visual vocabulary of the Bauhaus sits uneasily with Van der Velde's old academy in the photograph of Herbert Bayer's poster for the Bauhaus exhibition of 1923 (see page 134), but the school at Dessau was of course purpose built, and intended as a statement of aims and principles.

There is at first sight little that is significant about this entrance. It is tucked into a corner between the more dynamic forms of the workshop wing on the right and the administrative offices in the bridge over the road that can be seen on the left. However, the theme of the radical break with the past is embodied here firstly in the refusal to accord the main entrance any of the traditional pompous architectural trappings, and then by the wall of glass that rises above it, behind which is the main staircase.

The lettering used for the entrance is in the same style as the lettering placed vertically on the corner of the workshop wing, but is much smaller. Evidently the prestige of the school as a whole would depend on what was produced in the workshops, not on the impression made on visiting dignitaries in the reception area.

CREATED

Dessau

MEDIUM

Architecture

Walter Gropius *Born* 1883 Berlin, Germany

Died 1969

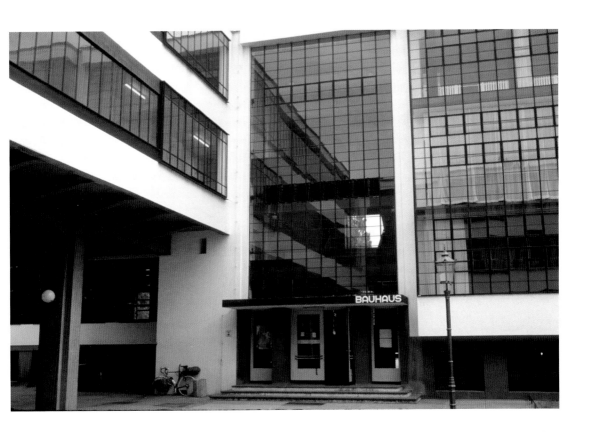

Gropius, Walter

Student apartments, east façade of Bauhaus, Dessau, 1925–26

Courtesy of akg-images/Schuetze/Rodemann/© Estate of Walter Gropius

Twenty-eight students and junior teaching staff occupied these bedroom/studios, which seem to have been much-loved. Most students had to make do with an overcrowded dormitory.

Most bedroom/studios had their own balconies. Breaks for sun and air bathing were judged important, especially if the students were working on their projects all day. It was also part of modernist visual rhetoric that the barrier between outside and inside be dissolved as much as possible, as a metaphor for human liberation.

This design helped to foster a community spirit at the Bauhaus. As one student recalled, to call a friend all one had to do was to whistle up to their balcony. The design also suggests a community in itself, like a colony of birds roosting on a cliff face.

CREATED

Dessau

MEDIUM

Architecture

Walter Gropius *Born* 1883 Berlin, Germany

Died 1969

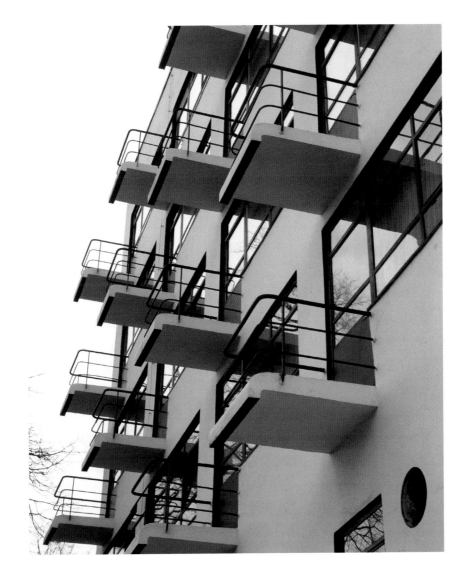

Breuer, Marcel

Seating in the auditorium at the Bauhaus, Dessau, 1925–26

Courtesy of © Florian Monheim/Bildarchiv Monheim/© Estate of Marcel Breuer

This view is from the Bauhaus stage, host to theatrical performances, concerts and lectures. Breuer's seating is fixed in rows, with lightweight tip-up seats. The seats are cantilevered, with support only at the back. Hence they exploit the strength of tubular steel far more effectively than does Breuer's Wassily chair (see page 282). The armrests are plain lengths of tubular steel, while the rear horizontal bar and the seat have small pieces of rubber attached at strategic points to minimize the noise. The fluorescent tube lighting is by László Moholy-Nagy and recalls the fixtures in Gropius's office at Weimar. Both installations were based on lighting developed by Gerrit Rietveld of *De Stijl* in 1922, which derived from industrial lighting.

In his film 'Man with a Movie Camera' (1929), the Russian Constructivist Dziga Vertov shows a cinema in which the tip-up seating appears to operate by itself. He thus points to the power of assemblages of mass-produced objects to evoke and reinforce mass, machine-like patterns of human behaviour. This would not necessarily have been seen as a bad thing by modernist apostles of the Utopian collective.

CREATED

Dessau

MEDIUM

Interior design

SIMILAR WORKS

Marcel Breuer, Stool B37 for Thonet

Marcel Breuer *Born* 1902 Pecs, Hungary

Died 1981

Gropius, Walter

Master Houses in the Ebertallee, Dessau 1926–28

Courtesy of akg-images/Schuetze/Rodemann/© Estate of Walter Gropius

This view of two of the three houses for the Senior Masters that were built at Dessau emphasizes their standardized forms, as though they were built using mass production methods. They were not, in fact, but Gropius was influenced by Le Corbusier's notion that houses should be 'machines for living', assembled from standard elements. The three blocks, intended for six Masters, were identical in plan, although there were differences between the two dwellings comprising each block. The façades are notably asymmetrical, in contrast to traditional classical conceptions of architectural balance. They suggest geometric elements interlocked in space.

This view shows the extensive provision of balconies, for healthy sun and air bathing. The floor plans are fairly conventional, compared to the open plans of Reitveld's Schröder House and Mies van der Rohe's Villa Tugendhat and Barcelona Pavilion, but the location of the studios on the first floor maximized the available illumination and the view of the wooded surroundings, and gave a sense of elevation. The Master Houses suffered from neglect in the period after the Second World War. The photograph shows them after extensive restoration.

CREATED

Dessau

MEDIUM

Architecture

SIMILAR WORKS

Gerrit Rietveld, the Schroder House, Utrecht, 1924

Walter Gropius *Born* 1883 Berlin, Germany

Died 1969

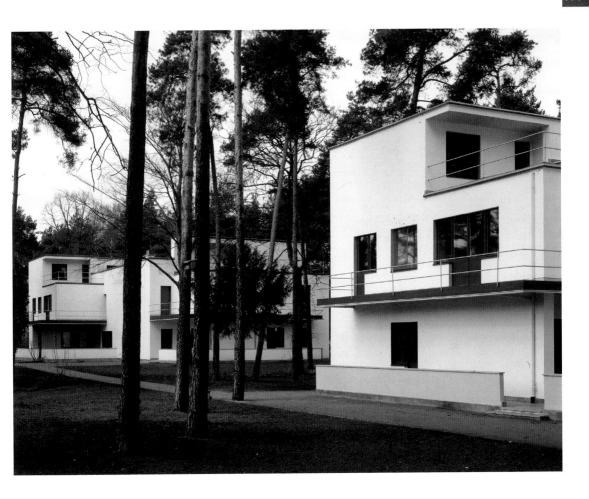

Gropius, Walter

Living room of Julia Feininger, Ebertallee, Dessau (restored), 1925–26

Courtesy of © Florian Monheim/Bildarchiv Monheim/© Estate of Walter Gropius

The house for Lyonel Feininger was the first of the Master Houses to be restored, in 1992–94. The other half of the block, the house originally inhabited by László Moholy-Nagy, had been hit by a bomb during the war.

The presence of the wives in the Masters' houses helped to project a reassuring image of modern bourgeois domesticity to the outside world, counteracting the Bauhaus's (partially deserved) reputation for unconventional morality. A short film exists in which Gropius's wife, Ise, demonstrates the advantages of a built-in sofa in the Director's house. The Feiningers' house does not generally seem to have been furnished in a modern style, as Gropius might have preferred. Nonetheless, this restored room shows, among other pieces, a tubular steel and wood desk by Marcel Breuer and the famous table lamp by Wilhelm Wagenfeld. To facilitate the circulation of light and air, the amount of fabric in the room has been kept to a minimum, there are large areas of glazing, and doors open onto a balcony. Feininger gave up teaching at Dessau in 1927, but he and his wife Julia were allowed to live rent free in this house.

CREATED

Dessau

MEDIUM

Interior design

Walter Gropius *Born* 1883 Berlin, Germany

Died 1969

Stölzl, Gunta

Gobelin wallhanging, 1926–27

Courtesy of Bauhaus Archive, Berlin, Germany/Bridgeman Art Library/© Estate of Gunta Stölzl

This virtuoso piece of weaving combines geometric and organic forms in a range of primary, secondary and tertiary colours. It stands in contrast to the more austere abstract compositions featuring horizontal and vertical bars that were a mainstay of the work of both Stölzl and Anni Albers in the 1920s (see page 178). Geometric and abstract forms were felt to be more suited to the rational methods of modern production.

This composition, in contrast, hovers between abstraction and figuration. Like many of the works of Paul Klee, who was an important influence on the weavers, it can be read both as a two-dimensional 'pattern' and as a series of overlapping spatial planes, something like a landscape. In which case, we could read this as an image of a city or factory on an island in a lake surrounded by hills, with more buildings appearing on the hill behind. The wavy forms could be read (largely) as water, the vertical forms as buildings, and the chequerboards as land. This may be a vision of the Utopian modernist future, with Art and Nature in balance. It is called a Gobelin weaving because it is done in the old tapestry technique associated with the royal Gobelin tapestry workshops in France, prior to the French revolution, rather than on the more modern jacquard looms bought for the weaving workshop in 1925 when it was developing a more industrial orientation.

CREATED

Dessau

MEDIUM

Linen warp and mainly cotton woof

Gunta Stölzl *Born* 1897 Munich, Germany

Died 1983

Stam-Beese, Lotte
Bauhaus weavers, 1928

Walter Gropius was initially worried at the 'excessive' numbers of female students and directed them towards the weaving workshop, associated with a traditional 'feminine' activity. With the support of Paul Klee, and by dint of the hard work and researches of Gunta Stölzl and Anni Albers in particular, the weaving workshop became one of the most successful examples at the Bauhaus of industrially-oriented design and lasted right through the period of the school's existence. The workshop was aided by the purchase in 1925 of jacquard looms, which used punched cards to guide or 'programme' the thread. Gropius later defended the workshop against those who wanted to abolish it.

In 1925, Stölzl took over as technical director of the workshop. In 1927, with the support of the students, she became workshop head on the resignation of the unenthusiastic Georg Muche, a painter. This photograph was taken in the year that the self-identified Marxist Hannes Meyer became Director, by a student who was Meyer's partner. It was used on the cover of issue four of the Bauhaus magazine, published in 1928, with the caption 'Young people, come to the Bauhaus'. Meyer thought that there were too many barriers to entry and that willingness to learn scientific and practical principles was more important than 'talent'.

CREATED

Dessau

MEDIUM

Gelatin silver photograph

Lotte Stam-Beese *Born* 1903 Germany

Died 1988

Stölzl, Gunta

Design for jacquard-woven wall hanging, 1928–29

Courtesy of Victoria and Albert Museum, 2005/© Estate of Gunta Stölzl

In its command of colour and abstract forms, this design for a wall hanging is intended to rival painting; to stake a place for weaving as art. It both recalls and supplants the tapestries of the past, with their outdated figurative compositions and aristocratic clientele. It is intended to be woven using the more modern, partly-mechanized jacquard technique, as opposed to the old tapestry weaving technique associated with the old royal French Gobelin workshops.

Not only are the shapes more rectilinear and less organic than Stölzl's Gobelin tapestry of 1926–27 (see page 174), but the colours are brighter and the contrasts sharper. This is a design that evokes mass production, with its repetitive forms and even modern architecture, with the black verticals. There is also an effect of dazzle, movement and spatial illusionism suggested by the small repeated diagonals and circles. This fast, intoxicating movement possibly creates a visual analogy to the rhythms of contemporary jazz, and indeed, the Bauhaus had its own jazz band. Yet the composition is also anchored by the pull towards the centre and by the strong architectonic elements.

CREATED

Dessau

MEDIUM

Watercolour

Gunta Stölzl *Born* 1897 Munich, Germany

Died 1983

Gunta Stölzl
Jaquard

Mies van der Rohe, Ludwig

Lange House & Esters House, Krefeld, Germany, 1928–30

Ludwig Mies van der Rohe was commissioned to build these villas on adjacent sites by Hermann Lange and Dr Josef Esters, directors of the state silk industry in Krefeld. The Esters house is the closest in this view of the garden fronts. The two sites are conceived as a single extended composition, with a strong horizontal movement. Large picture windows on the ground floors create an interplay between internal and external space. The houses, in simple brick, are characterized by a mixture of repeated motifs, such as the window openings, and by asymmetric variations on basic rectangular forms.

Most modernist architects in the 1920s frowned on brick as a building material. It was not seen as a machine-age material like concrete, steel or glass – it recalled older forms of production, having to be painstakingly laid, rather than poured or welded. But Mies van der Rohe liked the rhythmic repetition of brick, and its honesty, unlike some of his colleagues who might have given it a plaster skim to create a more austere or futuristic effect.

CREATED

Berlin/Krefeld

MEDIUM

Architecture

SIMILAR WORKS

Mies van der Rohe, Monument to Karl Liebknecht and Rosa Luxemburg, 1926

Ludwig Mies van der Rohe *Born* 1886 Aachen, Germany

Died 1969

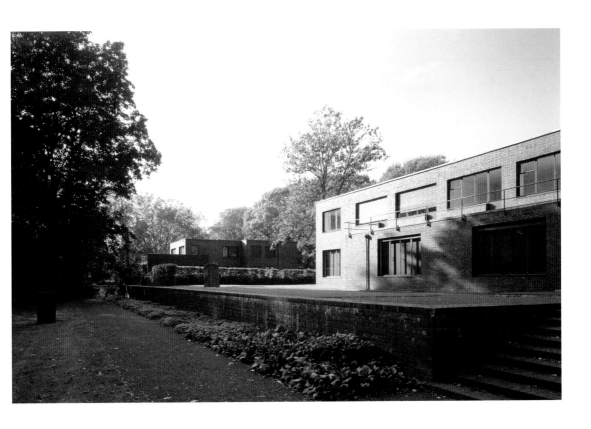

Rubinstein, Naftali

Study with letters — photo from *Bauhaus* published by Hannes Meyer, 1929

This student photograph was published by Director Hannes Meyer in *Bauhaus: Year 3 Dessau* when its author was 19. It shows the influence of the Constructivist László Moholy-Nagy, who taught that a work in any medium should investigate the material possibilities of that medium. Here the printed book and the photographic image become their own subject. Typography and page design is shown here as a laborious, constructive process, producing radical new forms for modern mass living. The 'artificial', quasi-abstract composition of the image emphasizes that photography too is a constructive process, rather than a mere imitation of life. Modernism in art and design frequently called on the viewer to actively reflect on the nature of the image or work and become critical participants in the process of making and viewing, rather than passively treating the work as merely a fictional space to escape into. It is difficult to see how the last danger is avoided here. The bold, heavy modernist sans-serif typeface possesses a certain steely industrial glamour.

CREATED

Dessau

MEDIUM

Photograph

SIMILAR WORKS

László Moholy-Nagy, cover for 14 Bauhaus books

Naftali Rubinstein *Born* 1910 Pinsk, Belarus

Died 1977

Breuer, Marcel

B27 occasional table for Thonet, 1928

Courtesy of Christie's Images Ltd/© Estate of Marcel Breuer

This was the first Breuer design to make use of an element with two V-shaped sections at either end. When two of these were joined together, they created the illusion of two large rectangles arranged in a cross shape. The table certainly gives the impression of free, separate, geometric forms that have come together in a sculptural arrangement in space, on three different planes, especially in versions which have a glass top rather than a wooden one, as here. The two 'rectangles' of the tubular steel frame also describe a dematerialized quartered circle, echoing the circular top.

A brochure issued in 1929 by the manufacturers Thonet contains this and other new designs for chairs and tables, as well as designs previously made for the company Standard Möbel, which had been co-founded by Breuer. Thonet bought the rights to Standard in 1929 and became the leading manufacturer of tubular steel furniture in Germany. All pieces in the brochure were in this material, which had become a symbol of modernity and modern interior design. Breuer has expressed its lightness by stressing the separate elements in this design, but the conjoined rectangles also give the impression of stability and strength.

CREATED

Dessau

MEDIUM

Tubular steel and wood

SIMILAR WORKS

Josef Albers, occasional table for Wassily Kandinsky,, c. 1933

Marcel Breuer *Born* 1902 Pecs, Hungary

Died 1981

Ballmer, Theo

Arbeit, c. 1929

There could not be a more obvious example of El Lissitzky's much-quoted statement: 'In communicating, the printed word is seen, not heard' than this collage by Theo Ballmer. Ballmer studied briefly at the Bauhaus from 1929–30. He had already studied with Ernst Keller, a pioneer of Swiss graphic design, and he went on to teach at the Basel design school. With other Swiss designers and Germans who had fled to Switzerland to escape the Nazis, he become a leading force in the development of the International Typographic Style, which was adopted worldwide in the 1950s and 1960s.

The main features of Swiss modernist graphics, to which the Bauhaus made its contribution, are already exhibited here – the use of sans-serif typefaces, a rigid grid structure, strong contrasts of light and dark, limited or non-existent colour and the strong role of typography in the design. Ballmer often made the typographic elements dominant, as here, and his fonts tend to be tall in proportion to their width, giving a sense that the page layout has been architecturally built. *Arbeit* means 'work', and there is a Constructivist interest here in the process of construction and in how the materials used determine a certain form.

CREATED

Dessau

MEDIUM

Typographic collage, fabric and card cutout

Theo Ballmer *Born* 1902 Lausanne, Switzerland

Died 1965

Gropius, Walter

Former employment office, August Bebel Square, Dessau, 1927–29

Courtesy of akg-images/Florian Profitlich/© Estate of Walter Gropius

This employment office was commissioned by Dessau town council, which was led by the Social Democrats. Committed to reforming capitalism rather than overthrowing it, the Social Democrats accepted unemployment as an inevitable evil that had to be rationally managed. For the public access areas, Gropius devised a semi-circular floor plan divided into segments. Six entrances directed the potentially unruly mass of jobseekers into separate waiting areas according to the type of work being sought and the sex of the jobseeker. From there, individuals were called for interview by job placement officers. They then went to the office where unemployment benefit was paid out. Here we see the inner corridor leading to the exits.

The plan moves people efficiently through space according to the ideas of the American Frederick Taylor about industrial organization. The aesthetics are also industrial: Gropius used yellow-brown brick cladding for the steel structure, the lighting is from the roof, as found in factories, and the walls between offices are partitions (they do not extend all the way to the roof), enabling the floor plan to be altered to meet changing requirements. This generalized illumination from above, allied to the concentric plan, creates the notion that the jobseekers are all individually visible and traceable within the system, just as they would be at work.

CREATED

Dessau

MEDIUM

Architecture

Walter Gropius *Born* 1883 Berlin, Germany

Died 1969

Slutzky, Naum
Necklace, 1929

Slutzky, a young Viennese jeweller, was the first Craft Master at the Weimar metal workshop. He had worked as a goldsmith in the *Wiener Werkstätte*, where he established his own private jewellery workshop alongside the metal workshop, and initially there was no clear demarcation between the two. The early products of the Weimar metal workshop, including Slutzky's, are very much in the craft tradition of skilled handiwork with precious metals.

This piece, however, was produced when Slutzky was working as an industrial designer. This necklace is still a fine hand-worked piece, but has more of a modern industrial feel to it. It is made out of a modern material, chromium-plated brass tubing, which is divided starkly into straight and curved sections with no ornamentation. The later Bauhaus placed much emphasis on the introduction of industrial themes into personal and domestic items, but French Art Deco jewellery at this time was also often radically simplified in its form.

CREATED

Hamburg

MEDIUM

Sections of chromium-plated brass tubing, linked together

SIMILAR WORKS

Koloman Moser or Josef Hoffmann, geometric brooch, *c.* 1910

Naum Slutzky *Born* 1898 Ukraine

Died 1965

Slutzky, Naum
Bracelet, 1929

Courtesy of Victoria and Albert Museum, 2005/© Estate of Naum Slutzky

Slutzky had been a Craft Master at the Bauhaus, but there was no jewellery workshop at the Dessau Bauhaus. Jewellery would have been seen as an elitist handicraft for a richer clientele. Later on he seems to have worked in the modern material of chromium-plated brass, although he also worked with gold and cabochon stones. The cold metallic rectilinear forms of this bracelet, with a rectangle as the central motif, is a statement of modernity and the machine age.

Like the previous piece, its cool sharp minimal form might have complemented the short, severely cut hair and reduced clothing of the *neue frau* ('new woman'). It looks rather 'masculine' as opposed to the feminine delicacy of more traditional bracelets, and hence speaks of changing ideas about gender roles. A Jew, Slutzky left Germany in 1933 to escape the Nazis.

CREATED

Hamburg

MEDIUM

Chromium-plated brass with haematite panel

SIMILAR WORKS

Koloman Moser or Josef Hoffmann, geometric brooch, c. 1910

Naum Slutzky *Born* 1898 Ukraine

Died 1965

Wagenfeld, Wilhelm

Set of bowls for Vereinigte Lausitzer Glassworks, 1938–39

Courtesy of Christie's Images Ltd/© DACS 2005

Wagenfeld, an ex-Bauhaus student, went on to become a successful commercial designer, producing very popular designs for this company (see also page 280) and for Jenaer Glassworks. The pressed glass technique, invented in the early nineteenth century, allowed for mass production of cheap wares, in contrast to traditional hand-blown and cut glass techniques. A piece of glass would be pressed in a two-part metal mould. More decorative and expensive pieces required hand finishing, but the lack of ornament here reduced manufacturing costs. Art Nouveau and Art Deco designers like René Lalique in France produced less practical, more decorative pieces in pressed glass, such as car mascots.

These pieces were made during the Nazi period. The Nazis are often believed to have condemned all modernist design and to have opted for traditionalism, but the party hierarchy believed that efficient design, suited to mass production, would benefit the German nation. Thus a diluted modernism was often tolerated, especially in design items which had no obvious ideological connotations.

CREATED

Germany

MEDIUM

Pressed glass

Wilhelm Wagenfeld *Born* 1900 Bremen, Germany

Died 1990

Marcks, Gerhard

Sintrax coffee percolator for Schott and Genossen (Jenaer Glaswerke), 1925

Marcks, a sculptor, was Form Master of the Bauhaus pottery workshop at Weimar. After the school moved to Dessau, Marcks taught ceramics at the School of Applied Arts at Burg Giebichenstein near Halle .

The coffee percolator was developed from chemical filtering machines in laboratories. Otto Schott, of Schott and Genossen, developed the heat-resistant glass. Marcks was one of the first designers from outside the firm to be employed by Schott. His design avoids the severe geometric nature of Bauhaus products of the early 1920s – by the latter half of the decade, the Bauhaus metal workshop had developed a less eccentric, simpler and more functionally-oriented approach.

However, geometric purism is still alluded to here in the cylinder shape of the upper vessel and hemisphere shape of the lower vessel. It is also very much a modernist design in that, like a glass skyscraper or a glass-clad staircase, it makes structure and function transparent.

CREATED

Halle/Jena

MEDIUM

Glass and metal

Gerhard Marcks *Born* 1889 Berlin, Germany

Died 1981

Marcks, Gerhard

Vegetable dish, 1929

Courtesy of Christie's Images Ltd/© Estate of Gerhard Marcks

As Form Master of the pottery workshop at the Weimar Bauhaus between 1920 and 1925, Marcks encouraged the production of pieces with strong basic forms, without traditional ornamentation. This piece was produced the year after Marcks became Director of the School of Applied Arts school at Burg Giebichenstein.

This dish was manufactured by the Royal Porcelain Factory in Berlin. It has a much simpler, more functional character, with less of a personal stamp than Marcks' Bauhaus work of the early 1920s. Althugh modernist in its form, it is executed in a traditional luxury material that the Bauhaus pottery workshop lacked the facilities, sophistication and perhaps the inclination to work with. It can also be contrasted with the Utopian abstract designs produced by avant-garde artists for the St Peterburg porcelain factory during the early Soviet republic, which in the main consisted of decorations for existing pieces, rather than designs for new formal prototypes (see page 276).

CREATED

Burg Giebichenstein/Berlin

MEDIUM

White glazed porcelain

Gerhard Marcks *Born* 1889 Berlin, Germany

Died 1981

Bayer, Herbert

Installation for the exhibition 'Bauhaus 1919–1928' at MoMA, 1938

The exhibition of Bauhaus work at the Museum of Modern Art in New York in 1938 signalled that European modernism had arrived in America after being ejected from Germany, one of its main countries of origin. The Museum's curator, Alfred Barr, had visited the Bauhaus in 1927 and campaigned for years to make modernism culturally acceptable in the US. The exhibition covered the history of the Bauhaus from its beginnings, including Johannes Itten's basic course, paintings of the well-known Masters, highlights of design and Oskar Schlemmer's theatrical and balletic projects.

Bayer developed some ingenious and innovative solutions to ensure a flow of information for the visitor negotiating the series of small rooms, including false walls, blocked areas and signs on the floor to focus and direct the viewer and make the information manageable. Certain spaces, such as this, were left relatively bare. Here, Schlemmer's painting *The Dancer* (1922–23) is seen with theatrical masks on one side and two paper constructions hanging on the right, thus emphasizing the unity of the Bauhaus's concerns across a range of media, but placing the concerns of 'Man', as Schlemmer would have expressed it, at the centre of the new design discourse.

CREATED

New York

MEDIUM

Installation

Herbert Bayer *Born* 1900 Haag, Austria

Died 1985

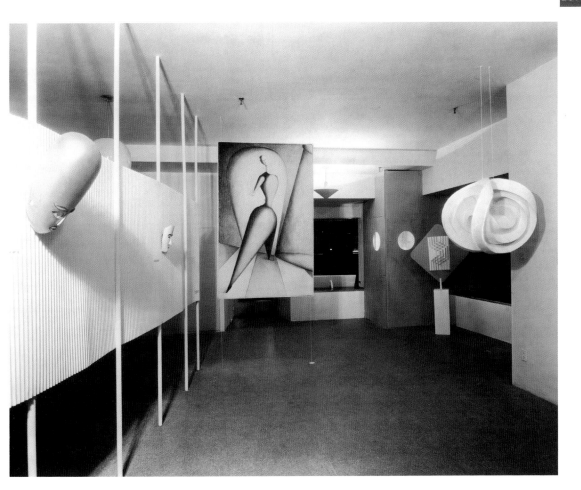

Bayer, Herbert

'Bauhaus 50' exhibition poster, 1968

This poster, for an exhibition in Stuttgart and London marking the fiftieth anniversary of the founding of the Bauhaus (although it was actually founded in 1919, not 1918), is a statement of faith in the continuing validity of Bauhaus principles in the 1960s, when modernist ideas still seemed current.

The three basic shapes, each with their assigned colour, dominate the poster, precisely as Kandinsky, Klee and Itten had taught in the early 1920s. The red square, the most architectonic earthbound element, occupies the centre. The yellow triangle is sharp in both colour and shape, while the blue circle is associated with the spiritual. By the side of each shape is its three-dimensional equivalent, in the purity of white. Large models of these solids graced the exhibition hall, along with the poster. This is a statement about the interconnection between drawing and building, between concept and realization, between design in two-dimensions and architecture. In their purity, these shapes also recall the Utopian ideals of early European modernism. The main font used is the typographic counterpart to the universal visual language represented by the basic shapes – simple, clear and apparently rational.

In 1968 young people were again embracing left-wing Utopianism, as had many at the Bauhaus. In terms of visual culture, though, they were far readier to embrace the rebellious subjectivitism of Dada and its derivatives rather than a style compromised by its association with postwar corporate culture.

MEDIUM

Poster

Herbert Bayer *Born* 1900 Haag, Austria

Died 1985

50 Jahre

bauhaus

Ausstellung
5. Mai - 28. Juli
1968

Württembergischer
Kunstverein
Stuttgart
Kunstgebäude
am Schlossplatz

Gropius, Walter

Bauhaus Archive, Berlin, 1976–79

This museum and archive housing Bauhaus objects and records was originally designed in 1964 for the city of Darmstadt, where the archive had been established four years previously. Gropius died in 1969, and the archive had to relocate to West Berlin in 1970 because of financial problems. It was there that his plans were realized by Alexander Cvijanivoic and Hans Bandel, with the help of Wils Ebert and Louis McMillen.

The repetitive industrial-type forms of the shed roofs culminate in north-facing skylights, providing natural light for scholarly study and for viewing artifacts. As well as exhibition and study rooms, the complex houses a lecture hall, administrative offices and a cafeteria. In a departure from the original plan, the façades are prefabricated, with seams between the prefabricated elements.

It seems appropriate that the study of the history of modernism should be organized with quasi-industrial rationality. On the other hand, if this architecture embodies a demand that this history be written solely upon modernism's own terms, that is arguably deeply problematic.

CREATED

West Berlin

MEDIUM

Architecture

Walter Gropius *Born* 1883 Berlin, Germany

Died 1969

Bauhaus

Influences

Huszar, Vilmos

Cover for *De Stijl*, no. 1, vol. 1, 1917

This is the cover for the first issue of the monthly magazine of the Dutch avant-garde group *De Stijl*, produced in neutral Holland during the First World War. Theo van Doesburg, the leader of the movement, whose name appears on the cover here, settled in Weimar between 1921 and 1922 and was instrumental in getting *De Stijl* ideas accepted at the Bauhaus. This cover is based on a woodcut, and certainly the integration of letters and image and the strong contrasts of black and white recall a woodcut design. They thus look back to an arts and crafts approach, but also look forward to the embrace by modernists after 1918 of standardized forms based on industrial mass production.

The Italian Futurists and Zurich Dadaists were already engaged in breaking up the traditional printed page into exciting chaos, but it is this geometric and integrated conception of typography and image, designed to give an effect of rationality and clarity, which proved to be most influential at the Bauhaus. The blocky, abstract shapes suggest that graphic design and architecture are related constructive activities, sharing a common visual language. That this common language should be universal is made clear by the name of the magazine and the group, which means, in English, 'The Style'.

CREATED

The Hague

MEDIUM

Lithograph

SIMILAR WORKS

Aleksandr Rodchenko, poster, 1925

Vilmos Huszar *Born* 1884 Budapest, Hungary

Died 1960

**MAANDBLAD VOOR DE MO-
DERNE BEELDENDE VAKKEN
REDACTIE THEO VAN DOES-
BURG MET MEDEWERKING
VAN VOORNAME BINNEN- EN
BUITENLANDSCHE KUNSTE-
NAARS. UITGAVE X. HARMS
TIEPEN TE DELFT IN 1917.**

van Doesburg, Theo & van Esteren, Cornelis

Design for the entrance hall of a university, 1923

© akg-images/Erich Lessing

Van Doesburg, the central figure in the Dutch movement *De Stijl*, has here added colour to van Esteren's design for a university entrance hall. What is proposed here is a vast roof or skylight of stained glass, with blocks of the trademark *De Stijl* primary colours, plus black and grey, freely placed across the floors and walls of the interior.

This would have created a spatial illusion whereby the colour would appear to float free of or even to dematerialize the architecture. Rietveld used contrasts of white, grey and black, with colour accents to achieve a similar effect with his Schröder House of 1924 (see page 250). The *De Stijl* interest in an effect of transcendence through such a colour scheme is a reflection of their initial interest in the doctrines of Theosophy, which held that the age of the spirit would replace that of materialism. However, there was also a more general modernist Utopianism which employed effects of weightlessness in architecture and design as a metaphor for liberation from historical and social constrictions. Hinnerk Scheper (1897–1957), a Master at the Bauhaus, also employed wall painting to intensify architectural effects rather than as mere decoration.

CREATED

The Hague

MEDIUM

Pen, pencil and oil collage on transparent paper mounted on cardboard

Theo van Doesburg *Born* 1883 Utrecht, Holland

Died 1931

Cornelis van Esteren *Born* 1897

Died 1988

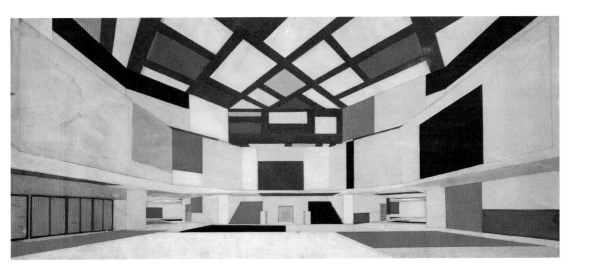

Behrens, Peter

Electric kettle for AEG, 1908

Behrens designed this kettle for the huge German company AEG (General Electric Company). Behrens was an example of a new breed: the professional industrial designer. He was a key member of the *Deutsche Werkbund* (German Craft Union), which played such a leading role in German design and architecture from the 1900s to the 1930s.

The design has clean, simple lines but is not exactly modernist. The octagonal shape, with the bead motif, recalls eighteenth century neo-classical chinaware, something that might have been reassuring to more traditionally-minded customers. Behrens thought that manufactured objects which formed part of people's lives should be more complexly formed, be made of better materials and have a degree of ornamentation. Several finishes were available, including a 'machine-hammered' one.

Behrens did not hold to the idea that the function could straightforwardly dictate the form – the role of the designer was to express in aesthetic terms not only the function of the object, but the spirit of the age. It could be argued, however, that even the most apparently functionalist designs of the Bauhaus also do this.

CREATED

Germany

Peter Behrens *Born* 1868 Hamburg, Germany

Died 1940

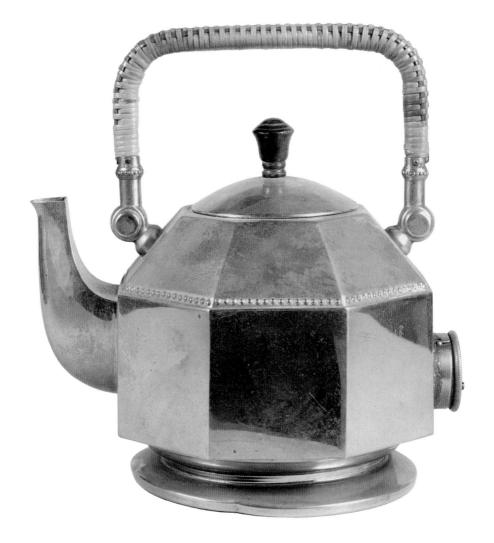

Behrens, Peter

Staircase in administrative building of Hoechst AG, Frankfurt, 1920–24

Courtesy of akg-images/Electa/© DACS 2005

Behrens was first employed as an architect and designer by AEG. He led the way in the design of industrial buildings and had a great influence on Walter Gropius and Ludwig Mies van der Rohe, both of whom worked in his office. Hoechst manufactured paints, dyes and pharmaceuticals, and their new headquarters were for research as well as administration. It is surprisingly unmodernist, given Behrens' previous work and the nature of the commission – indeed, with its clock tower and dramatic central hall it recalls Gothic architecture. In spite of the concrete structure, all the building's surfaces are of two types of brick of different texture and colour. This staircase is one of two at each end of the toplit central hall. The balconies give on to it, creating an emotive gradation from dark to light as one ascends. It is not self-consciously modern in its use of materials or light, like Gropius's pre-war staircase at the Fagus works.

Given the economic and social crisis, as well as the French occupation of Frankfurt and the Rhineland and their purloining of the firm's technical know-how, it might have been difficult to have confidence in a bright modernist future in the early 1920s. The building instead looks back to Germany's medieval past.

CREATED

Frankfurt

MEDIUM

Architecture

Peter Behrens *Born* 1868 Hamburg, Germany

Died 1940

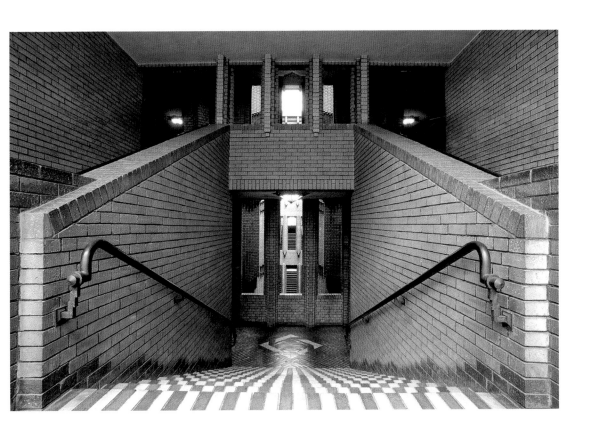

El Lissitzky

Study for Proun RVN 2, 1923

'Proun' is an abbreviation of the Russian words meaning 'project for the establishment of a new art.' It occupies a position midway between the forms of abstract painting and architectural plans. They appear to float in space, always in movement, with an inclination towards the diagonal like the rectilinear shapes here. This transcendent world, Lissitzky thought, was already being realized through such gravity-defying inventions as the aeroplane, out of which these shapes appear to have been dropped.

Constructivists believed that the artist should give up producing exquisite easel paintings for a small clientele and should instead become creators of new forms appropriate to the new Utopia. Since they were (in the main) partisans of the Russian Revolution, this Utopia was socialist as well as technological. It had to be realized in strictly material form, but El Lissitzky was also influenced by the Suprematist ideas of Malevich, who held that the artist was a visionary who could access the infinite and create a new universe of forms. The cross motif here, with its unavoidable religious associations, is borrowed from Malevich. Lissitzky was present at the Dada-Constructivist congress in Weimar in 1922, also attended by László Moholy-Nagy, who was instrumental in disseminating and adapting the ideas of Lissitzky and his colleagues at the Bauhaus.

MEDIUM

Crayon and gouache on paper

SIMILAR WORKS

László Moholy-Nagy, *Composition XX*, 1924

Eliezer (El) Lissitzky *Born* 1890 near Smolensk, Russia

Died 1941

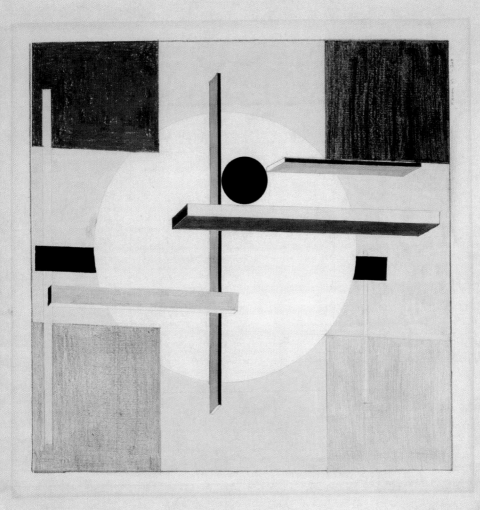

El Lissitzky

Book cover design for *Of Two Squares: A Suprematist Tale in Six Constructions*, 1920

This small book for children was designed by El Lissitzky during the heady early days of the Russian Revolution and was published in Berlin in 1922. He regarded the book as the modern equivalent of the cathedral. Bauhaus Masters such as László Moholy-Nagy and Herbert Bayer assigned it a similar importance. This book tells the story of how a red square (socialism) brings order to a world dominated by chaotic black squares (reaction).

Suprematism was the radical movement invented by Malevich in 1915. It stood for the supremacy of the artist's will in creating his own forms over the forms of the existing material world. Its original icon was the transcendental black square, which represented the radical negation of all form and the need to start over again with a new visual language. But in this book the strong red square brings the new system to earth, just as, after 1917, El Lissitzky and Malevich saw the Revolution as bringing into being the new world prophesied in their art. For them, this change was of cosmic, not just terrestrial, significance. Such mysticism, however, co-existed with a new emphasis on the material forms and techniques that were going to assist in the construction of a new society – an emphasis that was to be called Constructivist. Hence El Lissitzky stressed that his book had been 'built', and urged his audience to get involved in painting and constructing for themselves.

MEDIUM

Graphic design

SIMILAR WORKS

Herbert Bayer, poster for an exhibition celebrating Kandinsky's 60th birthday, 1926

Eliezer (El) Lissitzky *Born* 1890 near Smolensk, Russia

Died 1941

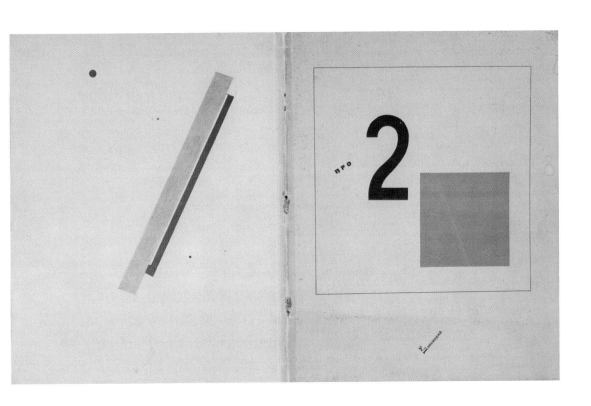

Rodchenko, Aleksandr

'Decorative Art of the USSR', catalogue cover for the Paris Exposition, 1925

The idea of 'decoration', and indeed of 'art' itself would have had no positive connotations for the Russian Constructivist Rodchenko in 1925. However, his catalogue was produced to mark Soviet participation in the Paris Exposition of 1925, following the restoration of diplomatic relations between the two countries.

Rodchenko was much more of a materialist than his fellow Constructivist Lissitzky. He had little sympathy for the residual mysticism of Suprematism. In this 'poster-construction' or 'advertising-construction', as Rodchenko termed such designs, his red, black and grey shapes do not appear to float in space, but sit there grimly doing their job, along with the squat letters U. R. S. S. (USSR). The interlocking forms allude partly to the construction of socialism, partly to the poster itself as a construction, but also partly, perhaps, to the installations erected in the Soviet pavilion at the exhibition, including Rodchenko's design for a workers' recreational club.

The contacts between Berlin and Dessau on the one hand and Moscow on the other had been extensive in previous years, but here was a chance for the consolidated Soviet regime to project a dynamic image to the West. Its economy was recovering from the impact of civil war under the New Economic Policy, which re-introduced some aspects of capitalist market relations. Rodchenko developed his poster designs as a result of the increased need for advertising during these years.

MEDIUM

Colour lithograph

Aleksandr Rodchenko *Born* 1891 St Petersburg, Russia

Died 1956

L'ART DECORATIF

U.R.S.S.

MOSCOU-PARIS 1925

Rodchenko, Aleksandr

Composition, 1920

Courtesy of Art Museum of Tomsk, Russia/Bridgeman Art Library/© DACS 2005

This abstract painting could be the basis for a work in three dimensions. It demonstrates a Constructivist approach in that it is intended as an experiment in form, which could be translated into architecture or industrial design, rather than as a self-enclosed easel painting in the old sense. It is influenced by the wall constructions, using everyday materials, by Rodchenko's fellow Russian Vladimir Tatlin.

Composition is a dynamic aggressive form showing the Italian Futurist influence on the Russian avant-garde. But unlike El Lissitzky's compositions, any impression of forms floating in infinite space is counteracted by the fact that the form's forward point meets the edge of the inner frame. This is a form whose affinity is with the material world, not with spiritual transcendence. The paintings of Bauhaus master László Moholy-Nagy show the influence of this sort of Constructivist work. Rodchenko was using a ruler and compass to create his compositions as early as 1915, well before Moholy-Nagy began to do the same.

MEDIUM

Oil on panel

SIMILAR WORKS

Vladimir Tatlin, *Monument to the Third International*, 1919–20

Aleksandr Rodchenko *Born* 1891 St Petersburg, Russia

Died 1956

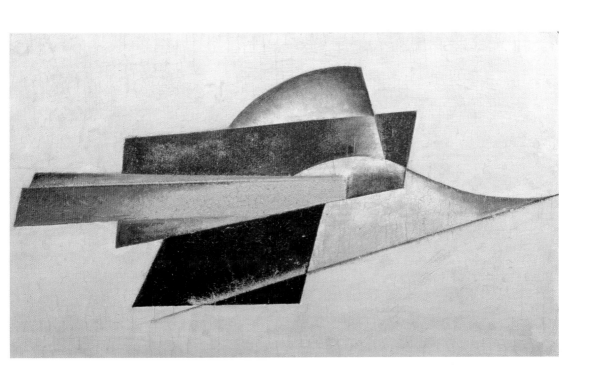

Moholy-Nagy, László

Circular Segment, 1921

Moholy-Nagy, a Hungarian, was heavily influenced by Russian Constructivism and took this gospel to the Bauhaus when he became a Master there in 1923, following the Dada-Constructivist congress at Weimar which he attended in 1922.

Like Aleksandr Rodchenko, Moholy-Nagy has juxtaposed impersonal abstract shapes which one feels could easily become components in architectural or other forms of design. Indeed, Rodchenko had also employed circular segments in his compositions. Segment shapes are juxtaposed in a very similar way in this image to Marianne Brandt's teapot of 1924, made after Moholy-Nagy took over as Form Master of the metal workshop. The lower segment here could correspond to the body of the teapot, and the upper segment to the solid handle of the early teapot, which was replaced by the more practical handle of the version shown on page 33.

This composition – like Brandt's teapot – has a concern for pure, ideal geometric form about it which is perhaps absent from the work of Rodchenko and which is instead closer to the work of El Lissitzky.

MEDIUM

Oil on canvas

SIMILAR WORKS

Marianne Brandt, teapot, 1924

László Moholy-Nagy *Born* 1895 Bacsborsod, Hungary

Died 1946

Klee, Paul

Vollmund in Mauern ('Full Moon Within Walls'), 1919

Klee was one of the well-known artists teaching at the Bauhaus who made it such an attraction for prospective students. These included the young women who arrived wanting to be fine artists but who were generally shepherded towards the weaving workshop, where, nonetheless, they continued to be influenced by his teaching. Klee designed a special course for the weavers.

Klee was interested in the 'primitive' purity of child and tribal art, as were many of the weavers, especially in the Expressionistic early years of the Bauhaus. The triangle was a frequent motif in textiles, at this time, in contrast to the horizontal bar motif which predominated later and evoked machine production.

The moon was a traditional Romantic symbol of nature, the infinite and human longing to escape or transcend this earthly existence. Here, however, it seems to be imprisoned by gable ends and embedded in bricks. Klee supported the notion of the unity of art and technology that the weaving workshop came to represent so effectively, but he felt that rational, mechanical forces also tended to imprison and suppress the creative impulse.

MEDIUM

Tempera, watercolour and ink on gauze

Paul Klee *Born* 1879 Münchenbuchsee, near Berne, Switzerland

Died 1940

Stölzl, Gunta

Textile design, 1927

Courtesy of Sotheby's/akg-images/© Estate of Gunta Stölzl

This textile design was made in the year that Stölzl was appointed head of the weaving workshop. It shows the influence of Paul Klee's teaching in that it has an architectural sense of form organized by reference to a grid. Stölzl's use of the grid here is more rigid than in much of Klee's work. This is emphasized by the presence of the two smaller chequerboards within the design. Overall, the composition is more oriented towards the impersonal geometric rationalism that the Bauhaus associated with industrial production. However, the interest in juxtaposing squares of warm and cool colour, or complementaries, in such a way that they appear to float in depth, to advance and recede, is very characteristic of Klee. An attempt is also made to avoid the effect of continuous horizontal lines, although the vertical lines extend throughout.

This design may be for a carpet rather than a wall hanging – the smaller squares around the border tend to make the larger forms bow outwards, which might be inappropriate in a wall hanging. They also have a framing effect, making the design possibly appear too much like a traditional painting, unless it was meant to be laid flat. On the other hand, the strong vertical emphasis would be suited to a Bauhaus wall hanging.

CREATED

Dessau

MEDIUM

Gouache

SIMILAR WORKS

Gertrud Arndt, rug, 1923

Gunta Stölzl *Born* 1897 Munich, Germany

Died 1983

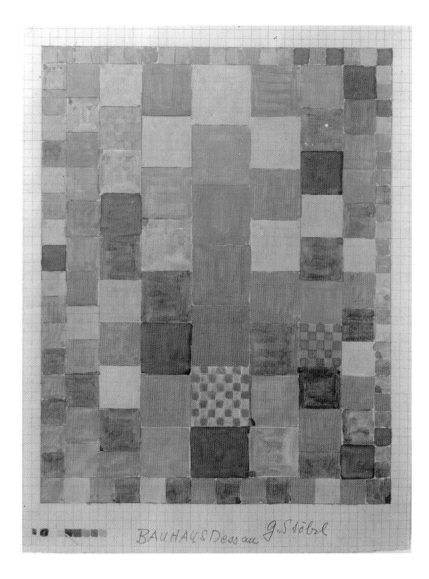

BAUHAUS Dessau G. Stölzl

Schwitters, Kurt

Merz Drawing 229, 1921

Schwitters was one of the exponents of the 'anti-art' movement of Dada, founded in Zurich in 1916. Its approach ranged from savage political satire on bourgeois civilization (especially in Germany) to a kind of child-like, anarchic primitivism. Schwitters stands at the latter end of this spectrum, making irreverent use of materials traditionally thought of as rubbish, as here, to conjure up a range of associations.

'Merz', which features in the titles of most of Schwitters' work, comes from an early collage which included the phrase *'Kommerz und Privatbank'* ('Commercial and Private Bank'). It also suggests the French *'merde'*. Schwitters has endeavoured to rediscover some core of poetry and playfulness, some human creative essence, amid the detritus of the civilization that had given birth to the First World War. In 1922 Schwitters attended a Dada-Constructivist Congress organized in Weimar. As the only State-funded modernist art and design school, the Bauhaus naturally attracted interest from leading avant-gardists. Like the work of Schwitters, much of the output of the early Bauhaus combines the personal and subjective tendencies of Dada and Expressionism with Constructivism's interest in building a new world with new forms.

CREATED

Hanover

MEDIUM

Paper and textile collage on card

SIMILAR WORKS

Kurt Schmidt, invitation to Bauhaus exhibition at Weimar, 1923

Kurt Schwitters *Born* 1887 Hanover, Germany

Died 1948

Citroen, Paul

Metropolis, 1923

This photomontage by a Bauhaus student is an example of a favourite Dada technique which was frequently used at the Bauhaus, often in a humorous or subversive way, and often to make a political point. As a movement which was against 'art' and the civilization that it stood for, Dada favoured the use of low-status materials and subjects such as cuttings from newspapers and magazines in disordered compositions featuring non-traditional subjects.

Here the excitement, disorentation and chaos of the modern city, opposed to traditional culture, is celebrated through juxtaposing buildings from a number of cities, seen from different perspectives. They include American skyscrapers and that icon of modernity, the Eiffel Tower. But there is an element of satire, of alienation from capitalistic commerce, in the inclusion of advertisements for Gillette razors and Odol, a breath freshener.

László Moholy-Nagy also employed the photomontage technique, seeing it as suited to evoking and commenting on the experience of modernity, in common with his fellow Constructivists in the Soviet Union. He published this image in his *Painting, Photography, Film* of 1924, where mechanical images are predicted to replace painting. He commented on the image thus: 'The experience of the sea of stone is here raised to gigantic proportions'.

CREATED

Weimar

MEDIUM

Photomontage

Paul Citroen *Born* 1896 Berlin, Germany

Died 1983

Moser, Koloman or Hoffmann, Josef
Small table, *c.* 1903

This daringly simple and geometrical table is similar to furniture produced by the *Wiener Werkstätte* (Vienna Workshop) for their showrooms. Its tall rectangular shape contrasts in its simplicity and rationalism and lack of ornamentation with the curved, decorative, organic forms of the then fashionable Art Nouveau. Their sparely constructed furniture, frequently painted off-white, as here, aided in the dissemination of light and air in a given space, in contrast to the dark, heavy, over-ornamented dust traps favoured by traditionalists. It was thus held to benefit the Workshop's employees.

Hoffmann and Moser, the main instigators of the Workshop, were influenced by William Morris and the English Arts and Crafts movement. They believed that beauty would be achieved by considering the object's function. They also thought that the artist or designer should acquire craft skills. A practical knowledge of materials was necessary for the creation of objects and environments that were both beautiful and humanly useful. These ideas influenced the craft-oriented approach of the early Bauhaus. *Wiener Werkstätte* furniture, in particular, was a source for the designs produced in the carpentry workshop at Weimar.

CREATED

Vienna

MEDIUM

Painted wood

SIMILAR WORKS

Alma Buscher, child's bench, 1923–24

Koloman Moser *Born* 1868 Vienna, Austria

Died 1918

Josef Hoffmann *Born* 1870 Moravia

Died 1956

Moser, Koloman

Geometric brooch, *c. 1910*

© Sotheby's/akg-images

This brooch would have been regarded as daringly simple in the pre-war period. The emphasis, as with other *Wiener Werkstätte* products, is on fine workmanship, interesting combinations of materials and well-proportioned design rather than on precious metals and intricate chasing. Moser's and Hoffmann's manifesto of 1905 stated that, 'In artistic terms, copper (used here, along with enamel) is just as valuable as precious metals'.

The emphasis on closely aligned straight verticals is typical of the *Wiener Werkstätte*. A contemporary article commented that if applied to a dining table, the new aesthetic would result in strands of macaroni being laid out in parallel. The elaborate, curvilinear decorative language of post-Renaissance tradition is rejected here. While the materials and techniques used recall 'purer' medieval times, the use of geometric lines looks forward to post-1918 modernist jewellery, including jewellery produced at the Bauhaus and that of former Bauhaus teacher Naum Slutzky in the late 1920s.

CREATED

Vienna

MEDIUM

Copper and enamel

SIMILAR WORKS

Naum Slutzky, bracelet, 1929

Koloman Moser *Born* 1868 Vienna, Austria

Died 1918

Albers, Anni
Design for a tablecloth, 1930

This tablecloth design was intended for everyday use and recalls the seating designs produced by the Bauhaus weaving workshop in its focus on regular small-scale repetition of forms, combined with a certain intricacy in the weaving that might produce more visual incident and interest for people sitting a few inches away from it.

Evidently it is not designed as a large-scale abstract composition like Albers' wall hangings, since it is not intended to be viewed in the same way. It does not, for example, have the architectonic quality of her wall hanging in black, white and gray of 1927 (see page 300). Yet it is based, like that piece, on a clear grid structure, with rectangles made up of two or more large squares giving a sense of order and clarity to the intricate honeycomb of small squares. Grid structures also underlay some of the more austere designs of the *Wiener Werkstätte* (see page 236). This is a variation on a traditional check tablecloth, but the design suggests the mechanised complexity of modern production methods. The links with industry were maintained and even expanded in the last years of the Bauhaus, even though student numbers began to fall after.

CREATED

Dessau

MEDIUM

Gouache on paper

SIMILAR WORKS

Anni Albers, wall hanging, 1927

Anni Albers *Born* 1899 Berlin, Germany

Died 1994

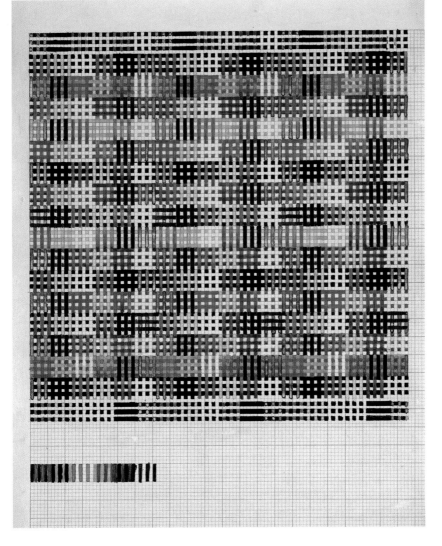

Hoffmann, Josef
Chocolate pot, *c.* 1906

Courtesy of Private Collection/Bridgeman Art Library/© Estate of Josef Hoffmann

The artist-designers of the *Wiener Werkstätte* put a lot of effort into redesigning middle class life, including the rituals of eating and drinking. Samovars, tea and coffee pots all feature in the output. This chocolate pot rather luxuriously combines two traditional materials but the form has a new simplicity, based on a feeling for proportion and shape and a craft-based intimacy with the materials, rather than ornamentation.

With its curving shapes, based on ovals, this has more of an affinity with the early productions of the Bauhaus metal workshop than with the rigidly geometric machine-age aesthetic of the metal and ceramic workshop products of the mid-1920s – such as the teapots of Marianne Brandt (see page 32) or Theodor Bogler's teapot (see page 274). The latter also has a handle that sticks out at right angles to the body of the pot. The inclusion of this feature is perhaps evidence of too great an interest in the conjunction of geometric forms, at the expense of practicality. However the long handle of the pot shown here would allow the chocolate to be poured as from a ladle, suggesting copiousness and – again – luxury

CREATED

Vienna

MEDIUM

Silvered metal and wood

SIMILAR WORKS

Marianne Brandt, teapot, 1924

Theodor Bogler, teapot, 1923

Josef Hoffmann *Born* 1870 Moravia

Died 1956

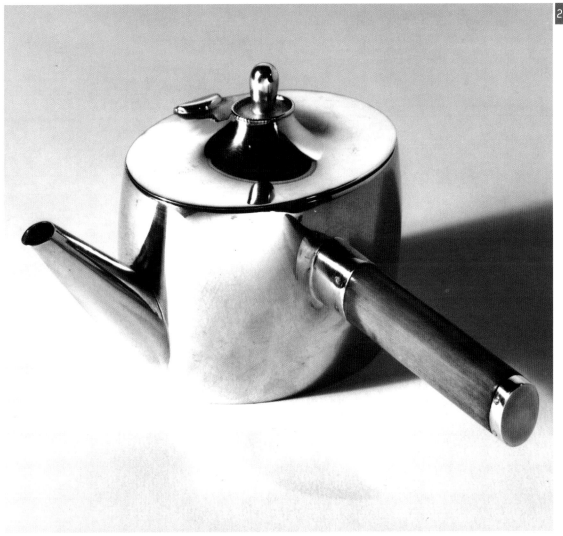

Hoffmann, Josef

Cabinet, 1906

Courtesy of Private Collection/Bridgeman Art Library/© Estate of Josef Hoffmann

The simplified forms and colour scheme of this piece, made by the *Wiener Werkstätte*, stand in contrast to the ornate furniture gracing the home of most bourgeois Viennese at this time. It has been greatly influenced by the furniture of William Morris and the English Arts and Crafts movement, which emphasized beauty of form and sound materials over needless ornament. The vertical forms are a motif running through Viennese art and design in 1900s, but are also a feature of the designs of Charles Rennie Mackintosh in Glasgow. The use of luxurious marble here is sparing and the marble chosen is pale and lightly veined. Pale colours aided in creating brighter interiors.

Alma Buscher and Erich Dieckmann were among those in the carpentry workshop of the Bauhaus at Weimar who seem to have been inspired by such furniture, particularly the rectilinear and rational grid structure. Simple, round knobs are a common feature. This piece was made for Hermann Wittgenstein, a member of a family which were major early patrons of the *Wiener Werkstätte* and who also included the philosopher Ludwig Wittgenstein.

CREATED

Vienna

MEDIUM

Painted wood and marble

SIMILAR WORKS

Alma Buscher, children's changing unit, 1924

Josef Hoffmann *Born* 1870 Moravia

Died 1956

Rietveld, Gerrit

Militar dining table and chairs, designed 1923

Rietveld was a leading member of the Dutch avant-garde group *De Stijl*. He trained both as an architect and as a cabinet maker, and saw both architecture and furniture design as essentially means of bringing together geometric forms on precise co-ordinates in infinite space.

In this design, finally produced in the 1960s, an invisible three-dimensional grid determines the placing of elements. The cross struts project slightly beyond the corners of the table and chairs, and thus appear to be juxtaposed rather than joined. They seem to have no structural function and aid in giving the impression that the dining suite is an assemblage of elements that have come together in space. For example, the struts are placed at a slight distance from the table top and seats, which thus seem to float unsupported. In true modernist fashion, the chairs appear to give minimal support to the back. It might have been felt that the addition of a lower back support would detract from the overall feeling of airiness and lightness. His furniture had an immense influence on furniture design in the early Bauhaus. Bauhaus designers emulated his attempt to reduce furniture to its 'essential' form and even to give a sense of weightlessness. But they also generally felt that the structural principles of the ensemble should be made clear and that the connections between different elements should be evident.

MEDIUM

Wood, originally lacquered white, resprayed red

SIMILAR WORKS

Erich Dieckmann, armchair, 1928

Gerrit Rietveld *Born* 1888 Utrecht, Holland

Died 1964

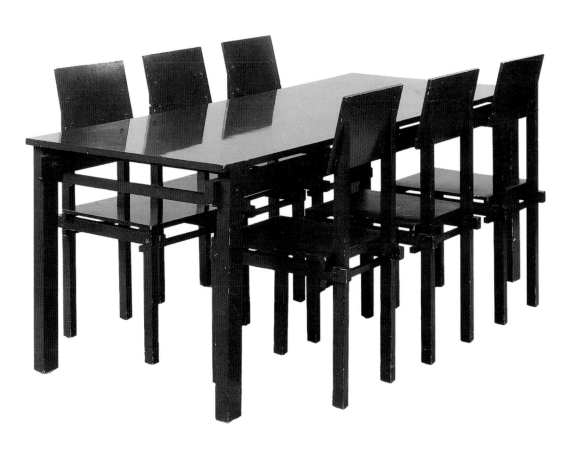

Rietveld, Gerrit

Red chair 1917–18

This chair was influential on most of the furniture produced in the carpentry workshop of the Bauhaus between 1922 and 1925. It is envisaged as a purist geometrical arrangement of lines and planes in space, rather than as a piece of luxurious bourgeois upholstery. Comfort would be ensured, not by upholstery, but by the angling and positioning of seat, back and armrests.

The structural or supportive function of each element is separately articulated, in what was seen as a clear and rational way. This was characteristic of the developing visual language of modernism and especially of the *De Stijl*, group, of which Rietveld was a member. The chair had been reduced to its 'basic', universal, objective form, and artistic subjectivity had apparently been erased from the process.

The original chair is in the three primary colours favoured not only by *De Stijl*, but by the Weimar and Dessau Bauhauses, although the rigid geometry, with its machine-age associations would have been (and was) more favourably received from 1922 onwards. The chair was placed against a dark background in Gerrit Rietveld's Schröder House of 1923–24. The red, blue and yellow quadrilaterals would have appeared suspended in space, giving an effect of elevation and weightlessness.

MEDIUM

Painted wood and plywood

Gerrit Rietveld *Born* 1888 Utrecht, Holland

Died 1964

Breuer, Marcel

Armchair, 1924

Courtesy of Private Collection/Bridgeman Art Library/© Estate of Marcel Breuer

This chair was first produced in 1922, when Marcel Breuer was a twenty year old Bauhaus student. It was manufactured by the Bauhaus carpentry workshop until 1925. The early version at the Victora and Albert Museum in London is in cherrywood.

This chair shows the early influence of *De Stijl* on the workshop, and in particular Gerrit Rietveld's red chair of 1925. It is an arrangement of rectangular slats and canvas strips in space. It envisages a world in which machine production will promise harmonious arrangements of universal basic forms. But in its gawky honesty it also looks back to early workshop experiments in authentically 'primitive' form.

The German artist Georg Grosz, writing in 1925, saw this chair as an example of the Bauhaus tendency to romanticize technology for its own sake, rather than paying attention to practical considerations like comfort. In fact, comfort was taken into account, but the theory was often wrong. For example, it was thought that pressure on the spine was uncomfortable and unhealthy. Hence the spine should be only minimally supported, if at all. This doctrine, translated more generally into modernist furniture design, has proved to be orthopaedically disastrous.

MEDIUM

Stained oak with brown canvas slung seat

Marcel Breuer *Born* 1902 Pecs, Hungary

Died 1981

Rietveld, Gerrit

Schröder House, Utrecht, Holland, 1924

This is Rietveld's first important architectural project, based on *De Stijl* ideas which go back to 1917, but built in the same year that Theo van Doesburg published his ideas on architecture in *De Stijl* magazine. The radical use of geometric forms and overlapping planes inside and out is paralleled in Gropius's Master Houses at Dessau and in Ludwig Mies van der Rohe's Villa Tugendhat and Barcelona Pavilion. The two-storey house, planned in conjunction with Mrs Truus Schröder-Schrader, is seen here against adjoining three-storey older houses. The contrasting white- and grey-painted stucco, with details in primary colours, accentuates the effect of planes floating in space, rather like Rietveld's red chair, an example of which graces the Schröder House.

Inside, the internal vertical partitions defining the top-floor living space do actually move, to create a well-lit open-plan area or a more enclosed area, as required. With the aid of balconies and overhanging eaves, Rietveld has managed to blur the boundaries between inside and outside, aiming for a Utopian evocation of weightlessness and transcendence so characteristic of early modernism.

CREATED

Utrecht

MEDIUM

Architecture

SIMILAR WORKS

Walter Gropius, Master Houses at Dessau, 1925–26

Gerrit Rietveld *Born* 1888 Utrecht, Holland

Died 1964

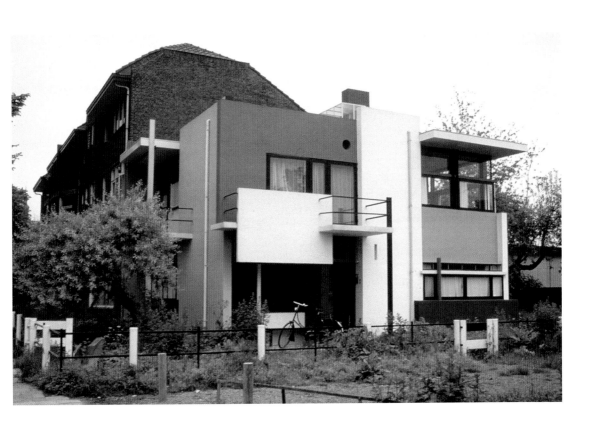

Klee, Paul

View of G, 1927

Klee's rather ramshackle little village in the moonlight is in many ways a far cry from the grand architectural projects of the technological rationalists at the Bauhaus, such as Walter Gropius. It has more affinities with the subjective Romantic and Expressionistic tendencies of the early Bauhaus. As an urban view-cum-map, it is most perplexing, although there is a not-very helpful arrow in the street at the top, which may be intended to evoke the progress of a drunken party through the streets. The time, according to the clock tower, may either be twenty minutes past midnight or three or four in the morning.

Klee maintained an interest in architecture dating from his pre-war visit to Tunisia in 1914, where he perceived analogies between the forms of buildings and landscape and the vocabulary of Cubism. This composition seems to contain Arab-type flat-roofed buildings (in spite of the clock tower). In the year this watercolour was produced, the Weissenhof estate in Stuttgart, the product of an international collaboration between modern architects, opened to the public. Conservatives denounced it for its 'Arab' (non-Aryan, Semitic) roofs, as compared to German and Aryan traditional pitched roofs.

CREATED

Dessau

MEDIUM

Watercolour and oil transfer on paper

SIMILAR WORKS

Paul Klee, wall painting from the *Temple of Longing Thither*, 1922

Paul Klee *Born* 1879 Munchenbuchsee, near Berne, Switzerland

Died 1940

Tatlin, Vladimir

Monument to the Third International, 1919–20

Young modernist artists in Russia flocked to the banner of the Revolution after 1917. This is a lithograph of Tatlin's famous design for a monument to the new, *Communist International*, made after its first congress in Moscow in 1919. Designed to be higher than the other great steel icon of modernity, the Eiffel Tower in Paris, its structures was intended to house, in ascending order, a conference room, a committee room and a communications centre, all of which would revolve at different rates suited to the regularity of their meetings. A model of it was paraded through the streets and put on public view.

The structure was essentially a double spiral on a steep diagonal. In this view, it leans away from us. The double spiral may represent the startling twists and turns of the motion of history, which nonetheless advances, as represented by the diagonal. In spite of the parallel with the Eiffel Tower, the world it evokes and is designed for is very different – one in constant, revolutionary movement. Tatlin's tower quickly became a legend internationally, even though (or because) it was never built. It seemed to represent the ultimate daring fusion of abstract form, modern technology and revolutionary politics. It may have influenced Gropius's *Monument to the March Dead* of 1920–22 (see page 256), but the notion of dynamic diagonals representing forward and upward progress was a common element in the modernist vocabulary at this time.

MEDIUM

Lithograph

SIMILAR WORKS

Walter Gropius, *Monument to the March Dead*, 1920–22

Vladimir Evgrafovich Tatlin *Born* 1885 Moscow, Russia

Died 1953

ПАМЯТНИК III ИНТЕРНАЦИОНАЛА

Gropius, Walter

Monument to the March Dead, 1920–22, reconstructed 1945–46

Courtesy of akg-images/Erich Lessing/© Estate of Walter Gropius

This is a postwar reconstruction of Gropius's monument to nine workers of Weimar who died in March 1920 when the army fired on a demonstration against the Kapp-Putsch, an unsuccessful attempt by a group of army officers to take power. The Nazis destroyed the monument in 1933. Under attack from the right in Weimar, Gropius had prohibited political activity at the Bauhaus, but his opinion on these events was evident in the monument, commissioned by the Weimar trade unions. Gropius had to be dissuaded from taking part in the demonstration at the workers' funerals, but many Bauhaus students attended. The work may represent either a lightning bolt, standing for the violence that struck down the workers, or a crystal of strength and hope. The diagonal thrust of the main element seems to represent the continuing dynamic of the struggle, much as in Vladimir Tatlin's *Monument to the Third International*, of 1919–20 (see page 254). This similarly combines bold abstraction, modern materials and leftist commitment. But the emotionality of Gropius's design has less to do with Russian Constructivism and more to do with the heightened visual language of German Expressionism.

CREATED

Weimar

MEDIUM

Sculpture

SIMILAR WORKS

Vladimir Tatlin, *Model for a Monument to the Third International*, 1919–20

Walter Gropius *Born* 1883 Berlin, Germany

Died 1969

Bauhaus

Styles & Techniques

Stam, Mart & Behrens, Peter

Row houses (right) and apartment block (left and centre), Weissenhof estate, Stuttgart, 1927

The Weissenhof housing exhibition of 1927 gave modernism the opportunity to break into the mainstream of German culture. Stam, a young Dutch architect who designed the three houses on the right, was invited to teach at the Bauhaus in 1926 and eventually taught there part-time in 1928–29. He was also in contact with *De Stijl*. He had pioneered the new cantilevered tubular steel chair, which was on display in one of the houses. A similar concern in this case to eliminate unnecessary volumes and ensure spatial flow, albeit on a larger scale, produced an almost uninterrupted common façade across these three houses, in contrast to Oud's terrace on the same estate (see page 106). This reduction of mass also cut down on building costs.

Contemporaries commented that Behrens' adjacent apartment block resembled a castle: 'The windows are cut out as holes in the masonry. The parapets are high and massive'. The work of the older architect exhibits a concern for grandeur and dignity which seems out of date compared to Stam's houses.

CREATED

Stuttgart

MEDIUM

Architecture

SIMILAR WORKS

J. J. P. Oud, row houses, Weissenhof estate, Stuttgart, 1927

Mart Stam *Born* 1899, Purmerend, Holland

Died 1986

Peter Behrens *Born* 1868 Hamburg, Germany

Died 1940

Brandt, Marianne

Ashtray, 1924

This is one of two well-known ashtray designs by Brandt from around 1924 (see page 152). Both are highly geometrical, this one being a simple cylinder shape. It is more straightforwardly practical and less dogmatic in its form than the other ashtray – there was no particular reason, apart from aesthetics, why the lid should be perforated by a triangle rather than any other shape. The cigarette rest also functions as a means of tipping up the lid, so that the ash can be deposited in the body of the ashtray.

At least some early versions of this ashtray were made in silver, others with a silver lid and bronze cylinder. This version is made from cheaper materials and is no doubt aimed at a wider market. It is perhaps significant that the two ashtray designs were produced by a woman. Cigarette smoking was an attribute of the modern liberated female.

CREATED

Weimar

MEDIUM

Brass cylinder, nickel-plated metal lid

SIMILAR WORKS

Marianne Brandt, ashtray, c. 1924

Marianne Brandt *Born* 1893 Chemnitz, Germany

Died 1983

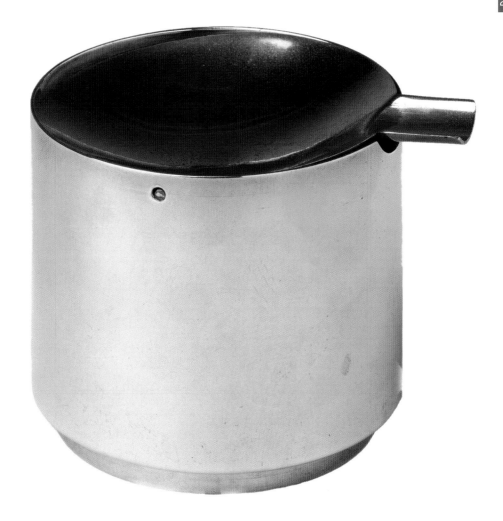

Dell, Christian
Tea infuser, c. 1924

Objects associated with tea- and coffee-making were produced in great quantity and variety in the early years of the Bauhaus metal workshop, before Moholy-Nagy re-oriented the workshop towards the production of modern lighting. This object is typical of the rather exquisite items made in the early years at Weimar, with their emphasis on delicate workmanship in precious metals. This electroplated brass could easily be silver, and most likely was, initially. The electroplating suggests that workshop production gave way to factory mass production in the case of this item. There is a gesture towards the new geometric language of 1922–23 onwards in the disk at the end of the handle. Otto Rittweger and Wolfgang Tumpel went further in this direction in 1924, producing tea infusers in which the tea was held in perforated spheres.

Christian Dell was Craft Master of the Weimar Metal workshop from 1922 until 1925, playing a major role in its development. He then became head of the metalwork class at the Frankfurt art school.

CREATED

Weimar

MEDIUM

Electroplated brass

Christian Dell *Born* 1893

Died 1974

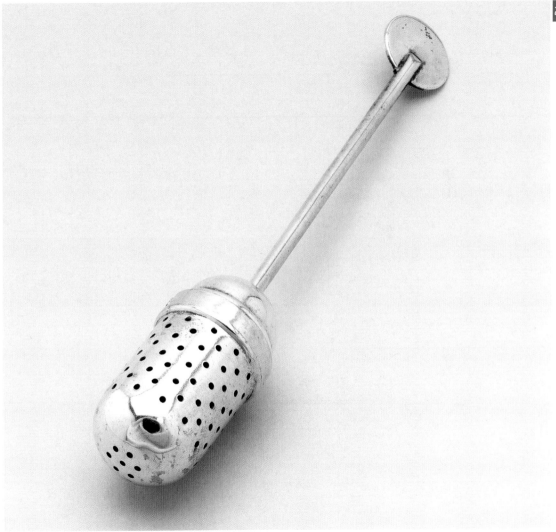

Tümpel, Wolfgang
Desk light, 1931

Courtesy of Christie's Images Ltd/© Estate of Wolfgang Tümpel

This light is typical of the later metal products of the Bauhaus. It was manufactured at workshops in Halle for a firm in Frankfurt. The formalist emphasis on geometry for its own sake, seen for example in Marianne Brandt's ashtray of 1924 has gone, and with it, seemingly, the overt stamp of personality of the designer. The traditional bell shape of the lamp has been entirely abandoned in favour of a shape that recalls industrial lighting, although this is for domestic and office use. The shape of the shaft allows the reader a less obstructed view than would previously have been the case. With its adjustable clamp, it suggests the austere functionality of laboratory equipment.

In 1923, László Moholy-Nagy had encouraged the metal workshop at Weimar to re-orient towards designing lighting to be mass produced for everyday use. The lighting showed an increasing tendency towards specialization and suitability for specific tasks. Marianne Brandt and Hin Bredendieck, for instance, produced designs for adjustable lamps.

MEDIUM

Nickel-plated brass

SIMILAR WORKS

Marianne Brandt and Hin Bredendieck, Kandem table lamp, 1928

Wolfgang Tümpel *Born* 1903 Bielefeld, Germany

Died 1978

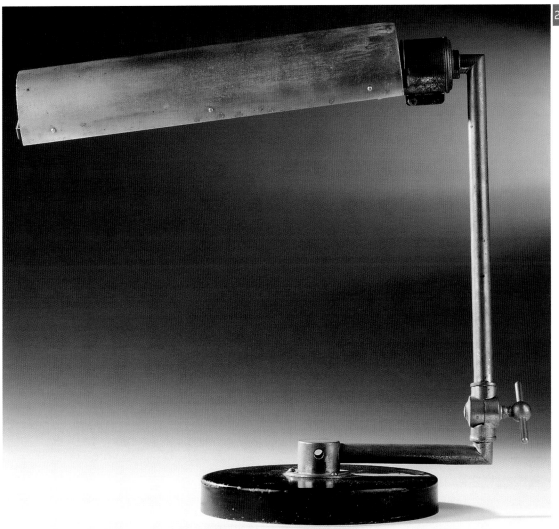

Brandt, Marianne & Bredendieck, Hinrich

Ceiling light model 657, *c.* 1929

This light apparently manifests a complete identity between form and function, achieving what many at the early Bauhaus might have considered complete anonymity, with no trace of the personal or subjective side of the designer apparently remaining. This is no egocentric style statement. The light, which is mostly shade, with a small, light-reflecting porcelain support, unimposingly gives a soft and diffuse illumination. It was a product of the fruitful collaboration between the metal workshop and the manufacturers Kandem (Korting and Mathiessen, Leipzig), for whom Brandt and Bredendieck had produced the famous adjustable desk light (see page 102). By 1932, when the Bauhaus and Kandem ceased their collaboration, over fifty thousand lamps and lighting fixtures had been sold which had some degree of Bauhaus involvement in their design.

Brandt became temporary head of the metal workshop in 1928, but left to take up employment in Walter Gropius's office in Berlin, before working for a metalware manufacturer in Gotha. Bredendieck later taught product design at Moholy-Nagy's New Bauhaus in Chicago, which opened in 1937.

MEDIUM

Porcelain and glass

SIMILAR WORKS

Wolfgang Tumpel, desk lamp, 1931

Marianne Brandt *Born* 1893 Chemnitz, Germany

Died 1983

Hinrich (Hin) Bredendieck *Born* 1904 Aurich, Germany

Died 1995

Pap, Gyula
Floor lamp MT 2a ME16, c. 1923

Pap produced an uplighter design similar to this for the *Haus am Horn* in the 1923 Bauhaus exhibition at Weimar. The flex is contained inside the stem and there is an easily visible and operable pull-switch, with a small sphere at the end, near the top of the lamp. The lamp is elegant in appearance, with its sparing use of geometrical forms. The circular shade echoes the shape of the base. It would be suited to a sparsely furnished modern interior with unobstructed floor and wall surfaces.

Pap, a Hungarian (Gyula is equivalent to Julius), seems to have shared ideas on developing new lighting with Wilhelm Wagenfeld and Karl Jacob Jucker, whose table lamp also has a flex enclosed in the stem and a delicate geometrical form (see page 28). Both items have a modernist rhetoric of weightlessness and immateriality.

MEDIUM

Black lacquered and nickel-plated metal with satinated glass circular shade

SIMILAR WORKS

Wilhelm Wagenfeld & Karl Jucker, table lamp, 1923–24

Gyula Pap *Born* 1899 Orosháza, Hungary

Died 1983

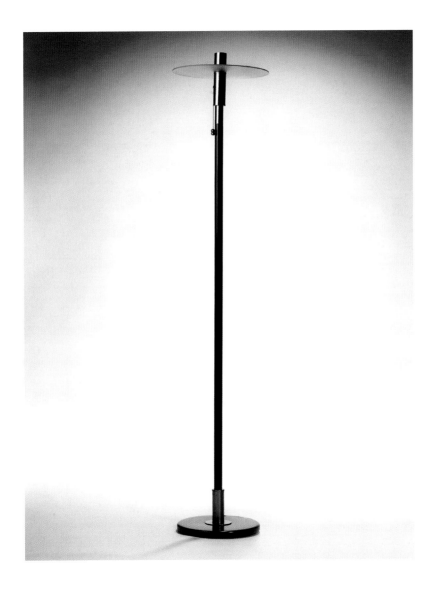

Lindig, Otto

Tea and coffee service, 1932

This sevice was manufactured by the State Majolica factory in Karlsruhe. The geometric motif of the circle recurs throughout, of course, but the handles have traditional and quite practical shapes which have no affinities to geometrical form. There are six cups and saucers and six plates in this set.

Otto Lindig had a solid early training at the Bauhaus, benefitting from the exhaustive practical work demanded by Max Krehan, the experienced Craft Master of the workshop, and from the sense of form provided by Gerhard Marcks, the sculptor appointed Form Master. Marcks emphasized strong form over decoration, working with Krehan to rediscover the 'authentic' forms of the local pottery tradition. Lindig was later employed as a journeyman in the workshop. After the division of the ceramics workshop in 1923 into educational and manufacturing departments, Otto Lindig was instrumental in redirecting the Bauhaus ceramics workshop away from decorative and rustic wares with the emphasis on handicraft, towards forms thought suitable for serial production. The aesthetic effect in the present case is meant to derive from the economy and proportions of the forms, accentuated by the quiet, simple glaze. When the Bauhaus moved to Dessau, Lindig stayed on as a teacher at the Dornburg ceramics workshop, employed by the Weimar *Bauhochschule* (School of Architure and Design).

CREATED

Karlsruhe

MEDIUM

Terracotta

Otto Lindig *Born* 1881 Germany

Died 1966

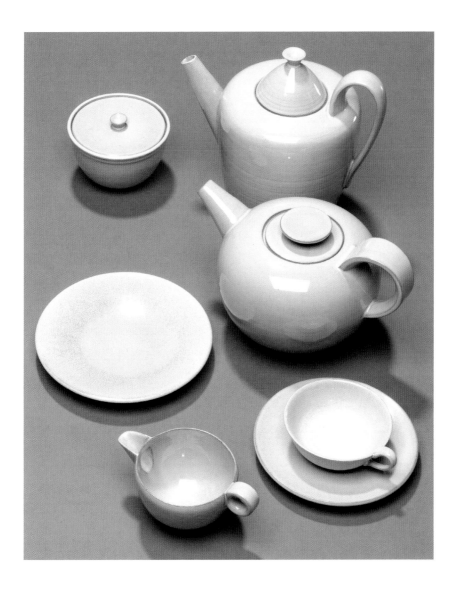

Bogler, Theodor

Teapot, 1923

Courtesy of Victoria and Albert Museum, 2005/© Estate of Theodor Bogler

Bogler, along with Otto Lindig, was a student who was employed as a journeyman at the Bauhaus ceramics workshop from 1923–25. Together, they supervised the apprentices when the workshop was divided into instructional and production facilities in 1923. They responded to the new industrial orientation of the Bauhaus from 1922–23 and were instrumental in developing prototypes for mass, or at least serial, production.

This teapot has been constructed from standard moulded forms. Like the elements of Gropius's house designs, these shapes could be produced in large numbers and combined on a modular basis to create a variety of forms for different purposes. The awkward-looking handle is hollow so that it does not heat up excessively. The strong geometric character of the pot is intended firstly to articulate the functional separateness of different parts, and secondly to create a harmonious object without resorting to superficial decoration. Here, the juxtaposition of circular forms on different axes (the spout and the lid) show a sculptural-architectural interest in how two-dimensional shapes interact in three dimensions.

CREATED

Weimar

MEDIUM

Ceramic

SIMILAR WORKS

Josef Hoffmann, chocolate pot, c. 1906

Theodor Bogler *Born* 1897 Germany

Died 1968

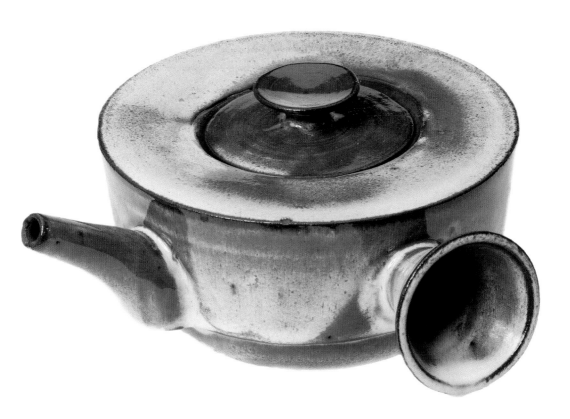

After Kandinsky, Wassily

Cup with saucer, 1923

In the spirit typical of the early years of the Russian Revolution, avant-gardists turned the products of the tsar's old Imperial Porcelain Factory at St Petersburg into vehicles for modernist experimentation. Artists influenced by Kasimir Malevich and Suprematism created adventurous abstract designs for pieces produced by the factory, which had been taken over by the State. These pieces were then usually sold abroad to earn valuable foreign currency for the Revolution. Nothing could have seemed further from the civil war and the famine, but these delicate pieces, as one porcelain artist wrote, seemed like a 'harbinger of the wonderful future for which the Soviet land was fighting'.

In 1921 Kandinsky produced several watercolour designs to be painted on tea sets and manufactured at factories in Novgorod and Dulyovo as well as at the St Petersburg Factory. Kandinsky played a major role in cultural and art administration and teaching in the early Soviet republic, but left the Soviet Union in 1921, so this piece was produced after his departure. It features the less defined, more painterly forms on a white background of his pre-Bauhaus work, and shows no trace of Suprematism or Constructivism. However, it anticipates the role he played at the Bauhaus in promoting a strong role for a universalist abstract aesthetics in industrial design.

CREATED

Moscow/St Petersburg

MEDIUM

Chinaware

Wassily Kandinsky *Born* 1866 Moscow, Russia

Died 1944

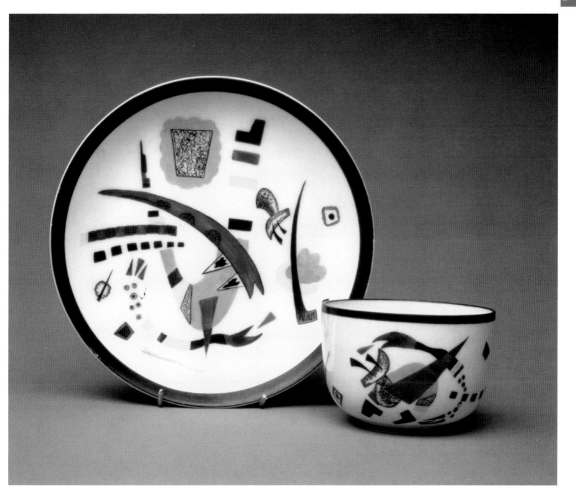

Wagenfeld, Wilhelm

Tea service for Schott and Gen. Jenaer Glaswerke, c. 1932–34

This tea service is is still being manufactured, and in particular the teapot, which was developed by Wagenfeld in 1931. Like the coffee percolator designed by Gerhard Marcks for this firm, it uses the tough borosilicate laboratory glass developed by Schott during the 1920s.

The process of tea infusion is literally made transparent in classic Bauhaus fashion. Just as staircases make the process of people-moving transparent, so visible percolators do the same with coffee making. Toughened laboratory glass, a modern material with scientific asscociations, permits no ornament here. Any aesthetic pleasure comes from shape and proportion and how well-suited to function the finished object is.

The design is practical as well as elegant. The tea infuser, holding the leaves, can be removed easily, leaving the transformed debris-free liquid to be contemplated. The long curving handle is intended not to overheat. Between 1931 and 1935 Wagenfeld designed a range of tableware and baking bowls for Schott.

CREATED

Jena

MEDIUM

Glass

Wilhelm Wagenfeld *Born* 1900 Bremen, Germany

Died 1990

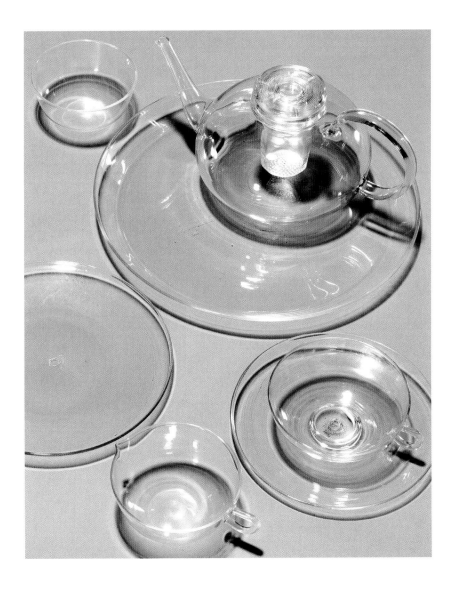

Wagenfeld, Wilhelm

Kubus containers manufactured by Vereinigte Lausitzer Glassworks, *c.* 1938–40

Courtesy of Christie's Images Ltd/© DACS 2005

Designed in 1938 and manufactured before 1941, these storage jars show that the Bauhaus influence in design could survive under the Nazis. Unlike the glass curtain walls of its architecture or the 'degenerate' art practiced by its painters and sculptors, this element of design survived simply because it tallied with the requirements of modern industry and the mass consumer and could be divorced from progressive ideological asssociations.

These containers and covers are designed to fit together, either in the newly invented refrigerator or in a cupboard, thus saving on storage space. Their contents are visible to the housewife so that they can be retrieved easily without opening the lids unnecessarily. They prefigure the plastic Tupperware containers that became so popular in the United States in the 1950s. The rational language of industry has been brought to another private domestic space. The modular system, allowing different combinations of standard units, could be used in the kitchen and not only in the factory or on the building site. It is significant that the most similar forms in this book are Gropius's designs for the Torten estate (see page 114) and the Master Houses at Dessau (see pages 58 and 170).

MEDIUM

Glass

Wilhelm Wagenfeld *Born* 1900 Bremen, Germany
Died 1990

Breuer, Marcel

Wassily chair, 1925

Courtesy of akg-images/© Estate of Marcel Breuer

This famous chair, which has become a symbol of modernism, is essentially a club chair with the upholstery removed. It appears to be a series of planes floating in space. This, together with the angle of the seat and back, shows the influence of the red chair of 1917–18 by Gerrit Rietveld, a member of *De Stijl*. The chair is typically early modernist in its Utopian evocation of weightlessness, dematerialization and transcendence.

This is Breuer's first design in tubular steel, eight pieces of which have been bolted together. Breuer developed his designs in this material in collaboration with the Junkers aircraft firm in Dessau, which also used tubular steel in its aircraft for its lightness and strength. He was reportedly first inspired by the construction of his newly acquired bicycle. Mart Stam and Ludwig Mies van der Rohe also produced tubular steel furniture at this time. The chair was first shown at an exhibition in Dessau in 1926. It was marketed as the Wassily chair in 1960, and is so-called because it was reputedly admired by Wassily Kandinsky. The steel was initially bent in Breuer's studio and closely woven horsehair was used, which was tougher than canvas.

CREATED

Dessau

MEDIUM

Steel tubing and leather or strong cotton

SIMILAR WORKS

Ludwig Mies van der Rohe, MR10 chair, 1927

Marcel Breuer *Born* 1902 Pecs, Hungary

Died 1981

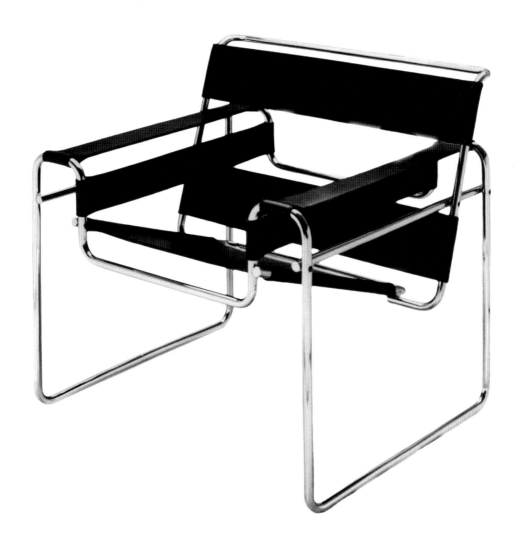

Breuer, Marcel

Desk manufactured for Thonet, designed *c.* 1930, manufactured 1993

Courtesy of Christie's Images Ltd/© Estate of Marcel Breuer

In the approved modernist manner, the functions of the parts of this desk are separately articulated. It has been built up in what seems to be a modular manner, so certain parts can be exchanged for others if a different kind of furniture item is required. A modern tubular steel structure provides the basic support but it is clear that the desk top and the drawers are standard units that are interchangeable.

The inner frames holding the drawers fail to meet the frame supporting the desk top This unusual feature indicates the lightness and strength of tubular steel as a material, and is similar to Breuer's stool, for example, in creating a continuous, dramatically flowing steel shape. The modernist rhetoric of weightlessness is also evident in the way that the drawers appear suspended in this armature. It also seems to be attuned to modern considerations of mobility and functionality, like a sled with supplies stacked onto it. The handles of the drawers help to articulate the structure and are clearly visible to the user. The overall 'feel' is chilly and modern, but the use of quality materials and the elegant contrast of black painted wood and cold chromed steel recalls the furniture of Ludwig Mies van der Rohe.

MEDIUM

Chromed tubular steel and wood

SIMILAR WORKS

Marcel Breuer, stool B37 for Thonet, 1932

Marcel Breuer *Born* 1902 Pecs, Hungary

Died 1981

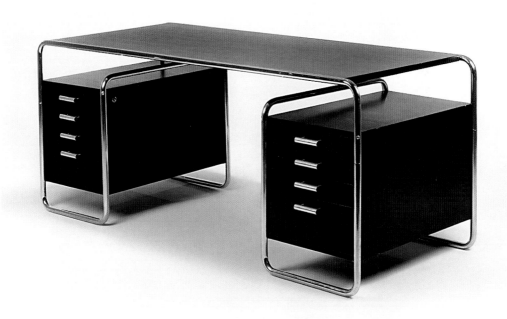

Mies van der Rohe, Ludwig
MR10 side chair for Thonet, 1927

This is a version of the chair exhibited at the Weissenhof exhibition in Stuttgart in 1927 (see page 290) with the arms removed. Mart Stam, Ludwig Mies van der Rohe and Marcel Breuer seem to have developed the cantilevered tubular steel chair almost simultaneously, in 1926–27.

 With Mies van der Rohe's eye for high quality, the extravagant curves of this chair exploit the flexible properties of Mannesmann steel tubing. This is a chair for a connoisseur, like many of Mies van der Rohe's furniture pieces. The firm of Thonet manufactured chairs by Breuer and by Mies van der Rohe from 1927–28. Stam's chairs place their emphasis on sober, inexpensive utility. Breuer's furniture occupies a middle position: equal consideration is given to both functionality and aesthetics.

CREATED

Berlin

MEDIUM

Chromed tubular steel, beech and upholstery

SIMILAR WORKS

Marcel Breuer, Wassily steel tube chair, 1925

Ludwig Mies van der Rohe *Born* 1886 Aachen, Germany

Died 1969

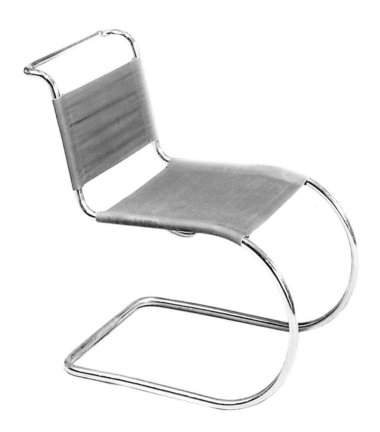

Mies van der Rohe, Ludwig

Barcelona chair MR90, designed 1929, manufactured c. 1931

Courtesy of Christie's Images Ltd/© DACS 2005

This chair was originally designed by Mies van der Rohe for his German Pavilion at the Barcelona International Exposition of 1929. Hence only two were made initially. The chair was designed to be fit for a monarch or ambassador – the king and queen of Spain visited the Pavilion at the opening ceremonies. Unlike chairs designed by Breuer and other chairs designed by Mies van der Rohe, it is luxuriously upholstered. It required an immense amount of hand work. Forty leather panels had to be hand-sewn together for the upholstery. Yet there is little apparent evidence that it has not been machine-produced. To lend extra dignity, there is a touch of classicism in the modernism – the elegant curves in the double x-shape of the frame recall antique Roman or Greek furniture They also suggest lightness, springiness and foldability – another illusion. This is a far cry from the light, inexpensive pieces designed for working class homes by Erich Dieckmann, for example. It anticipates the corporate modernism of the postwar period, rather than the Utopian or civic-minded strand of modernism.

CREATED

Berlin

MEDIUM

Chromed steel and leather

SIMILAR WORKS

Marcel Breuer, Wassily steel tube chair, 1925

Ludwig Mies van der Rohe *Born* 1886 Aachen, Germany

Died 1969

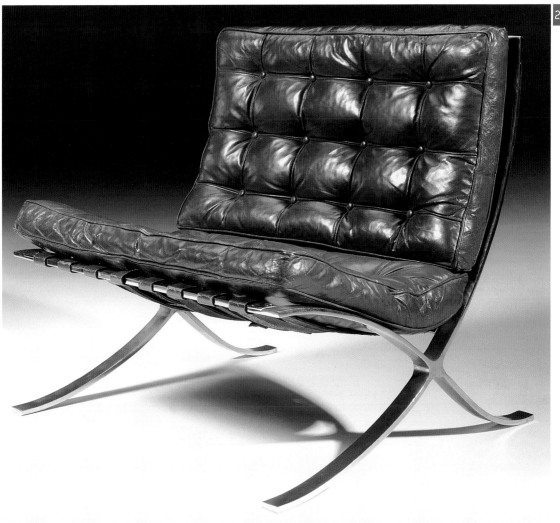

Mies van der Rohe, Ludwig

'Weissenhof' armchair and stool, designed 1927, manufactured 1930

This chair and stool were executed by Joseph Muller of *Berliner Metallgewerbe* for the New York apartment of the architect and writer Philip Johnson (1906–2005). Johnson was an early champion in the US of modernism and of Mies van der Rohe in particular – he was to design the Seagram building in New York with him in 1958.

Mies van der Rohe had shown a version of this tubular steel chair at the Stuttgart Weissenhof exhibition of 1927. Most of his chairs appear much more as luxury aesthetic items than do Marcel Breuer's, as here. The curve of the cantilever is much more pronounced than in Breuer's chairs. The dramatic armrest, however, which adds an extra touch of luxury and class, looks like an afterthought. Mies van der Rohe's partner Lilly Reich, who designed the seating, was also his main collaborator for some years in designing interiors. Cane was the sporty, light, modern seating material of the interwar period, featuring in ocean liners and aircraft. The staining however seems rather uncharacteristic: most versions had undyed cane.

CREATED

Berlin

MEDIUM

Tubular steel frames, with cane seating by Lilly Reich

SIMILAR WORKS

Ludwig Mies van der Rohe, side chair, 1927

Ludwig Mies van der Rohe *Born* 1886 Aachen, Germany

Died 1969

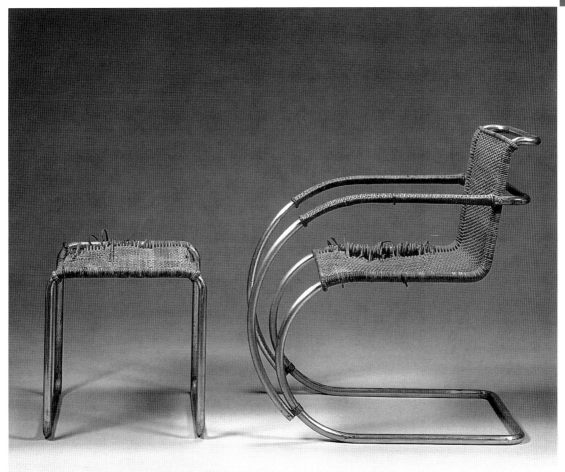

Keler, Peter
Armchair, 1925

Courtesy of Christie's Images Ltd/© Estate of Peter Keler

The purist and rather dogmatic character of this chair – the sides form two open near-squares – is typical of Keler's work in furniture. His cradle of 1922 has a severe triangular cross-section with an open circle of metal attached at head and foot to facilitate rocking (but possibly also overturning). In each case there is the idea that the human body and the forms in contact with it should be suspended between and enclosed by the basic geometric shapes that were such a feature of Bauhaus teaching.

The open sides form a startling contrast with the comfort suggested by the upholstery. However, the angled back was intended to be a distinctly modern way of relieving pressure on the spine and ensuring an easy posture. Unlike most modernist chairs, this one gives some support to the lower back, and the depth of the seat allows support for the thighs.

Keler was an architect and graphic designer as well as a furniture designer. He studied at the Bauhaus between 1921 and 1925 before opening his own private studio in Weimar, where he produced several furniture designs that were manufactured. Another version of this chair has a woven cane back and seat.

MEDIUM

Stained pearwood and striped wool upholstery

SIMILAR WORKS

Peter Keler, red cube chair, 1925

Peter Keler *Born* 1898 Kiel, Germany

Died 1982

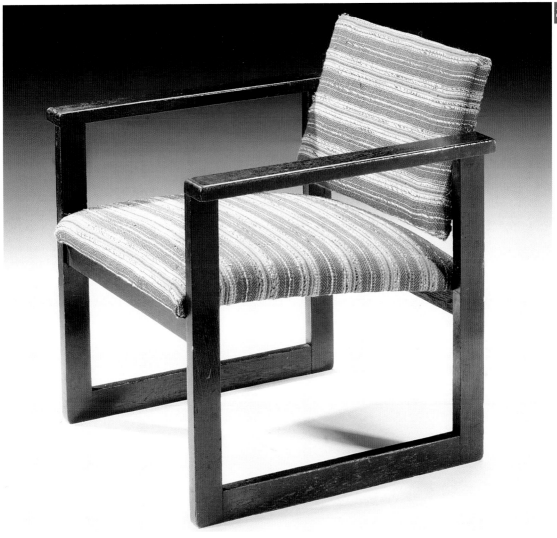

Dieckmann, Erich

Sidechair, c. 1925

This design was developed for the exhibition at the Weissenhof estate in Stuttgart in 1927, and used to furnish the apartment building designed by Ludwig Mies van der Rohe. Dieckmann, an ex-Bauhaus student, developed this piece at the State School for Crafts and Architecture in Weimar, in response to Mies van der Rohe's call to furnish a '...home for people on the breadline'. The design was later put forward as a suitable model for mass production of furniture for small apartments. Ironically, this chair stands in contrast to Mies van der Rohe's somewhat luxurious tubular steel chair (see page 290), shown at the same exhibition

This piece has the trademark Dieckmann angled back for comfort, with two wooden slats, shaped to the body, extending across. The contrast of ebonised wood and sporty, fashionable cane seating conveys a certain spare elegance, in spite of, or perhaps because of the economical use of materials. Dieckmann's designs tended to be simpler and clearer than Breuer's in the early and mid-1920s, seen for example with Breuer's wood slat chair of 1922.

MEDIUM

Ebonized wood with woven cane seat

Erich Dieckmann *Born* 1896 Kauernik, West Prussia (now Kurzetnik, Poland)

Died 1944

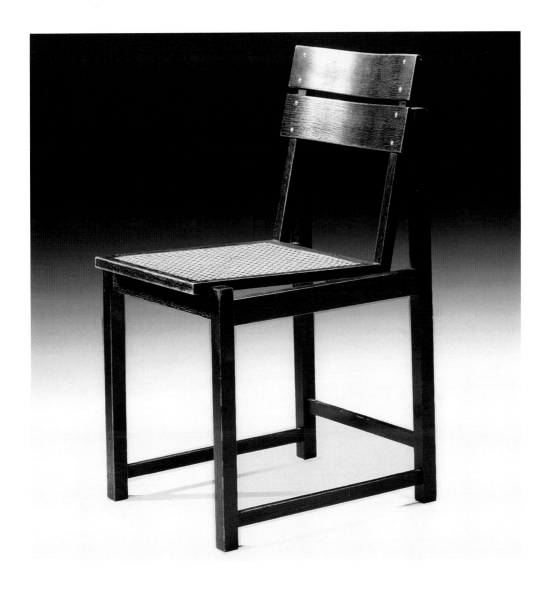

Albers, Josef (attributed)

Occasional table for Wassily Kandinsky, *c. 1933*

This is a fairly high-status piece of modernist furniture, recalling the pieces of Ludwig Mies van der Rohe perhaps even more than the furniture of Marcel Breuer. It combines traditional material and technique in the thick wood marquetry top, with a modern material, tubular steel, for the frame. The upward curves of the base are pleasing aesthetically, giving a feeling of lightness to the table.

Albers had been a student in the carpentry workshop at Weimar and liaised closely with the furniture makers while head of the workshop on the preliminary course. Along with Breuer, he was one of those most instrumental in changing the focus of the workshop away from 'expressive' craft-oriented pieces towards simply, rationally designed, geometric pieces intended for mass production.

In 1928 and 1929 Albers was head of the furniture workshop at Dessau after Marcel Breuer's departure. The careful investigation of form, combined with a certain impersonality, is also a characteristic of Albers's work in glass and in oil on canvas. This fits well with Breuer's statement of 1927 that furnishings should not be a 'self-portrait' of their maker. Albers and Kandinsky continued to be friends after they had both left the Bauhaus.

MEDIUM

Marquetry top and nickel-plated steel frame

SIMILAR WORKS

Marcel Breuer, B27 occasional table for Thonet, 1928

Josef Albers *Born* 1888 Bottrop, Ruhr, Germany

Died 1976

Stölzl, Gunta
Design for a tapestry, 1927

Courtesy of Victoria and Albert Museum, 2005/© Estate of Gunta Stölzl

This exuberant, experimental composition recalls Stölzl's Gobelin wall hanging of the same time (see page 174) and is possibly a preliminary design for it. The variety of forms and colours and clashing patterns suggests Stölzl is more concerned with richness of texture and colour here – with absorption in a creative craft process involving the hand loom, rather than the calm rationality and ordered geometry of her pieces for the jacquard loom, for which the weaving was programmed using punched cards.

She recalled that in developing a visual vocabulary for modern weaving, she felt that the Bauhaus weavers were in a whirling chaos with no prior reference points. That feeling is evoked here. Stölzl wrote disparagingly of early Bauhaus textiles as 'poems laden with ideas', burdened with an 'autocratic' richness of colour and form that did not 'subordinate itself' to the overall design of the home. That might be also said be said of this vibrant design, although not in a derogatory way. Like the realized Gobelin design, this piece suggests a landscape, in this case a fertile, flowering valley.

MEDIUM

Gouache on paper

SIMILAR WORKS

Gunta Stölzl, Gobelin wall hanging, 1926–27

Gunta Stölzl *Born* 1897 Munich, Germany

Died 1983

Albers, Anni

Wall hanging, 1927

This is one of Albers' most austere and simple compositions. The chequerboard design, in which the insertion of rectangles combats the tendency towards over-repetition and symmetry, would have been seen as suited to the context of industrial production in its evocation of rationality and geometry. The forms would be seen as expressing the construction of the piece itself. It also perhaps shows the continuing influence of pre-Columbian Andean textiles in Albers' work. Albers was fascinated by the chequerboard patterns of these textiles in the early 1920s. They connoted a primal 'authenticity' and seemed to show a universal tendency towards abstraction. They seemed to demonstrate the validity of the principle that the weaving process itself could aid in generating new visual forms.

Writing later, Albers was keen to stress that textile wall hangings should be seen not as decorations on walls, but as 'architectural elements' in their own right, 'a counterpart to soild walls'. The composition shown here has an architectural weight and solidity to it. Albers, with her husband Josef, fled the Nazis in 1933, emigrating to America. Anni recorded that she felt her textile designs were her 'passport to America' and she enjoyed success there, donating this piece to the Museum of Modern Art in New York. A number of other weavers were less fortunate, at least two former weaving students dying in the concentration camps.

MEDIUM

Cotton and silk

Anni Albers *Born* 1899 Berlin, Germany

Died 1994

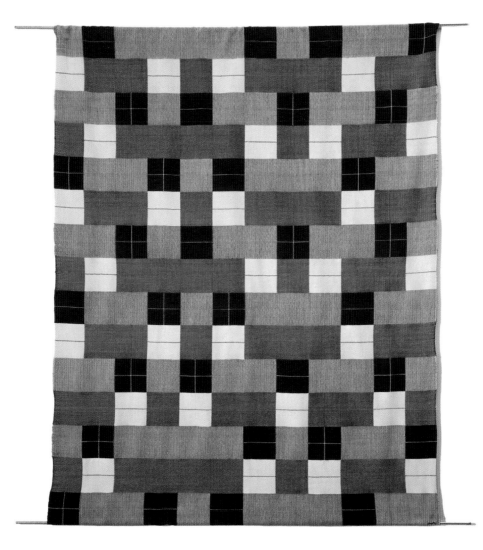

Bayer, Herbert

Design for a cinema, 1924

This is one of a number of drawings that Bayer made in 1924, afer finishing his studies and before becoming a Master. They include telephone kiosks and newspaper stands. Bayer was interested in how sound, colour and space could unite in the modern media to impact on the senses of the consumer. He was influenced, as here, by the architectural ideas of *De Stijl* in his bold use of primary colours and simple box shapes.

Bayer has used every device here to construct a powerful visual and auditory experience. The long, narrow, box-shape of the cinema ensures that the eye has no distraction from the screen. The colour of the walls changes from yellow through orange to deep red the closer one gets to the screen, in order to maximize one's focus on the bright moving image, and the floor likewise changes tone from light grey to dark grey. The reception area, accessed by revolving doors, is very small – one would have little opportunity to prepare oneself before experiencing the cinema's impact. The influences of Constructivism and Dada are also felt here in the inclusion of photo-collage elements in the design to convey the immediate character of the modern experience.

MEDIUM

Architectural design

SIMILAR WORKS

Walter Gropius, drawing of houses on the Torten estate, 1930

Herbert Bayer *Born* 1900 Haag, Austria

Died 1985

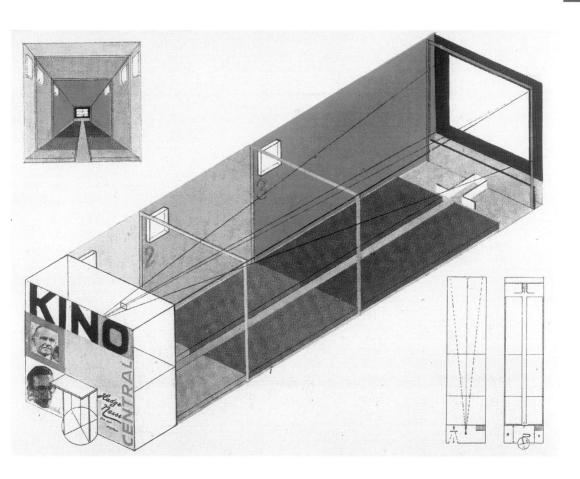

Gropius, Walter & assistants

Gropius's Office at the Bauhaus, Weimar, *c.* 1923

Gropius's draughtsmanship skills were notoriously poor – the original drawing for his office was no doubt done by one of his assistants. The image shows the Gropius' office at Weimar as a three-dimensional sculptural/architectural composition. It is organized on a rational grid structure, by which means any item can be positioned and measured. The lighting in the centre, on three axes, emphasizes this fact. The heavy furniture has similarities with Gropius's architecture, so that this could almost be a plan for a complex of buildings. The colours of the furniture indicate the different zones of the office. Thhe public zone for receiving guests is indicated by the light yellow armchairs. A more personal, intimate space is indicated by the brown furniture, designed for holding magazines. He would be able to turn the armchair by the desk to face either space. The desk appropriately straddles these zones, while the grey zone of shelving may be intended for files. The axonometric drawing used here was especially favoured by modernists. For the Constructivists and *De Stijl*, an aerial view of dynamic diagonals suggested the power to imagine and construct new forms amid an ever-changing modernity. Moreover, although this is a way of conveying three dimensions by using two, this is not the imprisoning perspectival box invented during the Renaissance, where the lines converge towards a vanishing point. The lines in the axonometric view will never converge; hence they suggest the infinite space of Utopian possibility.

MEDIUM

Colour lithograph

SIMILAR WORKS

Herbert Bayer, design for cinema, 1924

Walter Gropius *Born* 1883 Berlin, Germany

Died 1969

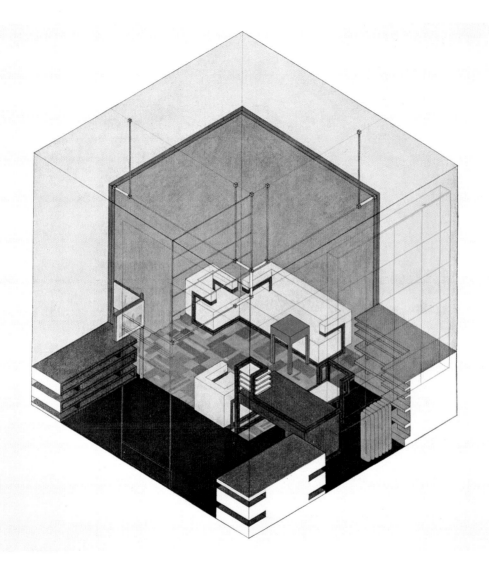

Dieckmann, Erich

Various architectural periodicals and design catalogues, 1930–31

Courtesy of Christie's Images Ltd/© Estate of Erich Dieckmann

By the early 1930s, modernism had gained widespread acceptance in German society, helped by the impact of the 1927 Weissenhof exhibition in Stuttgart and the perceived success of the mass housing developments in Torten-Dessau, Frankfurt and elsewhere. There was even some praise for modernist design and architecture in the Nazi organ *Volkische Beobachter* in the late 1920s, but in 1930–31 the Nazi party began to promote a return to the soil, to a traditional, racially 'pure' German peasant culture, which sat ill with the modernist concern with the urban environment.

Die Form (top left) was a periodical published by the *Deutsche Werkbund* and was devoted to promoting the new architecture. The cover shows the interior of Mies van der Rohe's Villa Tugendhat in Brno, with one of his 'Weissenhof' armchairs. The cover of *Das Neue Frankfurt* (top right) celebrates five years of housing construction in that city, under Ernst May. Ex-Bauhaus student Erich Dieckmann's furniture is advertised in the catalogue at bottom left, which shows that he was by now designing in the popular materials of tubular steel and cane. The Thonet catalogue (bottom right) features ex-Bauhaus teacher Marcel Breuer's furniture, including, here, designs for the office of the modern businessman and his apparently closely attentive secretary.

MEDIUM

Printed books

Erich Dieckmann *Born* 1896 Kauernik, West Prussia (now Kurzetnik, Poland)

Died 1944

DIE FORM

ZEITSCHRIFT FÜR GESTALTENDE ARBEIT
6. JAHR

HEFT 9

15. SEPTEMBER 1931

VERLAG HERMANN RECKENDORF G.M.B.H. BERLIN SW 68

VERLAG ENGLERT UND SCHLOSSER IN FRANKFURT AM MAIN

ERSTER TEIL ERSTER TEIL ERSTER TEIL
ERSTER TEIL ERSTER TEIL ERSTER TEIL
ERSTER TEIL ERSTER TEIL ERSTER TEIL
ERSTER TEIL ERSTER TEIL ERSTER TEIL

23

DAS N
INTERNATIONALE MON

1926 1927 1928

F
WOHN

VERLAG ENGLERT UND SCHLOSSER IN FRANKFURT AM MAIN

45

DAS NEUE FRANKFURT

INTERNATIONALE MONATSSCHRIFT FÜR DIE PROBLEME KULTURELLER NEUGESTALTUNG

1926 1927 1928 1929

FÜNF JAHRE

WOHNUNGSBAU IN FRANKFURT A. M.

ERICH DIECKMANN

MÖBELBAU

HOLZ · ROHR · STAHL

DIE BAUBÜCHER BAND II

JULIUS HOFFMANN VERLAG STUTTGART

THONET

STAHLROHR
MÖBEL

THONET
STAHLROHRMÖBEL

Ehrlich, Franz

Bauhaus Party postcard, 1930

Courtesy of Sotheby's/akg-images/© Estate of Franz Ehrlich

Bauhaus parties were famous for their elaborate themes, staging and costumes, combined with a riotous sense of fun. The previous year had seen a Metallic Party, with staff and students dressed in metallic costumes. 1930 was an unsettled year. The marxist Hannes Meyer had been forced to resign as Director and Mies van der Rohe, seen as a safe, conservative figure, was appointed in his place. The party of 1930 was notable for protests by students and the singing of communist songs

The tone of this invitation card, which is characteristically playful, belies the austere *De Stijl*-influenced design. Instead of actual images, the words and their ordering create images, like a Futurist poem/layout. There is a playful tension between the physical and potentially anarchic nature of the activities promoted – some (running, boxing, huffing and puffing, lazing about) more plausible than others (buck shooting) – and the orderliness of the invitees' expected attire: they are to be well-turned out with neatly pressed clothes, and to be powdered and made up (including, presumably, the men). The neat layout of the words – in two lists - contrasts with the images they evoke in the first list and absurdly mimics it in the second.

CREATED

Dessau

MEDIUM

Graphic art

SIMILAR WORKS

Theo Ballmer, *Arbeit, c.* 1929

Franz Ehrlich *Born* 1907 Germany

Died 1984

rennend
boxend
radelnd
pustend
schnaufend
grillen treibend
fliegen fangend
böcke schießend
hoffend
harrend

**so verbringt ihr
eure kurzen tage
bis zum**

auhaus fest

ge malt
ge scheckt
ge fleckt
ge putzt
ge schniegelt
ge bügelt
ge pudert
ge schminkt

wir erwarten sie **am 1. märz**

Bayer, Herbert

Advertisement for architecture slide lecture by Hans Poelzig, 1926

Courtesy of © 2005, Digital image, The Museum of Modern Art, New York/Scala, Florence/© DACS 2005

Bayer's graphic design was ubiquitous at the Dessau Bauhaus. He had key responsibility for developing the school's corporate profile. The dependence of this design on a strong grid structure and the use of geometric elements floating in space recalls the Dutch *De Stijl* group. Bayer has highlighted the key information here using large black lettering, in a slogan-like way. Red and black horizontal bars provide additional emphasis. Perhaps the red circle is meant to evoke the beam of the slide projector – it would not have been surprising, given his design for a cinema.

Hans Poelzig (1869–1936) was fourteen years older than Walter Gropius, of the same generation as Peter Behrens – that is, the pre-war *Deustcher Werkbund* generation that continued to influence German modernist ideas in the 1920s. He was enlisted by Gropius as one of the Friends of the Bauhaus and participated with Gropius, Behrens and other modernist architects in designing buildings for the Weissenhof estate, Stuttgart, in 1927.

CREATED

Dessau

MEDIUM

Graphic art

SIMILAR WORKS

Herbert Bayer, poster for exhibition celebrating Kandisnky's 60th birthday, 1926

Herbert Bayer *Born* 1900 Haag, Austria

Died 1985

ARCHITEKTUR

LICHTBILDER

VORTRAG

PROFESSOR HANS

POELZIG BERLIN

FREITAG

26.

FEBRUAR

ABDS. 8H IN DER AULA DES

FRIEDRICH - GYMNASIUM

KARTEN VORVERKAUF BEI:
ALLNER ● OLBERG ● RAUCH

DER KREIS
DER FREUNDE
DES BAUHAUSES

László Moholy-Nagy

Photogram, c. 1923

Moholy-Nagy made his 'photograms' from the early 1920s onwards by placing ordinary objects on a light-sensitive plate or paper and developing the results. Similar techniques had been around since the earliest days of photography, and fellow avant-gardists like the the Dadaist Christian Schad (1894–1982) and the Surrealist Man Ray (1890–1976) were conducting parallel experiments in the early 1920s. But in the spirit of the new unity of art and technology, it was useful to show that artists, like scientists, could produce technical inventions, and the photogram was heralded as such.

Moholy's use of the photogram was intended to liberate everyday forms from their usual associations and to create 'pure' painting with light. It is usually difficult to tell what original objects were used. This is a world of shape-shifting and continual movement. The Constructivists thought that new work should be developed out of an investigation of the material properties of the media employed, without reference to the artist's subjectivity, 'literary' narrative or traditional representation. As such, like all Constructivist projects, they were suited, as Moholy wrote, to 'the new world of the masses' which 'needs fundamentals without deceit'.

CREATED

Weimar

MEDIUM

Unique toned gelatin silver print

SIMILAR WORKS

El Lissitzky, study for *Proun RVN 2*, 1923

László Moholy-Nagy *Born* 1895 Bacsborsod, Hungary

Died 1946

Schmidt, Joost

Wood and Plaster, 1932

Courtesy of Christie's Images Ltd/© Estate of Joost Schmidt

This dream-like image, where a headless figure contemplates mysterious geometric solids, carries more than a hint of Surrealism. The compositions of Giorgio de Chirico (1888–1978), which were a major source for the Surrealists, are recalled here in particular. Herbert Bayer was another, younger Bauhaus Master who turned towards Surrealism in the late 1920s. The idealised female figure is also reminiscent of the fashion mannequins in the image by Otto Umbehr in this book (see page 76).

Schmidt had made abstract reliefs in stucco for the vestibule of the former Art Academy at Weimar for the 1923 Bauhaus exhibition. The Bauhaus visual vocabulary is evident in the geometricized forms shown in this image, which here, however tend to acquire irrational rather than strictly rational associations. The new environment of pure forms envisaged at the Bauhaus also anticipated a new, improved type of human being. Oskar Schlemmer's plays and sculptural works showed a satirical awareness of the fragility and artificiality of such an enterprise. The title of this image perhaps evokes something similar.

CREATED

Dessau

MEDIUM

Gelatin silver print

SIMILAR WORKS

Otto Umbehr, *The Newest Offer in Profile*, 1928

Joost Schmidt *Born* 1893 Wunstorf, Hanover, Germany

Died 1948

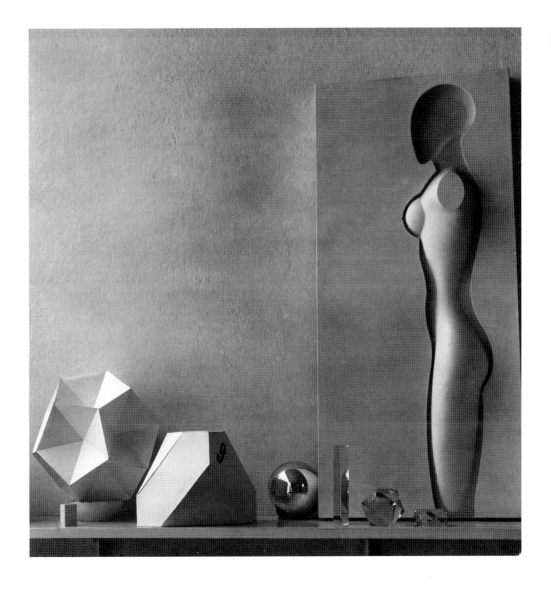

Schlemmer, Oskar

Grotesque (Abstract Figure), 1923

This is a bronze version of the sculpture executed in nutwood for the 1923 Bauhaus exhibition, dubbed 'Grotesque' by the artist himself. The head and breast/belly are joined in a sweeping curve which makes the figure resemble a treble clef, a motif also seen in Herbert Bayer's *Sheet Music* of 1921 (see page 362). Analogies between music and art were a perennial theme of Bauhaus formal investigations.

A little mouth marks where the curves join and divide. The eye was originally an ivory disc with a metal button, increasing the ludicrous effect, and the whole figure could swivel on the large single foot. It was presumably intended to form an absurd Dada-surreal counterpoint to the more dignified abstract figure above, an idealized man-machine hybrid in the approved modernist mould. The first is in effect just a profile, the latter is organized frontally.

Schlemmer's idealism and seriousness co-existed with a certain irony and humour. The irony comes from a sense of the distance between human physical limitations and the artificial ideal sought in art and the world of technology.

CREATED

Weimar

MEDIUM

Bronze

SIMILAR WORKS

Oskar Schlemmer, *Relief H*, 1919

Herbert Bayer, *Sheet Music*, 1921

Oskar Schlemmer *Born* 1888 Stuttgart, Germany

Died 1943

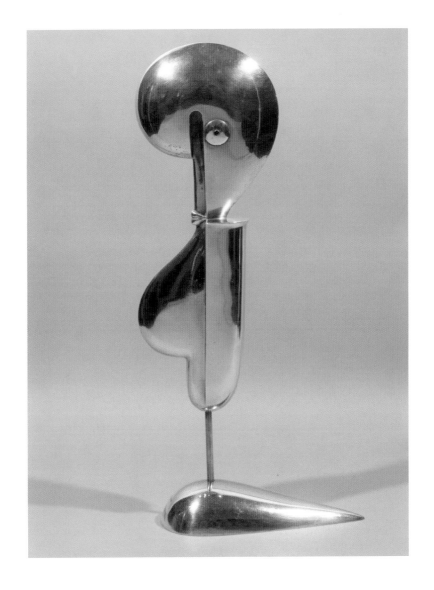

Schlemmer, Oskar

Ornamentale Plastik, 1919

This piece, made the year before Schlemmer joined the Bauhaus, recalls pre-First World War Cubist sculpture in the way it appears to assemble different objects seen from different angles. There are flutings like those of classical columns or organ pipes, but also what may be one end of a mechanical cylindrical form, like a print roller (centre left). With its uniform colour, free-standing status and attempt to balance and synthesize different elements, the piece aspires to the dignity of a piece of classical sculpture. This aspiration, however, is stymied by the forms that emerge from top and bottom, which appear to be part-phallus, part-worm, part-ship's ventilation funnel. There is also something absurdly ornamental about the flutings, which suggests that the title is ironic.

Schlemmer's interest in the combination of organic and mechanical characteristics anticipates his theatrical and painterly evocations of machine-beings at the Bauhaus. Both here and later on in Schlemmer's work there is an implicit awareness of the tension between the quest for perfection through technology and art and the imperfections of human bodies. Here the influence of Dada is evident, in the suspicion that the ordering project of 'art' masks the chaos of desire — yet an attempt is made to achieve this order just the same.

This appears to be a free-standing plaster version of Schlemmer's *Ornamental Sculpture on a Divided Frame*, rediscovered in 1975 in Holland, which was multi-coloured and attached to a wooden panel.

SIMILAR WORKS

Oskar Schlemmer, *Grotesque (Abstract Figure)*, 1923

Oskar Schlemmer *Born* 1888 Stuttgart, Germany

Died 1943

Schlemmer, Oskar

Relief H, 1919

As we have seen with the invitation card of 1923 and with the *Grotesque*, the profile is a frequent motif in Schlemmer's work. It accentuates the generic features of the human form and thus is associated with idealization and removal of the accidental. Here, the curve below the mouth could be read as a chin, but also perhaps as a female breast, with the curves of belly and hip below. These curves emphasize the human form against the surrounding rectilinear structures. Schlemmer did only a few free-standing sculptures – he was more interested in reliefs and in wall paintings. On the other hand, his theatre pieces, such as *Triadic Ballet* (1922) are experiments in moving sculpture.

The interlocking of figure and space represents the continuing influence of pre-war Cubism in its destruction of conventional illusionism and focus on the qualities of the artwork itself, playing on the tension between flatness and the viewer's desire to construct a viable fictional space in their perception of the work. Yet we also see here the postwar 'return to order' in the way the originally disruptive modernist language of Cubism is calmed down and classicized with a uniform colour and balanced composition. Schlemmer's previous reliefs had been multi-coloured. The following year he was invited to teach at the Bauhaus, where among other duties he taught in the sculpture workshop.

MEDIUM

Polished plaster relief finished with chalk paint

SIMILAR WORKS

Oskar Schlemmer, invitation card to Bauhaus Exhibiton, Weimar, 1923

Oskar Schlemmer *Born* 1888 Stuttgart, Germany

Died 1943

Albers, Josef

Factory, 1926

Courtesy of © Photo CNAC/MNAM Dist. RMN – © Georges Meguerditchian/© The Josef and Anni Albers Foundation/VG Bild-Kunst, Bonn and DACS, London 2005

In this work, presumably a design for a work in sandblasted glass (see page 34), Albers has evoked the tall forms of a factory – its buildings, windows and chimneys – and has associated them with the simple, harmonious forms produced by his labours and those of others, using industrial tools and techniques to work the glass. It is suggested that the long vertical and horizontal bars, the grid and the chequerboard are the forms best suited to the rationality, standardization and repetition of machine production. These forms not only suggest architecture, but carpentry – Albers studied and taught carpentry at the Bauhaus and indeed, produced furniture.

However, there is a closer parallel with the designs of Anni Albers and Gunta Stölzl for the weaving workshop. In the context of weaving, however, there was a correlation between the form used and the technique employed – the regular criss-cross pattern of weaving on a jacquard loom. It is arguable whether there exists such a correlation between form and material in Albers' designs for glass.

MEDIUM

Gouache and crayon on paper

SIMILAR WORKS

Anni Albers, design for Smyrna rug, 1925

Gunta Stölzl, design for a jacquard-woven wall hanging, 1928–29

Josef Albers *Born* 1888 in Bottrop, Ruhr, Germany

Died 1976

Albers, Josef

Variation – White, Grey, Yellow, Orange, 1948

In 1933, the year that the Nazis shut down the Bauhaus for good, Josef and Anni Albers emigrated to the USA, where Josef had been asked to teach the visual arts at the newly established Black Mountain College in North Carolina. His teaching hugely influenced modern American art. To American critics in the 1960s, Albers's paintings from the late 1940s onwards served as models of how painting should only investigate its own means and properties, refusing all 'literary' association. However, their hard-edged, somewhat impersonal qualities were also seen as a useful antidote to the emotionality and painterliness of the works of American Abstract Expressionists like Jackson Pollock, Robert Motherwell, Mark Rothko and Willem de Kooning.

Unusually, Albers'compositions were built up concentrically around one square. This is one of the rarer two-centre paintings, which manifests qualities of careful balance, colouristic delicacy, lack of size and apparent lack of egotism, appropriate to its status as merely one in a series of careful and limited investigations. Albers' concept of the individual was also very different to the bombastic and overblown Romanticism of Pollock. He said 'I've handled colour as man should behave.' In other words, colours, like people, should strike a balance between 'self-realisation and the realisation of relationships with others.' In this he maintains the Utopian social concerns of pre-war European modernism, so different from the rather narrow formal concerns of postwar American abstract artists, in spite of the great size of their canvases.

MEDIUM

Oil on canvas

Josef Albers *Born* 1888 Bottrop, Ruhr, Germany

Died 1976

Albers, Josef

Study for Homage to the Square, 1956

In 1950, Josef Albers exchanged the radical avant-garde atmosphere of Black Mountain College for a new post at Yale University, in the heart of the American educational establishment. In the same year he produced the first of hundreds of homages to the square. Squares within squares were used as a basis for exercises in the use of colour at the Bauhaus, for example on the Preliminary Course which Albers took and later taught, and on Kandinsky's Colour Course. Albers's own teaching on colour at Black Mountain involved a similar use of squares. He often claimed that the square was a neutral form, a dish on which colour could be served, or a stage on which colours could perform like actors. This is not the mystical, primordial form of Malevich and El Lissitzky. But the square has a range of associations, including rationality, planning and calculation, which the Bauhaus itself helped to inculcate.

Albers applied paint as thinly and as evenly as possible, eschewing the 'expressive' painterliness seen in the work of American Abstract Expressionists. Pink plays a key role here, modifying the impact of the red but creating quite a harsh contrast with the royal blue. With its connotations of femininity and commercial kitsch, it was a colour avoided by macho American modernists.

CREATED

New Haven, Connecticut, USA

MEDIUM

Oil on masonite

Josef Albers *Born* 1888 Bottrop, Ruhr, Germany

Died 1976

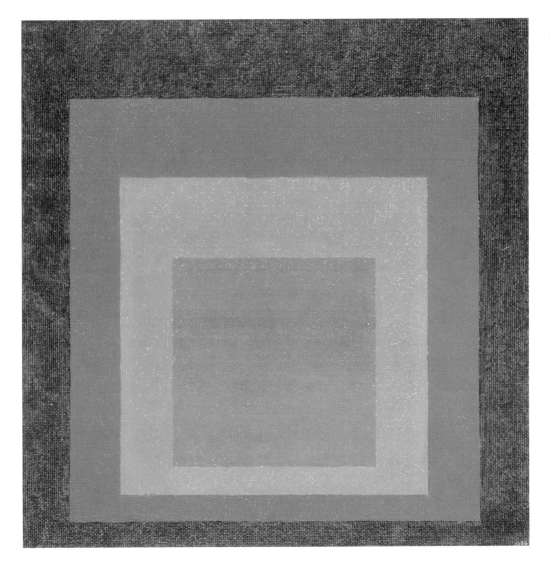

Albers, Josef

Homage to a Square: Intersecting, 1959

This murky composition of brown and blue is of course an exercise in the juxtaposition and intermingling, the advance and recession, of cool and warm colours. The choice of colours might also connote introspection and melancholy (a brown study, feeling blue, for example) as in a canvas by Mark Rothko, but the blue of the innermost square is a fairly light blue. Although a quietly insistent presence, its muted character means that it does not advance as confidently as its brighter cousins in other pictures in the series. It is only 'a' square, not 'the' square, as in the titles of other compositions. Wassily Kandinsky thought blue retreated into itself 'like a snail', while brown is 'unemotional, disinclined to movement'.

To further diminish the focus on the compositional core, the outer square has been divided into rectangles of varying shades of brown, creating a certain disruptive effect which is presumably referred to in the 'intersecting' of the title. A solemn, symmetrical and even perspectival effect is created here. In its recollection of a ritualistic space or passage, this type of composition was appropriate to the notion of a homage or meditation and hence was the typical format for this series. The innermost square in many of Albers' compositions has a tendency to advance, processing forward in order to receive our 'homage'. The anthropomorphism of this analysis would not necessarily be strange to Albers, given that he saw the relationships between colours as paralleling relationships between people.

MEDIUM

Oil on board

Josef Albers *Born* 1888 Bottrop, Ruhr, Germany

Died 1976

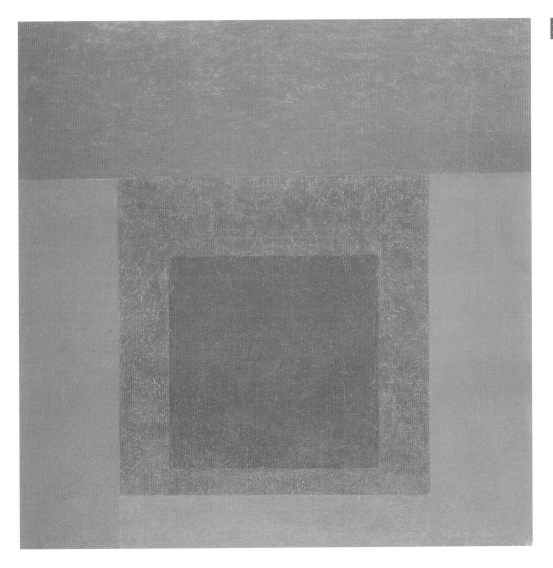

Moholy-Nagy, László

K VII, 1922

This painting was exhibited at the Bauhaus in 1923. The 'K' stands for 'construction', suggesting that this painting does not provide a fictional space, a means of escape into another world, but is itself a material construction that exists in the real world. However, it is also a two-dimensional conceptualization of something that must ultimately be realized in three dimensions, and hence represents an imagined future.

In the spirit of Constructivism, Moholy-Nagy's aim was not to make traditional easel paintings, but to visualize new forms that could be developed through industrial production into a lived environment for the masses. These clean, pure, geometric forms of the future are subject to repetition in this image, as they would be in mass production. Gone is the special status of the artist as the producer of unique artworks.

But there is also perhaps a Romantic wish for transcendence of the material world in the depiction of semi-transparent planes, which suggest the weightlessness and immateriality of architecture in glass, the ultimate modernist material.

MEDIUM

Oil on canvas

SIMILAR WORKS

El Lissitzky, study for *Proun RVN 2*, 1923

László Moholy-Nagy *Born* 1895 Bacsborsod, Hungary

Died 1946

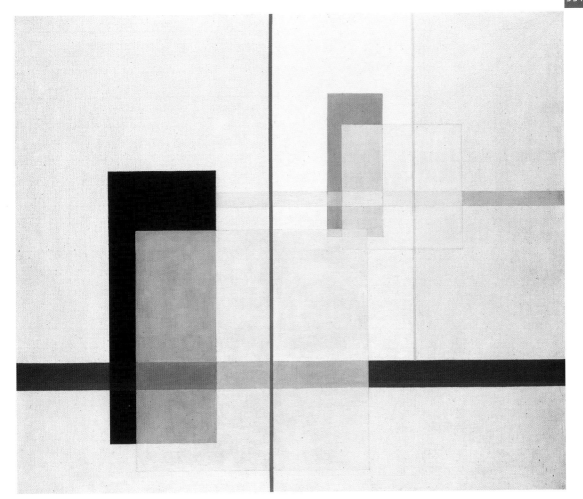

Moholy-Nagy, László

Constructions – Kestnermappe 6, 1922–23

Lithography was yet another new medium at this time for the experimentally-minded Moholy, who arrived at the Bauhaus in 1923. The prints in the *Kestnermappe* folder show a typically Constructivist approach. They are not intended to be 'artworks' in the traditional sense, but are experiments in the development of new forms, appropriate to the social and technological revolutions of the modern world. They resemble the 'prouns' of the Russian artist-designer El Lissitzky, who was an important influence on Moholy-Nagy. 'Prouns' were conceived of as dynamic diagonal forms that occupied a mid-way point between two-dimensional artwork and their three-dimensional material realization. The drifting, crossing, overlapping shapes additionally recall the quasi-mystical aspects of the Suprematism of Malevich, which influenced Lissitzky. They evoke transcendence and infinite space – but in so doing they also reminded the viewer of exciting aspects of modernity, like aeroplane flight.

The forms here are repeated within the same composition, making it clear that they can be mechanically reproduced and are not the precious, unique works of the of the old-fashioned 'genius' artist, scorned by Moholy-Nagy. Indeed a ruler has been employed here, as in industrial drawings, in contrast to the quirky subjectivity conveyed by the freehand drawings of, for example, Paul Klee.

MEDIUM

Lithograph

SIMILAR WORKS

El Lissitzky, study for *Proun RVN 2*, 1923

László Moholy-Nagy *Born* 1895 Bacsborsod, Hungary

Died 1946

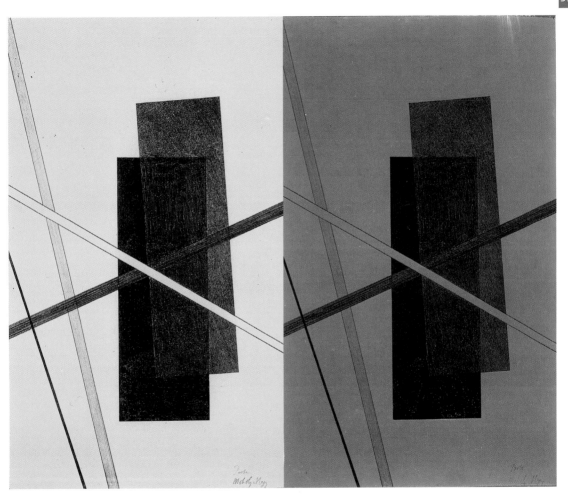

Moholy-Nagy, László

Composition XX, 1924

This composition has strong perspectival elements and seems to be on the edge of a transformation into architectural, three-dimensional form, perhaps in the form of the futuristic glass architecture that so interested Moholy-Nagy. The circle is duplicated here, suggesting that this vison of Utopian future forms is also a vision founded on the materiality of mass production.

The circle with a cross superimposed is a motif from Russian avant-garde art, specifically the Suprematism of Malevich and El Lissitzky, which became absorbed into the vocabulary of Constructivism. These Russian artists had wanted to start from zero, evolving a vocabulary of pure geometric forms in order to bring a new world into being. Yet the mystical-spiritual connotations of these shapes – not only the cross, but the circle, which can represent eternity – are unavoidable and suggest that the new world is based on spiritual as well as material transformation. Moholy-Nagy would no doubt have rejected any mystical association, but he advertised his affinity for these conjoined forms by appearing at a Bauhaus party on at least one occasion as a circle with a cross through it.

CREATED

Weimar

MEDIUM

Oil on canvas

SIMILAR WORKS

El Lissitzky, study for *Proun RVN 2*, 1923

László Moholy-Nagy *Born* 1895 Bacsborsod, Hungary

Died 1946

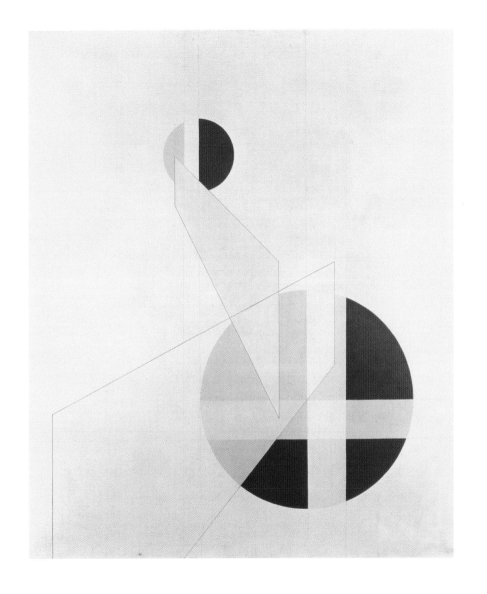

Moholy-Nagy, László

Composition (Self Portrait), 1926

Courtesy of Haags Gemeentemuseum, The Hague, Netherlands/Bridgeman Art Library/© DACS 2005

This work subverts the conventions of the artistic self-portrait, with its connotations of genius and unique individuality. A wooden frame, inside which one would expect to find the self-portrait, has been placed over a photogram, an abstract composition made by developing a photosensitive plate or paper over which everyday objects have been placed. Moholy-Nagy thought of this technique as painting with light, utilizing modern technology to replace traditional painting, with its brushwork and personal 'manner'.

He has therefore apparently erased himself, the individual artist, from the work. Inside the frame, abstract forms take the artist's place. The oval shape, however, possibly evokes his ghostly presence. On other occasions Moholy-Nagy experimented by pressing part of his face against the light-sensitive surface. There is a Constructivist concern here with movement and geometrical purity. The thin diagonal streak of light, which cuts across the entire image, works together with the collaged rectangular strip and the repeated circular elements, to suggest that this new machine-age Utopian space extends not only beyond the traditional wooden frame, but beyond the picture plane itself.

CREATED

Dessau

MEDIUM

Photogram with wooden frame and collage elements

SIMILAR WORKS

László Moholy-Nagy, photogram, *c.* 1923

László Moholy-Nagy *Born* 1895 Bacsborsod, Hungary

Died 1946

Feininger, Lyonel

Süssenborn, 1923

Courtesy of Christie's Images/© DACS 2005

Feininger loved the quiet atmosphere of Weimar and the surrounding Thuringian towns and villages. His paintings of churches in villages express the qualities of organic harmony and tranquillity which he believed underlaid medieval society. This society had united artists and craftspeople to produce the ecclesiastical building, a type of the *gesamtkunstwerk*, or total work of art, which was the ultimate objective of the idealistic, craft-oriented early Bauhaus. Feininger designed the woodcut of the cathedral which forms the frontispiece to the first Bauhaus manifesto. Here the cupola atop the spire of the little church at Süssenborn, near Weimar, is seen here over the steep gables and roofs of nearby houses of the village whose name means, rather idyllically, 'sweet spring'.

Feininger, a German-American, had joined the radical Expressionist *Novembergruppe* during the German revolutionary crisis of 1918. Although influenced by Cubism and Expressionism, Feininger became increasingly interested in the more traditional pictorial qualities of atmosphere and perspective which he found in the work of the early nineteenth century English artist, J. M. W. Turner. He had no sympathy with the technological orientation of the Bauhaus after 1922 and agreed to move to industrial Dessau only on condition that he gave up teaching.

MEDIUM

Oil on canvas

Lyonel Feininger *Born* 1871 New York, USA

Died 1956

Lyonel Feininger
Wolke II ('Cloud II'), 1925

Courtesy of Christie's Images Ltd/© DACS 2005

With its lonely figure on the seashore, this painting clearly recalls the painting *Monk by the Sea*, by the German Romantic painter Caspar David Friedrich (1774–1840). The sea for Friedrich was a symbol of infinity, as it seems to be here for Feininger, who began a series of annual visits to the Pomeranian Baltic coast in the summer of 1924. The artist for Friedrich resembled an unworldly monk, engaged in a spiritual quest. The painting evokes the sublime, which in German Romantic thought represented the vastness of the cosmos, something beyond the human scale which enlarged the artistic imagination. We look out over what is apparently a bay. A small island is dwarfed by cliffs behind, whose shapes are echoed by even larger clouds. Unsettlingly, there appears to be a double source of illumination, which could be a representation of the sun's rays being divided by the clouds. In the Friedrich painting, too, clouds ominously obscure the view of the infinite. The various planes here resemble broken and overlapping sheets of coloured glass. Glass was celebrated by modernists, and particularly the Bauhaus, as a material which could be employed in architecture to create a transcendent, dematerialized Utopian environment – yet here we only see confusing and ambiguous refractions.

CREATED

Weimar/Dessau

MEDIUM

Oil on canvas

SIMILAR WORKS

Lyonel Feininger, *Sailboats*, 1929

Lyonel Feininger *Born* 1871 New York, USA

Died 1956

Feininger, Lyonel

Gelmeroda IX, 1926

Courtesy of Museum Folkwang, Essen, Germany/Bridgeman Art Library/© DACS 2005

This work is one of a series of compositions celebrating the architecture of the Gothic churches of the villages of Thuringia. Feininger first sketched the church on his first visit to the Weimar area in 1906. He produced thirteen paintings of the church between 1913 and 1936, more than any other subject. Although in reality quite a modest church, in this picture it has the majesty of the Cathedral of Socialism in Feininger's woodcut for the Bauhaus manifesto of 1919.

For Feininger, in the tradition of the German Romantics and of William Morris, the medieval church or cathedral represented the union of the arts and crafts, a building which would spiritually enhance the lives of the community, here referenced by the flanking houses in the square. The church appears sublime, brooding and otherworldly, its spire uniting earth and heaven (unfortunately the spire was not medieval, but only added in 1830). Feininger believed that the laws of architectural composition reflected the harmonies of the cosmos. The figures of monks in the foreground are merely notes on this cosmic scale, their singing a part of the music which the entire painting attempts to embody. The shifting planes of the compositional space evoke a clearly delineated universal geometry which is not affected by earthly gravity.

CREATED

Dessau

MEDIUM

Oil on canvas

SIMILAR WORKS

Lyonel Feininger, *Cathedral*, 1919

Lyonel Feininger *Born* 1871 New York

Died 1956

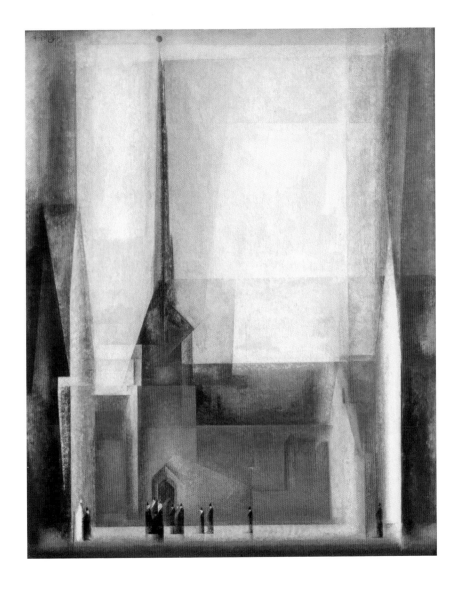

Feininger, Lyonel

Sailboats, 1929

This subject presumably derives from one of Feininger's annual visits after 1924 to the Baltic coast of Pomerania. The triangular shapes of the yachts are echoed in the shifting prisms of light that criss-cross the expanse of the sea. Far from being the lonely ships that the Romantic painter Caspar David Friedrich depicted along this coast, these are are fast modern yachts caught up in the excitement of a race, in a way that recalls the excitement and dynamism of Futurist painting.

An enthusiastic cyclist, in 1912 Feininger had depicted a bicycle race in the radical Cubist-influenced Futurist style which celebrated speed and modernity. As a child he loved to build and sail model boats and he returned repeatedly to this theme in the 1920s. Sailing vessels also form a significant reference point in the work of his colleagues Kandinsky and Klee, where they seem to stand, in Romantic fashion, for the lonely, questing human spirit in the cosmos. There is still a Bauhaus connection here between geometry and modernity. But the further link created here between the shapes of the yachts and a wider cosmic harmony belonged more to the Bauhaus of 1920 than to Hannes Meyer's Bauhaus of 1929.

CREATED

Dessau

MEDIUM

Oil on canvas

Lyonel Feininger *Born* 1871 New York, USA

Died 1956

Schlemmer, Oskar

Four Figures and a Cube, 1928

Courtesy of Staatsgalerie, Stuttgart, Germany/Bridgeman Art Library/© 2005 The Oskar Schlemmer Estate and
Archive, IT-28824 Oggebbio (VB), Italy. Photo Archive C. Raman Schlemmer

During his last year in Dessau, Schlemmer was commissioned to paint a cycle of murals for the fountain room of the Museum Folkwang in Essen. This is his first experimental panel for the project, but when it was placed in the small rotunda it overwhelmed Georg Minne's fountain, so the composition had to be adapted in subsequent panels. The overall theme was 'instruction', as befitted both the Essen museum and Schlemmer's own institution and vocation. Four androgynous figures, presumably students, face in four different directions, perhaps mirroring the sides of the form (not, in fact, a cube) behind them.

The geometric form, the object of their study, appears to be more solid than the students, who as they gravely process seem to partially dematerialize and to be gradually pulled into the force field of the form. Schlemmer always held that humans were by nature imperfect, and that the rational geometry of the machine, the central focus of the Bauhaus at Dessau, approximated to a superior and enduring world.

CREATED

Dessau

MEDIUM

Oil on canvas

SIMILAR WORKS

Oskar Schlemmer, Bauhaus stairway, 1932

Oskar Schlemmer *Born* 1888 Stuttgart, Germany

Died 1943

Schlemmer, Oskar

Encounter in a Room, 1928

This composition stands in marked contrast to *Four Figures and a Cube* on the previous page. In that image, students move inexorably and serenely towards the cube, the basic form, their destination. Here young women move quickly in opposed directions in a dark, confined space, in what is perhaps meant to be read as an image of suppressed hysteria. There is no collective goal, as in the previous composition, but only individual directions, not ideal if these figures represent Bauhaus students. Moreover, this is an 'encounter, not an orderly joint activity planned in advance.

Lotte Stam-Beese's photograph of the same year gives a much more positive image of the collective endeavour of the female weaving students. Schlemmer's own *Triadic Ballet* of 1922 used three figures to represent the new Utopian collectivity, in opposition to the static pair. But here the figures resemble in their mood the melancholic female figures in Schlemmer's painting *Bauhaus Stairway* of 1932, completed after he had left the school.

CREATED
Dessau

MEDIUM
Watercolour and pencil on paper mounted on cardboard

Oskar Schlemmer *Born* 1888 Stuttgart, Germany
Died 1943

Klee, Paul

Analysis of Several Perversities, 1922

Courtesy Musée National d'Art Moderne, Centre Pompidou, Paris, France, Lauros /Giraudon/Bridgeman Art Library/© DACS 2005

An abstract grid of delicate colour relationships is the basis of many of Klee's compositions from the Bauhaus period. Klee believed that art ought not to be an imitation of nature, but an independent, quasi-architectural construction that aims towards harmony and equilibrium in a manner paralleling that of nature. Here the incipient harmony seems to be put out of kilter by a pompous gentleman (a professor?) with absurd eyebrows and moustache. His yearnings for fulfilment have been sublimated into a grand machine that appears designed to measure the behaviour of the caged bird above, for whom, in his anxiety, he seems to have designed a net. An arrow, presumably representing a more direct form of his longing, shoots off uselessly into space. All this while, he refuses to attend to the prone figure, who may after all be the object of all this fuss. An arrow phallically extends from the loins of this neglected figure, who is nevertheless also associated with femininity through the vagina-like form next to the arrow and the large eye which echoes it. Klee's Freudian title hints at the multitude of forms – some constructive, others less so – that human desire may take in its search for spiritual wholeness.

CREATED

Weimar

MEDIUM

Pen and ink and watercolour on paper mounted on card

SIMILAR WORKS

Paul Klee, wall painting from the *Temple of Longing Thither*, 1922

Paul Klee *Born* 1879 Münchenbuchsee, near Berne, Switzerland

Died 1940

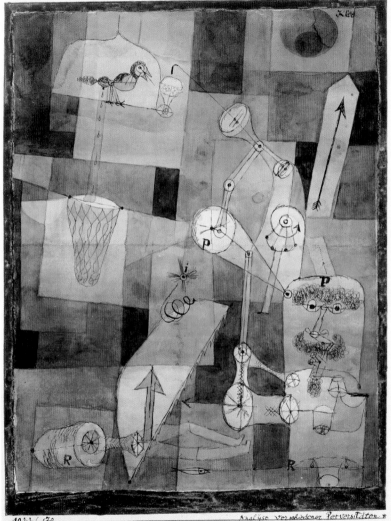

Analyse verschiedener Perversitäten E

Klee, Paul

Senecio, 1922

Courtesy of Kunstmuseum, Basel, Switzerland, Lauros / Giraudon/Bridgeman Art Library/© DACS 2005

This image, which bears some similarity to Klee's self-portrait drawings, seems to represent a man obsessed by his own thoughts, his eyes resembling slowly revolving propellers. The title combines associations of old age (the Latin *senex* means 'old man') with a slightly absurd youthful flourish (the 'io' recalling, perhaps, sprightly heroes of theatre or the opera, which Klee loved). Perhaps this is Klee's representation of that frequent middle-aged feeling of becoming obsolete while not being properly grown up. The rotating cerebral upper section contrasts with the naively smooth cheeks and prim little nose-mouth of the moon-face, unmarked by real experience.

This face can be compared and contrasted with the face of the new machine-man in Oskar Schlemmer's design for the Bauhaus seal of the same year, which recurs in his invitation card of 1923 and in Joost Schmidt's famous exhibition poster, among other products of these years. Klee has utilized a Cubist and primitivist (Ashanti sculpture) pictorial vocabulary in order to produce a personal image that evokes an individual, subjective mental state. Schlemmer uses a Cubist vocabulary to do the opposite: to create an impersonal, geometrically idealized and standardized face for the new human being of the machine age and for the Bauhaus itself.

MEDIUM

Oil on canvas

Paul Klee *Born* 1879 Münchenbuchsee, near Berne, Switzerland
Died 1940

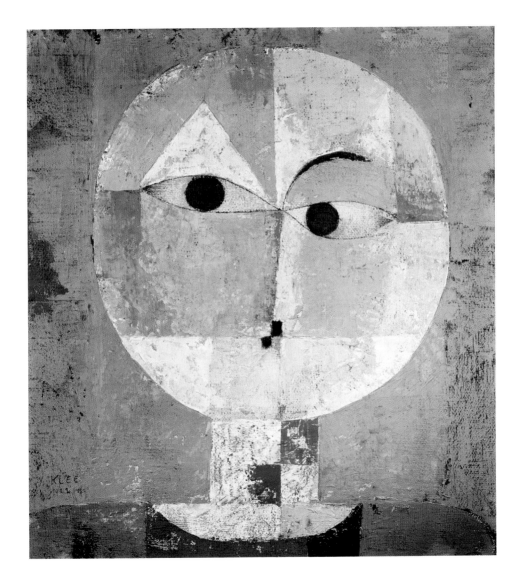

Klee, Paul

Garden with Birds, 1924

Here, a luxuriant midnight garden with birds amongst balconies or terraces seems to represent the creative space of art or the artist's imagination. Klee thought of art as a process of construction independent from nature, but imitating its organic processes of creation. However, the forms of architecture, which became so important for Klee at the Bauhaus as a metaphor and model of artistic creation, are not very prominent here.

This composition evokes a slightly more chaotic, playful and mysterious mood, with some structures and their attendant bird life represented upside down, and the vegetation growing here and there like weeds. The naïvely painted birds recall children's drawings. Childhood for Klee was a purer, more authentic and 'primitive' state, in which spontaneity was more important than the ordering principle.

CREATED

Weimar

MEDIUM

Watercolour on paper

Paul Klee *Born* 1879 Münchenbuchsee, near Berne, Switzerland

Died 1940

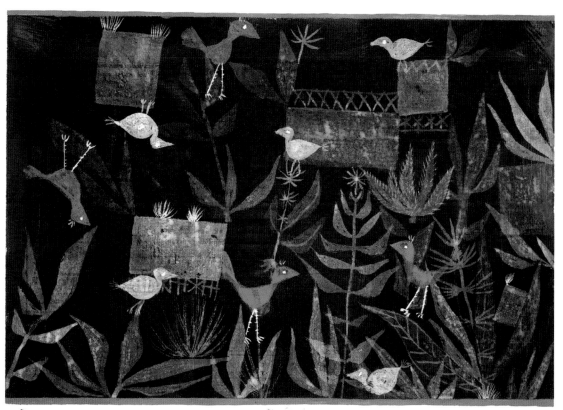

Klee, Paul

Small Fool in a Trance 2, 1927

Courtesy of Galerie Rosengart, Lucerne, Switzerland/Bridgeman Art Library/© DACS 2005

Drawing at the Bauhaus, especially at Dessau, tended to be constructive, oriented towards the realization of objects in three dimensions. Klee, on the other hand, thought of drawing as a line 'that goes out for a walk', with no particular purpose. This work shows that. It is seemingly a doodle, the title of which alludes both to the little gormless creature that emerges and to the artist himself. It is not surprising that the Surrealists saw in Klee a kindred spirit, in that he seemed to yield himself up to the promptings of his unconscious. But this was not entirely true. With its careful delineation of the hands and precise shading to create depth, this drawing does in some sense have a coherent, constructive character. For Klee, art had to be purposeful and contain a rational element, but it also had to imitate nature, not in what it represented, but in its organic unfolding in time.

This composition was also an exercise in what Klee, using a musical analogy, called polyphony. As the line wanders, it triggers the creation of different compositional layers. These simultaneous visual events resemble the playing of different themes at the same time.

CREATED

Dessau

MEDIUM

Oil transfer drawing on paper with glue, mounted on cardboard

SIMILAR WORKS

Paul Klee, *House: Inside and Outside*, 1930

Paul Klee *Born* 1879 Münchenbuchsee, near Berne, Switzerland

Died 1940

Klee, Paul

House, Inside and Outside, 1930

Architectural themes predominate in Klee's work of the early thirties. As has been noted, these works evoke the open areas of buildings by Walter Gropius and Ludwig Mies van der Rohe, which create a continuous flow of space between inside and outside. One thinks of Mies van der Rohe's Villa Tugendhat or the Barcelona Pavilion. This watercolour could thus be read as the plan of a house, with the lighter areas standing for areas illuminated by ceiling-to-floor glazing, or indeed for the outside areas visible through the windows. The overlapping planes of watercolour themselves are produced by the glazing of successive layers of colour. The overlapping of the rectangles also, especially the corners at the centre, creates an effect of structural interdependence.

Nevertheless, these mysterious, delicate, small-scale works maintain a personal aura as one-off artistic creations, rather than completely aligning themselves with the public face of the Bauhaus, based on rational and functional design. This work is also known as 'Polyphony in White'. Klee believed that the building up of successive planes of colour could produce an effect analogous to that of polyphony in music, where several themes interweave simultaneously.

CREATED

Dessau

MEDIUM

Watercolour on paper

SIMILAR WORKS

Herbert Bayer, *Sheet Music*, 1921

Paul Klee *Born* 1879 Münchenbuchsee, near Berne, Switzerland

Died 1940

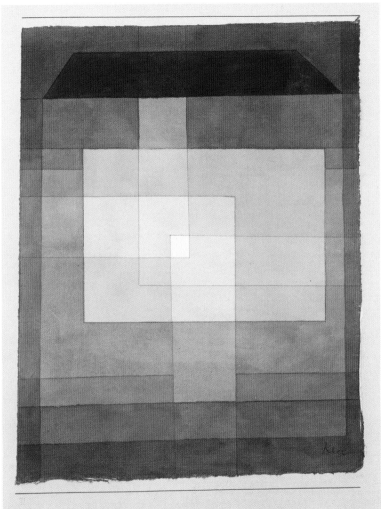

Muche, Georg
Untitled, 1925

Muche, a painter, began teaching at the Bauhaus in 1920. Along with Johnnes Itten, Muche very much belongs to the early years of the Bauhaus at Weimar, with their emphasis on the spiritual and disinclination to engage with modern industry. Closely allied with Johannes Itten, he disagreed forcefully with the slogan of 1922 onwards: 'Art and technology: a new unity'. He considered his innovative *Haus am Horn*, the centre-piece of the 1923 Bauhaus exhibition, as having nothing to do with art. Muche was an unenthusiastic head of the weaving workshop, resigning in 1927 to be replaced by Gunta Stölzl.

Muche had been inspired by the pre-war *Blaue Reiter* ('Blue Rider') group, which included Kandinsky, and which started from natural forms and moved towards abstraction. This piece incorporates leaf- and tree-like forms. The weaving students used some of his compositions in their designs, but Muche wrote later: 'I promised myself never to design a textile pattern with my own hands as long as I lived'. Indeed, with its organic references and personally 'expressive' approach and materials, this work is very far in spirit from the work of most of his teaching colleagues in 1925, who saw hard-edged, depersonalized abstraction as the visual language most suited to design for industry. He gave this work to Kandinsky in 1926.

CREATED

Weimar/Dessau

MEDIUM

Watercolour and ink on paper

Georg Muche *Born* 1895 Querfurt, Germany

Died 1986

Bayer, Herbert

Sheet Music, 1921

This work was made when Bayer was still a Bauhaus student. Against an underlying grid of abstract forms, it juxtaposes shapes of stringed instruments and treble clefs. The identification between art and music was central to the modern movement. Klee and Kandinsky taught that art should not imitate nature, but, like music, create its own independent harmony. Kandinsky believed that the composer Arnold Schoenberg's break with tonality paralleled his own break from figuration – both of them had left the material world behind. Schoenberg (1874–1951) was to become a Friend of the Bauhaus, as was Igor Stravinsky.

The influence of Klee is apparent in the use of delicately overlapping planes and mixing of colours, so that, as in music, several themes are developed at the same time. Klee called this polyphony.

CREATED

Weimar

MEDIUM

Watercolour and pencil on paper

SIMILAR WORKS

Paul Klee, *House: Inside and Outside*, 1930

Herbert Bayer *Born* 1900 Haag, Austria

Died 1985

Bayer, Herbert

Untitled, 1924

This was painted after Bayer had completed his studies at the Bauhaus and before he became a Junior Master in 1925. It is influenced by the French painter Fernand Léger, who is rarely mentioned in connection with the Bauhaus. Léger developed his pre-war Cubist vocabulary into a more ordered, machine-age style, with standardised human beings co-existing with mechanized forms. Bayer recalled that he saw a large Léger painting hanging in Walter Gropius's office at Weimar.

Bayer has turned a Cézanne-style composition of a village with a foreground tree, celebrating timeless nature, into an image of an industrialized and commercialized world. The leafless tree appears to be made of some dull metal. The shapes behind seem to be part-buildings, part-advertising billboards. Their rectangular character, together with the numbers and the striping, suggest the repetitive forms generated by mass production. In other works of 1924, such his designs for a cinema, newspapers stands and telephone kiosks, Bayer likewise explores the inorganic world of technology and the mass media, which form a new man-made environment with no reference to nature

CREATED

Weimar

MEDIUM

Oil on board

Herbert Bayer *Born* 1900 Haag, Austria

Died 1985

Kandinsky, Wassily

Black Triangle, 1925

The supposedly 'abstract' forms here recall nothing so much as an advancing armed and armoured mechanoid, like the human-machine hybrid beloved of the Futurists, or the fearsome female robot queen in Fritz Lang's film 'Metropolis' (1926). A wheel-like form on the left enhances this association with the world of machines and industry. Emerging from what can be seen as a breastplate, two 'arms' seem to hold dangerous weapons. More spiky elements emerge from the 'helmet'. The circles at the 'hips' recall those on the plate armour of fifteenth century German knights, not to mention the diagrammatic drawings of standardized human figures by Oskar Schlemmer, Kandinsky's colleague at the Bauhaus.

Kandinsky was disposed to see human figures in terms of abstract pattern - and presumably vice versa. Recalling his ethnographic visit to the Russian province of Vologda in 1889, he wrote: 'suddenly colourful costumes appeared which flitted about like bright, living pictures on two legs'. In the year that the Bauhaus moved from sleepy Weimar to the modern industrial town of Dessau, it may be that Kandinsky was signalling his disaffection with the school's new technologistic direction. The choice of title is relevant here: triangles for Kandinsky are disturbing, often violent forms, while black stands for death, including the death of possibility. The 'figure' has the black triangle at its heart.

MEDIUM

Oil on canvas

SIMILAR WORKS

Oskar Schlemmer, *The Dancer*, 1922–23

Wassily Kandinsky *Born* 1866 Moscow, Russia

Died 1944

Wassily Kandinsky

One Spot (Red on Brown), 1925

Most of Kandinsky's so-called abstract paintings contain figurative references, but this one is unusual in that it can be read in quite a conventional way as a ship sailing beneath a red sun. The ship is traditionally a symbol of the hope, danger and folly of human life. This one looks far too delicate to be sailing near the apocalyptic red orb, recalling Icarus in the Greek fable, whose wings, stuck together with wax, melted when he approached too near the sun, or the ship that transports the soul across the river Styx in the classical underworld. The red 'sun' bleeds threateningly into the intervening space between it and the 'ship', unobstructed by other objects. There is a disturbing contrast between the behaviour of this shape and that of the well-defined entities in most of the paintings of Kandinsky's Bauhaus period.

The absurdity of human attempts to confront, rival, conceptualize or measure the sublime scale of the cosmos can also be seen in the work of Paul Klee, for whom the grandeur of human imaginings was only matched by the puniness of our physical powers.

CREATED

Weimar/Dessau

MEDIUM

Oil on board

SIMILAR WORKS

Paul Klee, *Analysis of Several Perversities*, 1922

Wassily Kandinsky *Born* 1866 Moscow, Russia

Died 1944

Kandinsky, Wassily

Accent en Rose ('Accent in Pink'), 1926

This composition is free of some of the harsh triangular forms and sharp diagonals of some of the other paintings of Kandinsky's period at the Bauhaus. The pink form seems to have opened and produced celestial bodies which swim in the space around and in front of it. The circles, as others have commented, recall halos, Eastern mandalas and even the lamps that hung in front of holy images in the homes of Russian peasants. The composition seems designed to encourage a spiritual, meditative mood, a contemplation of the the cosmic unity underlying or overlying the differences in the forms of creation. This may seem a long way from the industrially-oriented Bauhaus of 1926, but the older artist-Masters, who had been there since the Weimar period, were allowed to enjoy a certain autonomy in exploring their own visual concerns, particularly Kandinsky, the oldest Master.

Given the warm, peaceful, open qualities of this painting, it is perhaps significant that in 1930 Kandinsky gave it to his wife Nina as a birthday present.

CREATED

Dessau

MEDIUM

Oil on canvas

Wassily Kandinsky *Born* 1866 Moscow, Russia

Died 1944

Kandinsky, Wassily

Soft Hard, 1927

The circular form on the left of this painting inevitably recalls an eye, which is being pierced by sharp triangular forms. Hence presumably the title. Here the circle, in accordance with its bluish colour, may be read as retreating protectively into itself 'like a snail' (according to Kandinsky's description of the behaviour of blue). Snails, of course, have soft bodies. This forms a contrast to the threatening, dynamic reddish tints associated almost wholly with the 'harder' forms. Kandinsky compared the effect of a triangle touching a circle to the touching of the fingers of God and Adam on Michelangelo's Sistine chapel ceiling. The triangles on the left tend to recall a sailboat, floating on a crescent which recalls the sea. Sailing ships were a traditional sign of the questing human spirit in German Romantic art. They also figure in the work of Klee. On the right, in contrast to the violent image on the left, the bluish curved form sustains the triangle without being wounded by it. The dominant theme here is contradiction. Kandinsky strove for effects paralleling those of Schoenberg in music: 'the strife of colours, the sense of the balance we have lost' in the modern age, rather than the soothing harmonies appropriate to a bygone age.

CREATED

Dessau

MEDIUM

Oil on canvas

SIMILAR WORKS

Wassily Kandinsky, *Counterweights*, 1926

Wassily Kandinsky *Born* 1866 Moscow, Russia

Died 1944

Kandinsky, Wassily
Points in the Arc, 1927

Courtesy of Private Collection, Paris, France, Alinari/Bridgeman Art Library/© ADAGP, Paris and DACS, London 2005

A blue circle, in Bauhaus and specifically Kandinsky's teaching, represented the marriage of a spiritual colour with an appropriately celestial shape. Here it seems to be stymied in its movement by the attentions of sharp-cornered triangles, mainly red. The juxtaposition of red and blue created a 'spiritual contrast of strong effect', according to Kandinsky. Perhaps the blue form is being prevented from uniting with a weaker, more distant circular object on the top right.

 The whitish forms on the left seem to be generating more such circles (white, for Kandinsky, was the blank canvas of creation, 'pregnant with possibilities') but their destiny is uncertain, given that several of their brothers and sisters appear to be trapped among the reddish forms. Red, for Kandinsky, was a strong, earthy colour. The composition seems to be organized around the conflict of heavenly aspiration with material reality.

CREATED

Dessau

MEDIUM

Oil on canvas

SIMILAR WORKS

Wassily Kandinsky, *Soft Hard*, 1927

Wassily Kandinsky *Born* 1866 Moscow, Russia

Died 1944

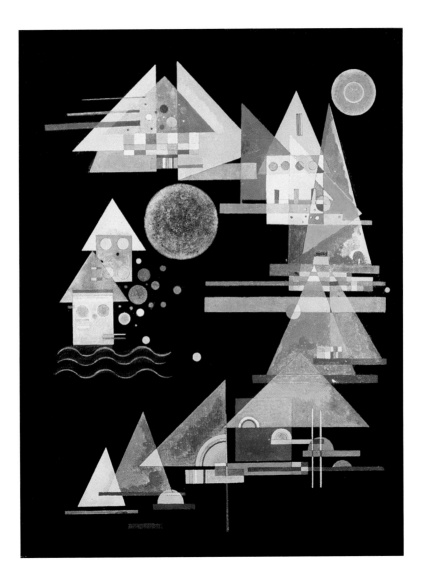

Kandinsky, Wassily

Zeichenreihen ('Rows of Signs'), 1931

The German title of this painting, *Zeichenreihen*, with *zeichen* meaning 'signs', 'symbols' or 'letters', seems a fitting work to end this book. The Bauhaus has been characterized as attempting to create a universal visual language which would be clearly intelligible to everyone, regardless of cultural difference. There is much truth in this characterization, but the Masters formed through pre-war Expressionism, such as Kandinsky and Klee, still believed there to be something mysterious about the acts of creation and communication, in spite of their attempts to articulate clear visual principles in their teaching.

This work recalls ancient Egyptian writings on papyrus. The very clarity of the delineation and arrangement of the signs suggests that they hover on the edge of our understanding, and we only need to be properly receptive. The sharply outlined crescent shapes, diagonal lines, squiggles, circles and triangles occur again and again in Kandinsky's work, especially in his Bauhaus period. Kandinsky stayed with the Bauhaus unitl it was finally wound up in 1933.

CREATED

Dessau

MEDIUM

Oil on canvas

SIMILAR WORKS

Paul Klee, *Egypt in Ruins*, 1924

Wassily Kandinsky *Born* 1866 Moscow, Russia

Died 1944

Author Biographies

Andrew Kennedy (author)

Andrew Kennedy received his doctorate from the Courtauld Institute in 1998. He lectures on 19th and 20th century art at Kingston University and teaches on the Comparative Studies in Cultures course at the School of Oriental and African Studies. He has a particular interest in the history of early twentieth century modernism. He has written for the *Oxford Art Journal and Art History* and has contributed to the following books: *Tracing Architecture: The Aesthetics of Antiquarianism* (Blackwell, 2003), *Deterritorialisations: Revisioning Landscapes and Politics* (Black Dog, 2003) and *The Oxford Companion to JMW Turner* (Oxford, 2001).

Michael Robinson (foreword)

Michael Robinson is a freelance lecturer and writer on British art and design history. Originally an art dealer with his own provincial gallery in Sussex, he entered academic life by way of a career change, having gained a first class honours and Masters degree at Kingston University. He is currently working on his doctorate, a study of early modernist period British dealers. He continues to lecture on British and French art of the Modern period.

Picture Credits: Prelims and Introductory Matter

Further Reading

Bayer, H., Gropius, W. and Gropius, I. (eds.) *Bauhaus, 1919–28*, Museum of Modern Art, New York, 1976

Carter, P., *Mies Van Der Rohe at Work*, Phaidon Press, 1999

Driller, J., *Breuer Houses*, Phaidon Press, 2000

Droste, M., *Bauhaus*, Taschen, 2002

Fielder, *Bauhaus*, Konemann UK Ltd, 2000

Girard, X., *Bauhaus*, Editions Assouline, 2003

Gropius, W., *The New Architecture and the Bauhaus*, The MIT Press, 1965

Gropius, W. and Wensinger, A. S. (eds.), *The Theatre of the Bauhaus*, Wesleyan University Press, 1961

Hochman, E. S., *Bauhaus: Crucible of Modernism*, Fromm International Publishing Corporation, 1999

Itten, J., *Design and Form: Basic Course at the Bauhaus*, Thames & Hudson Ltd, 1975

Kentgens-Craig, M. (ed.), *The Dessau Bauhaus Building*, 1926–99, Birkhauser Verlag AG, 1998

Khan, H. (ed.), *International Style: Modernist Architecture from 1925 to 1965*, Taschen, 2001

Klee, P., *Catalogue Raisonne: Works, 1923–1926 – The Bauhaus in Weimar and Dessau*, Thames and Hudson Ltd, 2001

Lupfer, G. and Sigel, P., *Gropius*, Taschen, 2004

Lupton, E. and Abbot Miller, J. (eds.), *The ABCs of the Bauhaus and Design Theory*, Thames & Hudson Ltd, 1993

Maciulka, J. V., *Before the Bauhaus: Architecture, Politics and the German State, 1890–1919*, Cambridge University Press, 2005

Marzona, E. and Fricke, R. (eds.), *Bauhaus Photography*, The MIT Press, 1987

Moholy-Nagy, Laszlo, *Laszlo Moholy-Nagy*, Phaidon Press, 2001

Naylor, G., *The Bauhaus Reassessed: Sources and Design Theory*, Herbert Press, 1985

Otto, E. (ed.), *Tempo Tempo: The Bauhaus Photomontages of Marianne Brandt*, Jovis Verlag, 2005

Pevsner, N., *Pioneers of Modern Design: From William Morris to Walter Gropius*, Yale University Press, 2005

Poling, C. V. (ed.), *Kandinsky: Russian & Bauhaus Years 1915–1933*, Guggenheim Museum Publications, 1983

Roters, E., *Painters of the Bauhaus*, Zwemmer

Rowland, A., *Bauhaus Sourcebook*, Grange Books

Sharp, D., *Bauhaus, Dessau: Walter Gropius*, Phaidon Press, 2002

Smock, W., *Bauhaus Ideal, Then and Now: An Illustrated Guide to Modern Design*, Academy Chicago Publications, 2004

Watkin, D., *Morality and Architecture Revisited*, University of Chicago Press, 2001

Whitford, F., *The Bauhaus: Masters and Students by Themselves*, Conran Octopus, 1992

Wingler, H., *The Bauhaus: Weimar, Dessau, Berlin, Chicago*, The MIT Press, 1969

Index by Work

General Index